Time Pieces

Barbara Hall, *Wright Morris,* 1986

WRITERS AND ARTISTS ON PHOTOGRAPHY

WRIGHT MORRIS

Time Pieces

Photographs, Writing, and Memory

APERTURE

My aim is to teach you to pass
from a piece of disguised nonsense
to some thing that is patent nonsense.

LUDWIG WITTGENSTEIN

Library of Congress Catalog number: 89-80239
Hardcover ISBN: 0-89381-381-8
Paperback ISBN: 0-89381-382-6
Book design by Wendy Byrne
Jacket design by Michelle M. Dunn

Printed and bound by RR Donnelley & Sons Company

The staff at Aperture for *Time Pieces* is Michael E. Hoffman, *Executive Director*; Steve Dietz,
Vice President, Editorial—Books; Stevan Baron, *Vice President, Production*; Jane Marsching, *Assistant Editor*;
Shelby Burt, Thomas Seelig, *Editorial Work-Scholars*; Linda Tarack, *Production Associate*.
Steve Dietz, *Series Editor*; Wendy Byrne, *Series design*.

Aperture Foundation, Inc., publishes a periodical, books, and portfolios of fine photography to
communicate with serious photographers and creative people everywhere. A complete catalog is available
upon request. Address: 20 East 23 Street, New York, NY 10010. Phone: (518) 789-9003. Fax: (518) 789-3394.
Toll-free: (800) 929-2323. Visit the Aperture website at: http://www.aperture.org

Aperture Foundation books are distributed internationally through: CANADA: General/Irwin Publishing Co.,
Ltd., 325 Humber College Blvd., Etobicoke, Ontario, M9W 7C3 Fax: (416) 213 1917; UNITED KINGDOM,
SCANDINAVIA, AND CONTINENTAL EUROPE: Robert Hale, Ltd., Clerkenwell House, 45-47 Clerkenwell Green,
London EC1R OHT. Fax: 44-171-490-4958; NETHERLANDS, BELGIUM, LUXEMBURG: Nilsson & Lamm, BV,
Pampuslaan 212-214, P.O. Box 195, 1382 JS Weesp. Fax: 31-294-415054; AUSTRALIA: Tower Books Pty. Ltd.
Unit 9/19 Rodborough Road Frenchs Forest, New South Wales. Fax: 61-2-99755599; NEW ZEALAND: Southern
Publishers Group, 22 Burleigh Street, Grafton, Auckland. Fax: 64-9-309-6170; INDIA: TBI Publishers,
46, Housing Project, South Extension Part I, New Delhi 110049. Fax: 91-11-461-0576.

For international magazine subscription orders for the periodical *Aperture*, contact Aperture International
Subscription Service, P.O. Box 14, Harold Hill, Romford, RM3 8EQ, United Kingdom. One year: £30.00.
Price subject to change.

To subscribe to the periodical *Aperture* in the U.S.A. write Aperture, P.O. Box 3000, Denville, New Jersey
07834. Toll-free: 1-800-783-4903. One year: $40.00. Two years: $66.00.

First edition
10 9 8 7 6 5 4 3 2

Contents

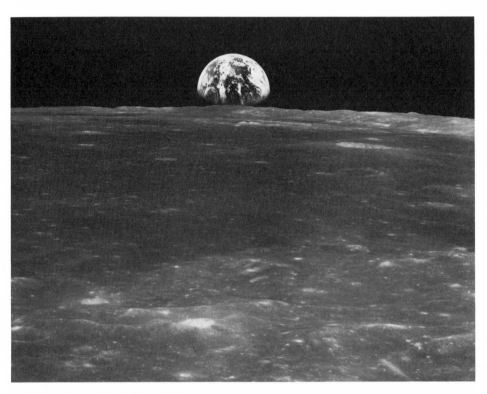

1. NASA, *View of Earth Rise*, 1969

In Our Image

LET US IMAGINE A TOURIST from Rome, on a conducted tour of the provinces, who takes snapshots of the swarming unruly mob at Golgotha, where two thieves and a rabble-rouser are nailed to crosses. The air is choked with dust and the smoke of campfires. Flames glint on the helmets and spears of the soldiers. The effect is dramatic, one that a photographer would hate to miss. The light is bad, the foreground is blurred, and too much is made of the tilted crosses, but time has been arrested, and an image recorded, that might have diverted the fiction of history.

What we all want is a piece of the cross. However faded and disfigured, this moment of arrested time authenticates, for us, time's existence. Not the ruin of time, nor the crowded tombs of time, but the eternal present in time's every moment. From this continuous film of time the camera snips the living tissue. So that's how it was. Along with the distortions, the illusions, the lies, a specimen of the truth.

That picture was not taken, nor do we have one of the Flood, or the crowded ark, or of Adam and Eve leaving the Garden of Eden, or of the Tower of Babel, or the beauty of Helen, or the fall of Troy, or the sacking of Rome, or the landscape strewn with the debris of history—but this loss may not be felt by the modern film buff who might prefer what he or she sees at the movies. Primates, at the dawn of humankind, huddle in darkness and terror at the mouth of a cave; robots, dramatizing the future, war in space. We see the surface of Mars, we see the moon, we see planet Earth rising on its horizon.

Will this image of our planet expand the consciousness of humans or take its place among the ornaments seen on T-shirts or the luncheon menus collected by tourists? Within the smallest particle of traceable matter there is a space, metaphorically speaking, comparable to the observable universe. Failing to see it, failing to grasp it, do we wait for it to be photographed?

There is a history of darkness in the making of images. At Peche Merle and Altamira, in the recesses of caves, the torchlit chapels of worship and magic, images of matchless power were painted on the walls and ceilings. These caves are archival museums. The human faculty for image making matched the

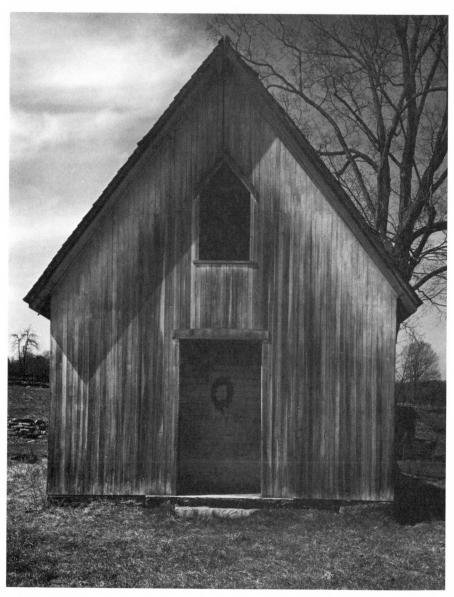

2. *Meeting House,* Southbury, Connecticut, 1940 *

need for images. What had been seen in the open, or from the cave's mouth, was transferred to the interior, the lens in the eye of a human capturing this first likeness. The tool maker, the weapon maker, the sign maker, are also image makers. In the fullness of time humans and images proliferate. Among them there is one God, Jehovah, who looks upon this with apprehension. He states his position plainly.

> Thou shalt not make unto thee any graven image, or any likeness of any thing
> that is in heaven above, or that is in the earth beneath, or that is in the water
> under the earth: . . . for I the Lord thy God am a jealous God. . . .

Did Jehovah know something the others didn't or would rather not know? Did he perceive that images, in their kind and number, would exceed any likeness of anything seen and in their increasing proliferation displace the thing seen with the image, and that one day, like the Lord himself, we would see the planet Earth orbiting in space, an image, like that at Golgotha, that would measurably change the course of history, and the nature of man?

Some twenty years ago, in San Miguel de Allende, Mexico, I was standing on a corner of the plaza as a procession entered from a side street. It moved slowly, to the somber beat of drums. The women in black, their heads bowed, the men in white, hatless, their swarthy peasant faces masks of sorrow. At their head a priest carried the crucified figure of Christ. I was moved, awed, and exhilarated to be there. For this, surely, I had come to Mexico, where the essential rituals of life had their ceremony.

This was, of course, not the first procession, but one that continued and sustained the tradition. I stood respectfully silent as it moved around the square, in the direction of the church. Here and there an impoverished Indian, clutching a baby, looked on. The pathetic masquerade of a funeral I had observed in the States passed through my mind. I took no photographs.

At the somber beat of the drums the procession approached the farther corner, where, in the shadow of a building, a truck had parked, the platform crowded with a film crew and whirring cameras. The director, wearing a beret, shouted at the mourners through a megaphone. This was a funeral, not a fiesta, did they understand? They would now do it over, and show a little feeling. He wrung his hands, he creased his brows. He blew a whistle, and the columns broke up as if unraveled. They were herded back across the square to the street where they had entered. One of the mourners paused to ask me for a handout. It is her face I see through a blur of confusing emotions.

In my role as a gullible tourist, I had been the true witness of a false event. Such circumstances are now commonplace. If I had been standing in another position or had gone off about my business, I might still cherish this impres-

*Unless otherwise indicated, all photographs are by Wright Morris.

sion of eternal human sorrow. How are we to distinguish between the real and the imitation? Few things observed from one point of view only can be considered *seen*. The multifaceted aspect of reality has been commonplace since cubism, but we continue to see what we will, rather than what is there. Image making is our preference for what we imagine, to what is there to be seen.

With the camera's inception an *imitation of life* never before achieved was possible. More revolutionary than the fact itself, it might be practiced by anybody. Intricately part of the dawning age of technology, the photographic likeness gratified the viewer in a manner that lay too deep for words. Words, indeed, appeared to be superfluous. Humans, the image makers, had contrived a machine for making images.

The enthusiasm to take pictures was surpassed by the desire to be taken. These first portraits were daguerreotypes, and the time required to record the impression on a copper plate profoundly enhanced the likeness. Frontally challenged, momentarily "frozen," the details rendered with matchless refinement, these sitters speak to us with the power and dignity of icons. The eccentrically personal is suppressed. A minimum of animation, the absence of smiles and expressive glances, enhances the aura of suspended time appropriate to a timeless image.

There is no common or trivial portrait in this vast gallery. Nothing known to humans spoke so eloquently of the equality of men and women. Nor has anything replaced it. With strikingly exceptional persons the results are awesome, as we see in the portraits of Lincoln: the exceptional, as well as the common, suited the heroic mold of these portraits. Fixed on copper, protected by a sheet of glass, the miraculous daguerreotype was a unique, one-of-a-kind creation. No reproductions or copies were possible. To make a duplicate one had to repeat the sitting.

Although perfect of its kind, and never surpassed in its rendering of detail, once the viewer's infatuation had cooled, the single, unique image aroused frustration. Uniqueness, in the mid-nineteenth century, was commonplace. The spirit of the age, and Yankee ingenuity, looked forward to inexpensive reproductions. The duplicate had about it the charm we now associate with the original. In the decade the daguerreotype achieved its limited perfection, its uniqueness rendered it obsolete, just as more than a century later this singularity would enhance its value on the market.

After predictable advances in all areas of photographic reproduction, it is possible that daguerreotype uniqueness might return to photographic practice and evaluation. This counterproduction esthetic has its rise in the dilemma of overproduction. Millions of photographers, their number increasing hourly, take billions of pictures. This fact alone enhances rarity. Is it beyond the realm of speculation that single prints will soon exist that were made from a negative that has been destroyed?

At the midpoint of the nineteenth century a new world lay open to be seen, inventoried, and documented. It has the freshness of creation upon it, and a new language to describe it. Whitman has the photographer's eye, but no camera.

> Wild cataract of hair; absurd, bunged-up felt hat, with peaked crown; velvet coat, all friggled over with gimp, but worn; eyes rather staring, look upward. Third rate artist.

Or the commonplace, symbolic object:

> Weapon shapely, naked, wan, Head from the mother's bowels drawn.

Soon enough the camera will fix this image, but its source is in the eye of the image maker. Mathew Brady and staff are about to photograph the Civil War. In the light of the camera's brief history, does this not seem a bizarre subject? Or did they intuit, on a moment's reflection, that war is the camera's ultimate challenge? These photographers, without precedent or example, turned from the hermetic studio, with its props, to face the facts of war, the sun glimmering on all of its surfaces. Life or death, what they craved was reality.

The relatively cold war of the Great Depression of the 1930s will arouse the passions of the photographers of the Farm Security Administration: Evans, Lee, Lange, Vachon, Rothstein, Russell, and others. They wanted the facts. Few facts are as photographic as those of blight.

A surfeit of such facts predictably restored a taste for the bizarre, the fanciful, the fabled world of fashion, of advertising, of self-expression, and of the photo as an *image*.

Does the word *image* flatter or diminish the photographs of Brady, O'Sullivan, Atget, and Evans? Would it please Cartier-Bresson to know that he had made an "image" of Spanish children playing in the ruins of war? Or the photographers unknown, numbering in the thousands, whose photographs reveal the ghosts of birds of passage, as well as singular glimpses of lost time captured? Does the word *image* depreciate or enhance the viewer's involvement with these photographs? In the act of refining, does it also impair? In presuming to be more than what it is, does the photograph risk being less? In the photographer's aspiration to be an "artist" does he or she enlarge his or her own image at the expense of the photograph?

What does it profit the photograph to be accepted as a work of art? Does this dubious elevation in market value enhance or diminish what is intrinsically photographic? There is little that is new in this practice but much that is alien to photography. The photographer, not the photograph, becomes the collectible.

The practice of "reading" a photograph, rather than merely looking at it, is part of its rise in status. This may have had its origin in the close scrutiny and

analysis of aerial photographs during World War II, soon followed by those from space. Close readings of this sort result in quantities of disinterested information. The photograph lends itself to this refined "screening," and the screening is a form of evaluation. In this wise the "reading" of a photograph may be the first step in its critical appropriation.

A recent "reading" of Walker Evans "attempted to disclose a range of possible and probable meanings." As these meanings accumulate, verbal images compete with the visual—the photograph itself becomes a point of referral. If not on the page, we have them in mind. "The Rhetorical Structure of Robert Frank's Iconography" is the title of a recent paper. To students of literature, if not to Robert Frank, this will sound familiar.

The ever-expanding industry of critical dissertations has already put its interest in literature behind it and now largely feeds on criticism. Writers and readers of novels find these researches unrewarding. Fifty years ago Laura Riding observed, "There results what has come to be called Criticism. . . . More and more the poet has been made to conform to literature instead of literature to the poet—literature being the name given by criticism to works inspired or obedient to criticism."

Is this looming in photography's future? Although not deliberate in intent, the apparatus of criticism ends in displacing what it criticizes. The criticism of Pauline Kael appropriates the film to her own impressions. The film exists to generate those impressions. In order to consolidate and inform critical practice, agreement must be reached, among the critics, as to what merits critical study and discussion. These figures will provide the icons for the emerging pantheon of photography.

Admirable as this must be for the critic, it imposes a misleading order and coherence on the creative disorder of image making. Is it merely ironic that the rise of photography to the status of art comes at a time when the status of art is in question? Is it too late to ask what photographs have to gain from this distinction? On those occasions they stir and enlarge our emotions, arousing us in a manner that exceeds our grasp, it is as photographs. Do we register a gain, or a loss, when the photographer displaces the photograph, the shock of recognition giving way to the exercise of taste?

In the anonymous photograph, the loss of the photographer often proves to be a gain. We see only the photograph. The existence of the visible world is affirmed, and that affirmation is sufficient. Refinement and emotion may prove to be present, mysteriously enhanced by the photographer's absence. We sense that it lies within the province of photography to make both a personal and an impersonal statement. Atget is impersonal. Bellocq is both personal and impersonal.

In photography we can speak of the anonymous as a genre. It is the camera

that takes the picture; the photographer is a collaborator. What we sense to be wondrous, on occasion awesome, as if in the presence of the supernatural, is the impression we have of seeing what we have turned our backs on.

As much as we crave the personal, and insist upon it, it is the impersonal that moves us. It is the camera that glimpses life as the Creator might have seen it. We turn away as we do from life itself to relieve our sense of inadequacy, of impotence. To those images made in our own likeness we turn with relief.

Photographs of time past, of lost time recovered, speak the most poignantly if the photographer is missing. The blurred figures characteristic of long time exposures are appropriate. How better visualize time in passage? Are these partially visible phantoms about to materialize, or dissolve? They enhance, for us, the transient role of humans among relatively stable objects.

The cyclist crossing the square, the woman under the parasol, the pet straining at the leash, are gone to wherever they were off to. On these ghostly shades the photograph confers a brief immortality. On the horse in the snow, his breath smoking, a brief respite from death.

These photographs clarify what is uniquely and intrinsically photographic. The visible captured. Time arrested. Through a slit in time's veil we see what has vanished. An unearthly, mind-boggling sensation: commonplace yet fabulous. The photograph is paramount. The photographer subordinate.

As a maker of images I am hardly the one to depreciate or reject them, but where distinctions can be made between images and photographs we should make them. Those that combine the impersonality of the camera eye with the invisible presence of the camera holder will mingle the best of irreconcilable elements.

The first photographs were so miraculous no one questioned their specific nature. With an assist from people, nature created pictures. With the passage of time, however, people predictably intruded on nature's handiwork. Some saw themselves as artists, others as "truth seekers." Others saw the truth not in what they sought, but in what they found. Provoked by what they saw, determined to capture what they had found, numberless photographers followed the frontier westward, or pushed on ahead of it.

The promise and blight of the cities, the sealike sweep and appalling emptiness of the plains, the life and death trips in Wisconsin and elsewhere, cried to be taken, pleaded to be reaffirmed in the teeth of the photographer's disbelief. Only when he saw the image emerge in the darkness would he believe what he had seen. What is there in the flesh, in the palpable fact, in the visibly ineluctable, is more than enough. Of all those who find more than they seek, the photographer is preeminent.

In his diaries Weston speaks of wanting "the greater mystery of things re-

vealed more clearly than the eyes see—'' but that is what the observer must do for himself, no matter at what he looks. What is there to be seen will prove to be inexhaustible.

Compare the photographs of Charles van Schaik, in Michael Lesy's *Wisconsin Death Trip,* with the pictures in *Camera Work* taken at the same time. What is intrinsic to the photograph we recognize, on sight, in van Schaik's bountiful archive. What is intrinsic to the artist we recognize in Stieglitz and his followers. In seventy years this gap has not been bridged. At this moment in photography's brief history, the emergence and inflation of the photographer appears to be at the expense of the photograph, of the miraculous.

If there is a common photographic dilemma, it lies in the fact that so much has been seen, so much has been ''taken,'' there appears to be less to find. The visible world, vast as it is, through overexposure has been devalued. The planet looks better from space than in a close-up.

The photographer feels he or she must search for, or invent, what was once obvious. This may take the form of photographs free of all pictorial associations. This neutralizing of the visible has the effect of rendering it invisible. In these examples photographic revelation has come full circle, the photograph exposing a reality we no longer see.

The photographer's vision, John Szarkowski reminds us, is convincing to the degree that the photographer hides his or her hand. How do we reconcile this insight with the photo-artist who is intent on maximum self-revelation? Stieglitz took many portraits of Georgia O'Keeffe, a handsome unadorned fact of nature. In these portraits we see her as a composition, a Stieglitz arrangement. Only the photographer, not the camera, could make something synthetic out of this subject.

Another Stieglitz photograph, captioned *Spiritual America,* shows the rear quarter of a horse, with harness. Is this a photograph of the horse, or of the photographer?

There will be no end of making pictures, some with hands concealed, some with hands revealed, and some without hands, but we should make the distinction, while it is still clear, between photographs that mirror the subject, and images that reveal the photographer. One is intrinsically photographic, the other is not.

Although the photograph inspired the emergence and triumph of the abstraction, freeing the imagination of the artist from the tyranny of appearances, it is now replacing the abstraction as the mirror in which we seek our multiple selves.

A surfeit of abstractions, although a tonic and revelation for most of this century, has resulted in a weariness of artifice that the photograph seems designed to remedy. What else so instantly confirms that the world exists? Yet a plethora of such affirmations gives rise to the old dissatisfaction. One face is

the world, but a world of faces is a muddle. We are increasingly bombarded by a Babel of conflicting images. How long will it be before the human face recovers the aura, the luster, and the mystery it had before TV commercials—the smiling face a debased counterfeit?

Renewed interest in the snapshot, however nondescript, indicates our awareness that the camera, in itself, is a picture maker. The numberless snapshots in existence, and the millions still to be taken, will hardly emerge as art objects, but it can be safely predicted that many will prove to be "collectibles."

Much of what appears absurd in contemporary art reflects this rejection of romantic and esthetic icons. The deployment of rocks, movements of earth, collections of waste, debris and junk, Christo's curtains and earthbound fences, call attention to the spectacle of nature, the existence of the world, more than they do the artist. This is an oversight, needless to say, the dealer and collector are quick to correct. Among the photographs we recognize as masterly many are anonymous. Has this been overlooked because it is so obvious?

If an automatic camera is mounted at a window, or the intersection of streets, idle or busy, or in a garden where plants are growing, or in the open where time passes, shadows shorten and lengthen, weather changes, it will occasionally take exceptional pictures. In these images the photographer is not merely concealed, he or she is eliminated.

Countless such photos are now commonplace. They are taken of planet Earth, from space, of the surface of the moon, and of Mars, of the aisles of stores and supermarkets, and of much we are accustomed to think of as private. The selective process occurs later, when the photographs are sorted for specific uses. The impression recorded by the lens is as random as life. The sensibility traditionally brought to "pictures," rooted in various concepts of "appreciation," is alien to the impartial, impersonal photo image. It differs from the crafted art object as a random glance out the window differs from a painted landscape.

From its inception the camera has been destined to eliminate *privacy*, as we are accustomed to conceive it. Today the word describes what is held in readiness for exposure. It is assumed that privacy implies something concealed.

The possibility of filming a life, from cradle to the grave, is now feasible. We already have such records of laboratory animals. If this film were to be run in reverse have we not, in our fashion, triumphed over time? We see the creature at the moment of death, gradually growing younger before our eyes. I am puzzled that some intrepid avant-garde film creator has not already treated us to a sampling, say the death to birth of some short-lived creature. We have all shared this illusion in the phenomenon of "the instant replay." What had slipped by is retrieved, even in the manner of its slipping. Life lived in reverse. Film has made it possible.

The moving picture, we know, is a trick that is played on our limited responses, and the refinement of the apparatus will continue to outdistance our faculties. Perhaps no faculty is more easily duped than that of sight. Seeing is believing. Believing transforms what we see.

If we were to choose a photographer to have been at Golgotha, or walking the streets of Rome during the sacking, who would it be? Numerous photographers have been trained to get the picture, and many leave their mark on the picture they get. For that moment of history, or any other, I would personally prefer that the photograph was stamped *Photographer Unknown*. This would assure me, rightly or wrongly, that I was seeing a fragment of life, a moment of time, as it was. The photographer who has no hand to hide will conceal it with the least difficulty. Rather than admiration for work well done, I will feel the awe of revelation. The lost found, the irretrievable retrieved.

Or do I sometimes feel that image proliferation has restored the value of the nonimage? Perhaps we prefer Golgotha as it is, a construct of numberless fictions, filtered and assembled to form the uniquely original image that develops in the darkroom of each mind.

Images proliferate. Am I wrong in being reminded of the printing of money in a period of wild inflation? Do we know what we are doing? Are we able to evaluate what we have done?

The Massachusetts Review, Winter 1978.

The Camera Eye

JUST FIFTY YEARS AGO John Dos Passos introduced into his novel *The 42nd Parallel* a device he called the Camera Eye. These short stream-of-consciousness passages, inserted between chapters, owed something to James Joyce but more to the prevalence of photographs, the uncanny effect of the camera's eye on the writer's field of vision. Time as a continuous narrative flow, as in Thomas Wolfe's *Of Time and the River,* was relevant to sentiment and nostalgia but not to the world of the Brownie snapshot, cubist paintings, or Einstein's calculations. A new time, *stopped time,* a fragmented and reassembled time, visible in Duchamp's *Nude Descending a Staircase* as well as those ascending the pages of fiction, would have to be accommodated by both the public and the arts.

These fissures in time's narrative flow, which the photograph calls to our attention, have left expanding and disquieting gaps in our perceived notions of reality, of a familiar and stable world. Some of the disorders common to Western culture, where time has been an objective, measurable event, may well have their rise in the new subjective time that has duration but no direction, that expands and contracts but does not evolve, such as the lost and found time of Proust. Discrete moments of this time, revealed moments of being, inwardly apprehended and assimilated, have turned the eyes and the heads of men and women of genius from the objective and accountable world around us to the unaccountable subjective world within us—from a world of law and order to a world of laws and orders. A fragment of this time, at a moment of media triumph, can be seen in the stopped frame of the television commercial where the victim who is shaving himself cries OUCH! Snipped from the spinning reel of time, this image might provide numerous messages. Quite beyond the telling of it, the camera eye is the one in the middle of our forehead, combining how we see with what there is to be seen.

In its literary rather than its technical context, the term *Camera Eye* was felt to define a personal point of view with an impersonal objectivity. ''To rip the veil of the old vision across, and walk through the rent,'' in the words of D. H. Lawrence, was the shared passion of many artists and writers, but only a few

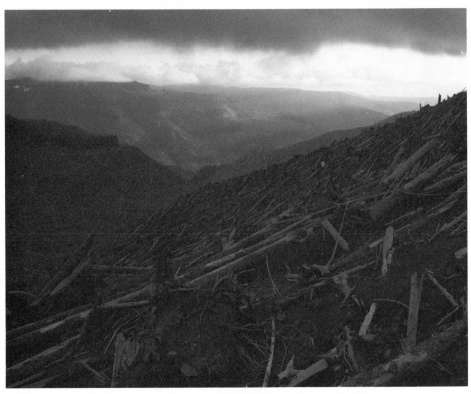

3. Frank Gohlke, *Looking West across Blown-down Area toward South Fork of Toutle River, six miles west of Mount St. Helens,* Washington, 1982

were so positioned to see the tear in this veil made by the camera. Photographs were everywhere and, increasingly, photographers. A magazine called *Life* had made all of life, literally and figuratively, its province. The photograph revealed a visible world seen and shared by all human beings. Dogs looked like dogs, some people like our friends, and objects looked smaller when seen at a distance, just like the real world.

In this halcyon period, the word *reality* was briefly restored to accepted usage. Visible things were real. Real things could not help but be visible. But this truce between words and images was predictably brief. Under the lens of analytical scrutiny—and some of it thanks to the lens of the camera—the word *reality* was found to be like the space between the dots in a pointillist painting. The closer the scrutiny, the larger the magnification, the less appeared to be there.

Those who deal in words, who rely on words for the ultimate affirmation of how and what things are, are periodically subject to these seizures, and it is no accident that the present renaissance of interest in photographs and photography follows a period given over to the ''abstract'' and our perplexity as to what, if anything, is real.

From their inception, photographs have lent themselves to the grain of American experience. American writers, in particular, have been challenged and sharpened by them. Walt Whitman, Mark Twain, and Stephen Crane had eyes for detail that we would call photographic. The camera eye came to them as naturally as the new vernacular language. The vernacular, indeed, finds its consummation in photographs. If there is a cunning passage in photographic history, it lies in the fact that an American was not the first to conceive it. But perhaps this oversight is still subject to correction. Somewhere, in the fixed pages of a journal, currently valued for its binding, will be found some sketchy images, with hasty notations, concerning something referred to as solar pictures.

When we are under the impression the world is new, we are inclined to look at it more closely. Henry James, with his mind's eye trained on the finest filaments of sensation, instinctively responded to what was *visible* in the American scene. On returning from England, he saw it all with fresh eyes and published a matchless book, *The American Scene*.

A decade before James, the ''close reading'' of photographs found a recruit in the writer Stephen Crane. Like Thoreau, Whitman, and Twain, he was obsessed with a dream of reality. He was obsessed with war, a very American addiction, but lacking one at hand for his personal observation he turned to the volumes of Civil War photographs taken by Alexander Gardner, Mathew Brady, and others. There he confronted the facts on which the sun glimmered in his own mind. In *The Red Badge of Courage*, he transformed his impressions into literature.

He was being looked at by a dead man who was seated with his back against a columnlike trunk. The corpse was dressed in a uniform that had once been blue, but was now faded to a melancholy shade of green. The eyes, staring at the youth, had changed to the dull hue to be seen on the side of a dead fish. The mouth was open. Its red had changed to an appalling yellow. Over the gray skin of the face ran little ants. One was trundling some sort of bundle along the upper lip.

The "photographic" details Crane so vividly described were in his feverish imagination . . . not the photographs. They provided him with the larger, harrowing, ponderable images on which his imagination could creatively brood. There is reason to believe an actual war would not have served him as well. He needed the visual facts as the leaven of his untried emotions. Through them he was able to revisualize a war that was more appropriate to his own nature. Do we still turn to the camera eye for such facts? In the face of all evidence to the contrary, which accumulates about us daily, we persist in feeling, if not in believing, the facts are what photographs give us—however much they may lie, they do so with the raw materials of truth.

Photography discovers, recovers, reclaims, and at unsuspecting moments collaborates with the creation of what we call history. That period we refer to as the Great Depression is largely a photographic triumph. United by sentiments of compassion and a shared enthusiasm for photography, a handful of gifted and committed men and women, including Walker Evans, Dorothea Lange, Russell Lee, Arthur Rothstein, and John Vachon, assembled a portrait of America and Americans profoundly at odds with the prevailing chromos of "America the beautiful." Nothing will compare with the camera to capture the seamier side of life—in particular, American life. To have lived in poverty and squalor is not new: human beings have made an art of it for centuries. Lewis Hine and Jacob Riis saw this darker side of the well-advertised American image of plenty, but the shock value was low since they were dealing with "foreigners" and urban blight. Both of these regrettable manifestations were very UN-American. But squalor in the open, squalor on the land that had just been broken for human advantage, and once broken was now being abandoned, this was news. Blowing dust, tidal waves of sand, wrecked cars, forsaken homes, derelict and hungry children, broken, bent, and damaged men and women—through powerfully direct and courageous photographs, these became symbols of a common human plight. It is highly possible that these photographs, in their worldwide distribution, constitute the most convincing and widely accepted American image. Even those who were not in the least depressed, and lived as comfortably as usual, not a few of them more so, will today recall the thirties in the nostalgic terms and characteristics of these photographs. Urban and rural blight, blowing dust and faded denim, highways bordered with blown tires, abandoned cars, utensils, and pieces of luggage are

not merely part of our shared past but perhaps its most convincing chapter. Thanks to photography, the grain of our experience is identified with photographs.

In my vulnerable years I would sit through the movies in order to enjoy the rerun of the Pathé Newsreel. The world could be seen revolving. A little too fast for my comfort, but reassuringly round. Blasts of sound and the narrator's voice accompanied the snatches of wars, marching men, crashing cars, disasters. Wide-eyed, open-mouthed, I was baptized with the new vision, and would keep the faith.

In this way the ground was prepared for the century's great moments of visual drama: the atomic blasts, the landing on the moon, and the space spectacle of *Star Wars*. In these extremes of imagery, the telling eyewitness was the camera. Without it, much that is known to have occurred would still be in the realm of rumor and science fiction. Understandably, doubters are not lacking. They see it as a piece of establishment propaganda.

"But I was there!" cries the man in the space suit, holding up his rock sample.

"Of course you were!" says the uniformed attendant, and leads him off.

A recent issue of *National Geographic*—reassuring in its yellow-framed format—featured the eruption of Mount Saint Helens six months after the actual event. The magnitude of this disaster, its awesome scale in terms of planetary happenings, had not been adequately captured or exploited by the news on television. The media had been prepared for human-made incidents, on the human scale, not these out-of-scale cataclysms. From a distance, the smoking cone of the crater was a familiar, even pastoral, tableau, seen by millions on the walls of high school classrooms, the labels of wine, travel books, or insurance policies. Only darkened skies and a choking rain of ash testified to the scale of the calamity, but what had actually occurred still had to be seen at firsthand. Photographs taken by campers and hikers were the first to confirm the devastation. Those taken before and after the eruption reveal a change in the landscape so profound they resemble different epochs in geological time. Forested land of wild and undefiled beauty had been transformed into a scene more desolate than the moon. Trees that had towered 150 feet high had been snapped off like twigs and strewn about like matches. Six months after the event, thanks to the camera eye, we are able to retrieve a moment of natural history as we are able to reexperience the disasters of war. Whatever it will prove to be, the vast fiction of history must now be reconciled with the testimony of the camera, and this will not come easily. The two ways of *seeing* seldom describe the same event.

Numerous remarkable and intrepid men—today we would find women among them—once lugged and carted an array of supplies and equipment to the world's picturesque outposts. The expedition of Samuel Bourne, into the

mountains of Kashmir, was like that of Stanley in search of Livingstone. The
secret ingredient in these enterprises was the passionate zeal of the photogra-
pher, a new breed of explorer. The panorama of history had prepared men for
surprises, and many had left memorably vivid descriptions, but the photogra-
pher rightly believed himself embarked on a new voyage of revelation. Seeing
was believing, and belief was crucial to progress and legislation.

In America a band of true believers, sharing a faith that was common to
missionaries, followed the receding frontier into the fabled far West. The more
fortunate among them attached themselves to government survey parties. Their
job was to convince a skeptical and faraway Congress that the West of tall
tales and immense vistas actually existed as more than an upside-down image
on the ground glass. Others became pioneers, commercial photographers who
settled in the cities or hamlets along the main routes of travel or continued
their wanderings to California, frequently documenting what they feared might
change before they set up their cameras and clicked the shutter.

In America, as nowhere else, photographers confronted a complex chal-
lenge. Their subject could be seen evolving, as well as vanishing, before their
eyes. In a decade the look of a place might alter, budding into green life or
crumbling into ruin, giving rise to that excitement and anxiety that is peculiar
to photographers. Like Satchel Paige, they feared to look back and see what
might be gaining on them. Nor need we doubt that they often turned, as we
do, to the photographs they had made for confirmation of their conflicting
impressions. The streets of New Orleans, Omaha, and Dallas, the whistle-
stops of Ohio, Wisconsin, and Indiana, the tepees of the plains, the pueblos of
the Southwest, the enchanted ruins of the Canyon de Chelly, and for the aston-
ishment of the world the remnants of an entire race. Presented in their full re-
galia, as if intuiting a final judgment, they faced the photographer as if
assembled to be shot. The miraculous device that stopped time recorded these
moments of the white man's triumph. Another time persisted where one had
stopped.

On the Nebraska plains, where no towns existed, Solomon Butcher persuad-
ed those who lived in their cave-dark sod houses to come into the open where
the camera could see them, bringing with them those articles of value squir-
reled away in their burrows. These objects testified to lives as unreal as
dreams. The westward course of the Empire has no stranger passage than this
moment of time stopped by Butcher, echoing a past time beyond accounting.
After the shutter has clicked, and he has put away his camera, I ride with him
on the buckboard seat of his wagon. Until we see what he has captured, we
will not believe what he has seen.

Van Schaik had a similar experience in Wisconsin, and Michael Lesy is
right, in my opinion, in observing that these photographs of the 1890s are
more religious than secular, are semimagical acts that deal with time and mor-

tality. The unexampled uniqueness of the photograph lies in the way these elements are commingled, giving rise to an intense poignancy. This emotion is not new, but American experience lends an enhancement to all that vanishes. To this extent we are more human than we were, but the gain, if it is one, is to be contemplated with mixed feelings. To be more human, rather than less, is no longer a prospect to be taken lightly.

Susan Sontag tells us that photographs of Bergen-Belson and Dachau, seen at an impressionable age, divides her life between a before and after. The mere mention of Buchenwald is sufficient to populate the mind with images of atrocity. If the human mind could be appraised, and its contents noted, would these photographs constitute a burden we must all carry into the future?

The extremes of modern suffering and debasement seem unrelated to the simple facts of extinction. Neither do the bald statistics bring home to us the nature of the crime. Yet if we seek for images that are adequate to this century, they will be found in photographs. Mushrooming clouds, open mass graves, and tidal movement of sand over once arable land. But these imperishable facts, made visible to us, have not perceptibly diminished our capacity to think well of ourselves.

The camera eye that began, just a few generations ago, to affirm the visible world around us is now in the process of displacing that world with its own more available, coherent image. When we think of the ''world,'' do we not think of a photograph? There it floats in space, as seen from the moon's barren surface, a marble like those I once carried in my pocket, vulgarly known as snotties. If the world is partially eclipsed by the moon's shadow, I am able to imagine that I see time itself, at the penumbra, crumbling away as the planet revolves. Clouds swirl, and on the land mass beneath them a map of the United States has been imposed, unchanged from the one I gazed at in grade school. This commingling of the natural, the miraculous, the arbitrary, in what we call ''The Weather,'' is the one television drama that I follow with devotion. The mountain ranges are wrinkles on the back of my hand. And better yet, no people! No visible pollution, no balance or imbalance of power. No on- or offshore drilling. No impending doom. The movement of armies, the cunning of spies, the alteration of boundaries, the construction of launching pads, silos, and shelters are fictions to be left to invading Martians. A circling UFO, with its cargo of space folk, makes a shadow like a Frisbee coming in for a landing. Do they come with personal greetings from Carl Sagan or golden discs of space rock music?

For many months, on the wall facing my desk, I contemplated an image of planet Earth, orbiting in space. Out of time as we know it had come this moment of stopped time. Under the veil of swirling cloud, Mount Saint Helens rumbled and prepared to erupt, the crust of the earth cracked, twitched, and crumbled, numberless creatures went about their daily murderous business, the

Yanks beat the Red Sox, Billy Carter sold beer, and I sat at my desk pondering a view of the planet from space. I experienced, that is, a timeless human quandary. For fleeting moments my mind's eye zoomed in to an unearthly double vision. Through rents in the cloud cover I saw the Great Plains, the pattern of fields and right angles, the dry bed of a river as it snaked its way eastward, and where flecks of green indicated a village, I strained to see who it was that returned my gaze. A child, clothed in rompers, sat in the talcum-like dust beneath the porch of a house. Wide-eyed and entranced, he dreamily gazed through the porch side slats in my direction. Between us shimmered a cloud of dust motes in which time's substance seemed suspended. If I would peer at this child from far enough in space, where earthly time was in abeyance, would not the child who sat there, recognizably myself, return my gaze?

One of the great and appealing charms of the snapshot is that we can see and easily appreciate what it captures. The moon peeping through clouds, a dog nursing pups, a youth's first pair of long pants, grandmother dozing in her rocker. The impression we receive is usually one we have already had. But as these images recede in time and their numbers diminish, their familiar ''message'' undergoes a sea change. The timeworn cliché is suddenly less time-bound, the commonplace is touched with the uncommon. The role of time in most photographs is like that of a sorcerer's apprentice. Alchemy is afoot. Before our very eyes dross metal is transformed into gold. Photographs considered worthless, time's confetti, slipped from their niche in drawer or album, touch us like the tinkle of a bell at a séance or a ghostly murmur in the attic. And why not? They are snippets of the actual gauze from that most durable of ghosts, nostalgia. They restore the scent, if not the substance, of what was believed to be lost. I was about to add—before scruple stopped me—that in such a transport the tongue is silent, but perhaps I am not the person to say so. Someone more qualified will have to reassure us on that point.

At some time during my lifetime, the individual person has ceased to be the standard unit of measurement. This is a question of feeling, rather than measure, but more tangible to our senses. The new unit is the aggregate, a system of dealing with sums and totals. In this way the gross national product has replaced the personal human image. To counteract this loss of individual status, we have the current and expanding epidemic of artists, of art as therapy, of art as a hobby, since we intuit that art is the transcendent way to self-discovery and self-fulfillment.

I am told that my grandfather, to escape the crowding back where he came from—to escape, that is, the sight and proximity of his neighbors—migrated to the plains of Nebraska. More than fifty years later he was scornful to hear that man was ''a social animal.'' What man? Not those he happened to know and admire. He was a bit of an eccentric, but it was not lost on me that he enjoyed the admiration of his more conventional neighbors.

If this example is extreme, I think it is not uncharacteristic. We once took our crusty uniqueness for granted. Writers and artists of that now far time made it a theme of their hymns of praise and complaint. They provided the last hurrah for a state of mind that is alien to the drift of this century—a shift in the spectrum of our psyche from the individual to the aggregate.

The word *masses* has always been offensive to the native ear. The *lonely crowd,* with its admission of *alone*ness, was more acceptable as a state of soul than that of new, awakened masses. Photographs of large multitudes, like those of May Day in Red Square, have provided most Americans with simplistic but basic images of un-American life. Recently, however, the tribal rites of the young have brought them together in similar multitudes. To form a meaningful unit, one begins with a measurable multitude.

Quantity in all things, the sheer magnitude of it, as in the aptly named *gross national product,* quantities of people, products, problems—and photographs. The mind boggles to think of the number of photographs that exist, that are now being taken, that are still to be taken. Is there a point in the life of numbers, as there was in the life of individuals, where the sheer accumulation, the quantity, leads to qualitative changes?

Just a decade ago, the private costume of rebellion, the faded, frayed, and patched denim Levi's, conferred the status of freedom on the wearer. In designer counterfeits—we might say parodies—they are now the symbol of high fashion and radical chic. In this painless, if not seamless, manner, fashion has made a frivolous comedy out of manners, but its effect on photography is at once less visible and more profound. It is hard to distinguish, in fashion's shimmering spectrum, if a color is advancing or receding, but the photographer's dilemma lies in the way all photographs tend to resemble each other. This is a triumph of fashion where it was not believed to exist.

Less apparent in what we see than in how we see it, it seems to me that an element of fashion increasingly dictates our manners and our tastes. It is the nature of the photograph both to document this predicament and to suffer from it.

If we pause to look about us for an emblem of our condition, it may well be so obvious we overlook it. Not the bomb, nor the computer, nor the black holes in space, but the low and not so lowly photograph. If we are looking for a likeness, that is where we will find it—if we know where to look. This was true in the time of Gaspard-Félix Tournachon, known as the Great Nadar, and it is true today. In my own little chamber of emblematic icons, apt to pop into my mind at unwary moments, I see the figure of Isambard Kingdom Brunel, the builder of bridges and steamships, in his stovepipe hat, one hand thrust into his vest front, as he posed beside the huge links of the anchor chain of the Great Eastern. The vast affairs of Empire, and its westward course, are made visibly concrete in this image.

Like the writer to writing, the painter to painting, the composer to music, the movie addict to movies, the photographer is incurably vulnerable to photographs. He or she can no longer avoid seeing the world in the manner photographers have seen it. In many ways photographs appear to have displaced it, and the visible world must be rediscovered.

All modern artists perhaps suffer from this overexposure, and some who are overexposed experience a loss of identity. The image of Marilyn Monroe in Andy Warhol's painting is an act of exorcism. We are freed of a bondage at the expense of the bond. What the camera eye gives us, unavoidably, are repeated images of ourselves. The sense of déjà vu is the view that is increasingly apparent. I give you merely one observer's impression, made neither in censure nor as an appraisal, but if I read it correctly, it gives notice of a surfeit of photographic riches.

Does the eye that once gloried in the visible world, and sometimes strained to accommodate it, now look for reassurance and find it in the photographic image? It is at once one of our frailties and our sources of creation that we see "images" better than we do the world around us. Indeed, that is why they exist. The mothers of this world, who feast their eyes on their loved ones, mapping their every feature, eagerly await the photographic likeness to confirm their hopes, their fears, their suspicions.

Although we have a general impression of a place, a person, and a landscape, the nature of the eye dictates that we must look at just one detail at a time. More and more these details are the property of photographs. Just as there are people—all known to us personally—who can only see clearly what has a frame around it, can we look forward to a generation that will only be at ease with a picture of something? A view, a pet, a loved one, a disaster? The image provides the confirmation that is lacking in the sight itself. Seeing is still believing, if what we see is a photograph.

I recall the day and the exact moment one of my friends thrust into my hands a copy of *Life* magazine open to reveal a human embryo, in the womb's sac, with its thumb corked in its mouth. Information and revelation were so combined in this image as to be overwhelming. I am still pondering what I saw. In this way our response to a photograph can be as individual as our response to life. At the flash of cognition we are able to dispense with the intermediary.

In its directness, its freedom from mediation, exegesis, and hermeneutics, the photograph has enjoyed—until recently—an unexampled artlessness of communication. Until recently. Now that it has undergone a rise in status and is an object of value, analysis, and speculation, the attention it receives is increasingly verbal. Tentatively, then with more and more assurance, words are now affirming the image, as the photograph once affirmed reality. No one planned it that way. It seems to be the fate of human enterprises that are open

to scrutiny and discussion. To the extent the photograph is a ponderable object—like the book, the painting, or the structure—it will have to be pondered with words. Already there is evidence, in the readable pages of *Exposure*, that photographic theory and analysis are more assured and innovative than much of photographic practice. Nor is that at all unusual. If the example of literature is instructive, the rise, influence, and ascendancy of criticism testifies to photography's coming of age. Critics too love to write, many write very well, and what they write we have agreed to call criticism. The photographer might be cautioned, however, that the more advanced literary critics have put the reading of novels and stories behind them. What critics read is each other. And it pretty well takes up most of their time. Now that photography is of age, critically speaking, and criticism continues to expand and flourish, we may look to a movement among photographers to spend more time brooding in the darkroom. Taking the pictures the critic has in mind, or in words, can be inhibiting.

More than a century ago Oliver Wendell Holmes, the elder, not a man to run a fever over a fashionable innovation, could not contain his enthusiasm for photography. Most of you are familiar with his prophetic statements. What interests me is his enthusiasm. The excitement generated by photography's discovery, and the unflagging fervor of its application, are more of a clue to its nature than volumes of analysis and theory. The camera eye partakes of the supernatural, of the miraculous. It is no accident that it is a gift of light and that its alchemy takes place in darkness. At work in the darkroom or under the hood of the camera, the photographer is in the charmed world of the séance, of bizarre and unearthly expectations. Nadar tells us that Balzac feared the camera's eye, believing that each exposure peeled away part of his actual substance, as if he were an onion. However extravagant such feelings appear to be, they touch the quick that is part of the photograph's inscrutable nature. Emotions of this depth and complexity fueled the enthusiasms of the nineteenth century, and we still feel their power among us. The commitment felt by those who feel the camera's eye is an extension of their own vision and assures us that the example of Ansel Adams has been duly noted and valued. A lifetime's work adds to the work of a lifetime a quality that we recognize as vintage. Adams is vintage. He has returned to the root, the soil, and the vine more than he received.

Time savored as vintage ennobles numberless photographs. I have in mind one, taken at the turn of the century, of the assembled survivors, men and women, of the first Mormon trek to Salt Lake. This photograph dazzles the eye and boggles the mind with its vision of Old and New Testament faces. I have gazed at it long and long. I turn from it with the need, explicit as a vow, to look at it again.

Many images compete for the twentieth century, but I would guess that

planet Earth, seen rising on the moon's horizon, will vibrate the longest in our memory. Perhaps it will mark an increase in human awareness. I recall saying somewhere that to be more human, rather than less, is enough, but I am no longer so sanguine, being less certain than I once was as to what it is to be human.

The camera's eye and the mind's eye share a vision that has imposed itself on this century. Photographs now confirm all that is visible, and photographs will affirm what is one day remembered. Human affairs have not quite been the same since the first images formed on plates of copper, but after a century and a half we are still uncertain if it is more or less than what Samuel Beckett described as a "stain on the silence." Whatever it is, look for the camera's roving eye to get a picture of it.

Critical Inquiry, Autumn 1981.

The Romantic Realist

ON THE OCCASION OF A RETROSPECTIVE exhibition of my photographs in Lincoln, Nebraska, in 1975, a visiting journalist from Israel turned to me and said, "You are a romantic." It was not what either of us had expected. He was puzzled and amused. I was startled. What was there in these remains and ruins of the New World, so reminiscent of the Great Depression, that would impress a visitor from the Old World with lineaments of the romantic?

Forty years earlier, in the fall of 1933, I had left college in California for a *Wanderjahre* in Europe. A year later I returned to California determined to be a writer. In Europe I had had a plenitude of those experiences that a young American went abroad in search of, but the first examples of my writing concerned the boyhood on the plains I had all but forgotten.

> My Aunt Clara came in with the eggs. She held them like clothespins in her apron and scratched off the hen spots. Uncle Harry came in with the milk. He took Capper's Weekly and the lamp into the parlor. He took off his shoes and filled his pipe with Prince Albert (*The Inhabitants*).

Rather than break the spoken rhythms of the words the details are obscure, the inner voices muted. What the writer seems to want is an "epiphanic" moment of revelation, but it will be some time before he knows that. He is laboring to "see," to visualize a remembered impression.

> Through the vines was Bickel's grocery store and a brown dog drinking at the fountain. Sparrows dropped from the trees to the wires, and then from the wires to the ditch grass. A pigeon dropped from the belfry to the roof of the barn. Jewel's Tea Wagon rocked on the tracks and the dust came along and went by (*The Inhabitants*).

Time hasn't actually stopped, but the movements are slow enough to be photographed. The living tableau is that of a still life, a decisive moment, but the movement of the words suggests a reluctant narrative.

The limitations of my camera (a Rolleiflex) were more of a challenge than a hindrance to me. I made do. All by myself I discovered the virtues of stopping down the diaphragm. In the alleys and byways of southern California I found

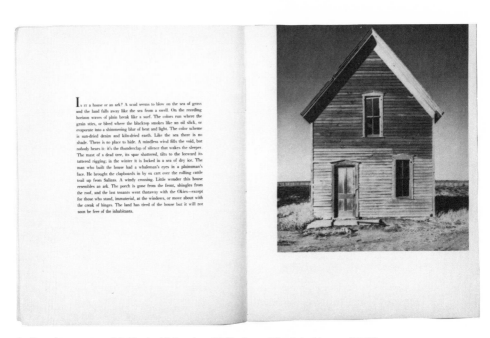

Is it a house or an ark? A scud seems to blow on the sea of grass and the land falls away like the sea from a swell. On the receding horizon waves of plain break like a surf. The colors run where the grain stirs, or bleed where the blacktop smokes like an oil slick, or evaporate into a shimmering blur of heat and light. The color scheme is sun-dried denim and kiln-dried earth. Like the sea there is no shade. There is no place to hide. A mindless wind fills the void, but nobody hears it: it's the thunderclap of silence that wakes the sleeper. The mast of a dead tree, its spar shattered, tilts to the leeward its tattered rigging; in the winter it is locked in a sea of dry ice. The man who built the house had a whaleman's eyes in a plainsman's face. He brought the clapboards in by ox cart over the rolling cattle trail up from Salinas. A windy crossing. Little wonder this house resembles an ark. The porch is gone from the front, shingles from the roof, and the last tenants went thataway with the Okies—except for those who stand, immaterial, at the windows, or move about with the creak of hinges. The land has tired of the house but it will not soon be free of the inhabitants.

4. *Farmhouse,* near McCook, Nebraska, 1940, from *The Inhabitants* (1946)

I guess Grandpa got away first — he just picked up and headed for Kansas — but the thing about Grandpa is that all you see is where he is from. No matter where he is all you see is where he is from —

I remember him leavin' his oatmeal with the sugar meltin' on it and walkin' out to where the privy stood. Then he come in and sit messin' with his spoon. Then he said, Ma—I'm goin' to build it on the rise. She turned from the stove and looked at him, then she looked away, and he got up and left his oatmeal just sittin' there. Through the window we seen him cross the yard and look off at the rise like the house was already built and the shingles on. And like he was standin' there in the door he waved to us. He's a damned old fool, I said—that wind'll blow you clean to hell—but I could see that what was growin' on him was growin' on her. And she just sat and looked at him like at a litter of new pups.

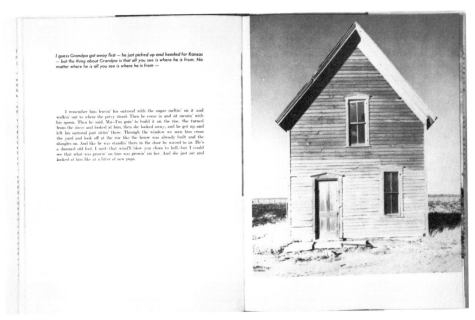

5. *Farmhouse,* near McCook, Nebraska, 1940, from *God's Country and My People* (1968)

the shards and artifacts that had their origin in the Midwest of my boyhood, and the images of my imagination. Through writing, through the effort to visualize, I became a photographer, and through my experience as a photographer, I became more of a writer. This has been well remarked by my readers, but I would make one crucial distinction. What I *see* as a writer is on my mind's eye, not a photograph. Although a remarkable composite of impressions, the mind does not mirror a photographic likeness. To my knowledge I have never incorporated into my fiction details made available through photographs. This is a mite singular, but not paradoxical. The mind is its own place, the visible world is another, and visual and verbal images sustain the dialogue between them.

My limited means, one small camera, and my limited experience, one large subject, spared me many pratfalls. That I was able to turn from the "imagined" artifacts of the Platte Valley, of Nebraska, to the existent artifacts of southern California, attests to the consistency of the look and feel of the American grain.

The mystique of the apparatus is an intrinsic part of the photographic machinery. To some degree all photographers feel it. The fever eventually abates in those whose interest lies in taking pictures; in others it rages like an addiction. I remember my lust for a Plaubel Makina, seen in the window of a pawn shop. Having once set eyes on a Zeiss Contaflex, I was distracted until I had one. It even took pictures. Possessing this object was quite separate from the necessity of using it. One kept it loaded. Surely the occasion would arise for which it was uniquely created. If my impression is correct, it weighed about the same as the 12-pound shot, but was harder to handle.

On Cape Cod, in the summer of 1939, I moved up from the Rolleiflex to a $3\frac{1}{4} \times 4\frac{1}{4}$ speed graphic, with a Schneider Angulon, and dreamed of a 4×5 Linhof. With the affluence of a Guggenheim Fellowship I acquired a 4×5 graphic view camera and a long-sought-for seven-element anastigmatic lens whose name I have forgotten. I'm not proud of that. It might have been Steinheil. It was a great satisfaction just to possess it. Fine-grain Panatomic film packs suited my purpose, as did Eastman's Velour-Black paper. An amidol solution, which I varied in strength, gave me the deep blacks I wanted. As an image maker, I emphasized structure at the expense of a full range of tones. Never having shown a faculty for chemical solutions, I have left the developing of the film, with few exceptions, to the laboratories.

In 1969, on a stay in Venice that my wife and I thought might be our last for some time, I took a quantity of snapshots to console us in our exile. For this purpose I used the small Rollei 35, a 2.8 Tessaar, and Kodachrome film. The results were gratifying and led to the book *Love Affair: A Venetian Journal*. During the making of the plates, in Italy, both for the quality of the work and the economics, one of the Kodachrome slides disappeared at an early stage

of the processing. What to do? In New York this would have been a question of insurance value. In Italy, an employee of the firm, a native of Venice, returned to the city on the chance he might retake the same picture, but the building had been repainted—conceivably the only repainted structure in modern Venetian history. The plate was printed in a muted color, very well suited to the rippling wall of a tenement in what had once been a Venetian ghetto. At the end of the book's manufacture, the missing slide was found wherever slides go to get away from people. Is there anywhere people and objects can go to get away from photographers?

In the plains environment the relative scarcity of objects, people, and places enhances their meaning. With the passage of time many will function as icons, and the writer will seek to redeem time through them. The structures and artifacts in my photographs are vernacular icons of this order, as well as the collection of human-made ruins impersonally recorded by the lens of the camera. That paradox conceals what the visitor from Israel saw so clearly but is not often apparent to the natives. The man who took these photographs—these clichés of nostalgia, in the same category as the prongs of a fork used to open the clogged holes in a milk can—was a dreamer.

> Out here you wear out, men and women wear out, the sheds and the houses, the machines wear out, and every ten years you put a new seat in the cane-bottomed chair. Every day it wears out, the nap wears off the top of the Axminster. The carpet wears out, but the life of the carpet, the figure wears in.
>
> I watched the old man in his nautical hat cross the yard like one of his harrows, the parts unhinged, the joints creaking under a mat of yellow grass. He stopped near the planter to suck on his pipe, tap the bowl on the seat. On the spring handle of the gear lever was a white cotton glove, the fingers spread, thrust up in the air like the gloved hand of a traffic cop. The leather palm was gone, worn away, but the crabbed fingers were spread and the reinforced stitching, the bib pattern, was still there. The figure on the front of the carpet had worn through to the back *(The Home Place)*.

At the end of the 1930s, crossing the country by car, I was possessed by the desire to photograph those structures more accurately described as ruins. As they emerged in the gloom of the darkroom, I experienced the amateur's disillusion. What I saw, and what the Rolleiflex recorded, were not the same. This did not diminish my sense of mission, and I acquired a more suitable camera, with a ground viewing glass and a wide-angle lens. Under the black cloth, eyes fixed on the ground glass, the photographer would learn to see what was actually there before him, intriguingly upside down. Thus the lens of the eye sees the world until some cunning in the mind's darkroom corrects the impression. Anything so miraculous is compelled to become commonplace.

That fall in Connecticut I put aside the novel I was writing and converted a farmhouse bathroom into a darkroom. Some of these vintage prints are still

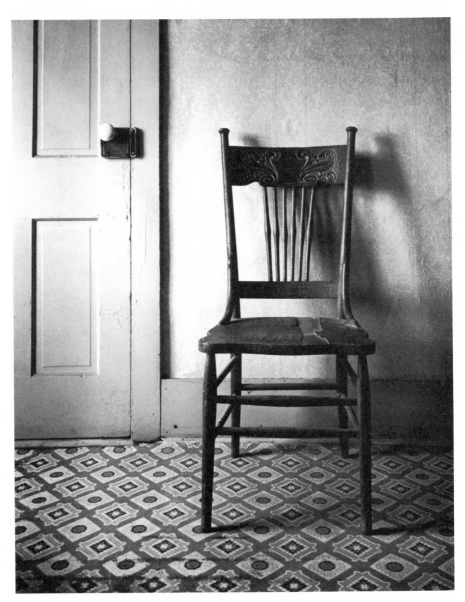

6. *Straightback Chair, Home Place*, Norfolk, Nebraska, 1947

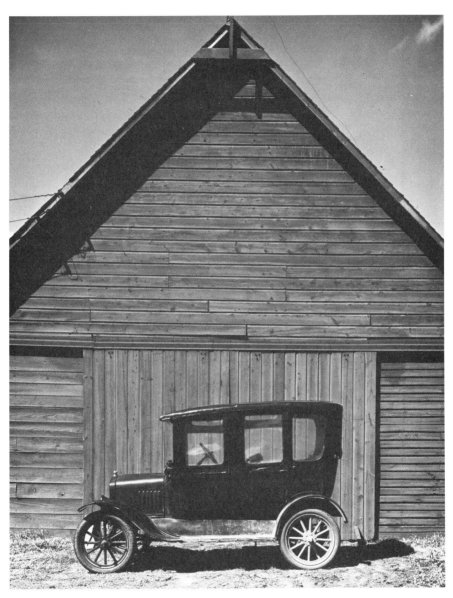

7. *Model T, Ed's Place*, near Norfolk, Nebraska, 1947

embedded with the iron pumped up from the well. This period of euphoria also triggered my first experiments with photo-text. Those prose pieces that led me to take my first photographs I now saw as complement and counterpoint to the photographs I was taking. I sensed, at the outset, that the two media must retain their independence. This proved workable because the same persona, out of the same impulses and obsessions, produced the complementary images. When we say—and how often we do—"But what I *mean* to say is"—and then wave our arms, roll our eyes, make faces that are both signs and signals, we are all rudimentary media mixers involved in relating words, the limitations of words, to what we *see*.

My commitment to the promise of photo-text burned with a gemlike flame for the decade between 1940 and 1950, when it became apparent that the public did not share my enthusiasm. In that period, *The Inhabitants* and *The Home Place* were published, and I had clearly in mind a series of photo-text volumes that would deal with the American scene as a whole. Such a view of the United States recalls the maps that once ornamented the lobbies of railroad stations, where the prospective traveler, nine years of age or older, could see all of the places he or she hadn't been to. That prospect, and the dreams it generated, have been replaced by the views from space, wherein the inhabitants, their enterprises, and their pollutions are equally invisible. Little wonder the images of Star Wars and other close encounters register a change in perspective that still waits on its resolution. What might these young viewers see, if they should care to look at the images in this retrospective? Do they testify to gains or losses? Do they invoke ancestors or nightmares? Ruins to be buried and forgotten or fossils to be rehabilitated?

If I assume *their* perspective, for a moment, I see photographs other than those in my books. They are as clear and as ambiguous as faces. Like a glimpse through a narrow crack in time, these arrested moments, in the lives of objects, are open to numerous and contrary interpretations. Will any of the viewers judge them romantic, or has that word itself undergone a sea change? We only get the better of words, as T. S. Eliot reminded us, for the thing one no longer has to say or for the way in which one is disposed to say it. Twenty years after *The Home Place* the photographer himself takes a new perspective on the same material in *God's Country and My People*. Many of the photographs are the same, but the writer has changed and is more explicit. To this extent, and uniquely, the photograph constitutes a given fragment of the visible world to which the writer, as he changes, will have differing responses. It is that simple. It is that inexhaustibly complex.

Am I mistaken in detecting in these photographs something of the wonder of a small boy who pondered the map of the States in the station lobby? If we abandon the clichés of childhood bedazzlement, with the exception of the one that old houses are haunted, we will find the core of life-enhancing sentiment

that seems at odds with the images. I am drawn to these materials by an accumulation of expectations and an explorer's sense of discovery. Remember that this young man has just returned from Europe and looks about him, as we say, with new eyes, for the first time. He is aware of a new-found land before he thinks in terms of salvage, of recovery. The effort to check what is slipping, to hold what is escaping, is the response of a more experienced observer than the young man who took the first pictures. ''Look at that!'' he said to himself, in the spirit of a traveler, pointing out the sights. This catalogue of objects and places is more of a celebration, in the spirit of Whitman, than a documentation in the spirit of the thirties. The photographs themselves will not resolve this paradox. They are at once artifacts, representing conditions, and ballads singing of heartbreak, death, and pleasurable longing. We see character, fate, and that fine madness that gives to airy nothing a local habitation and a name. Unquestionably romantic. Could that visitor from Israel have been right?

From a lecture given at Pomona College, Claremont, California, 1978.

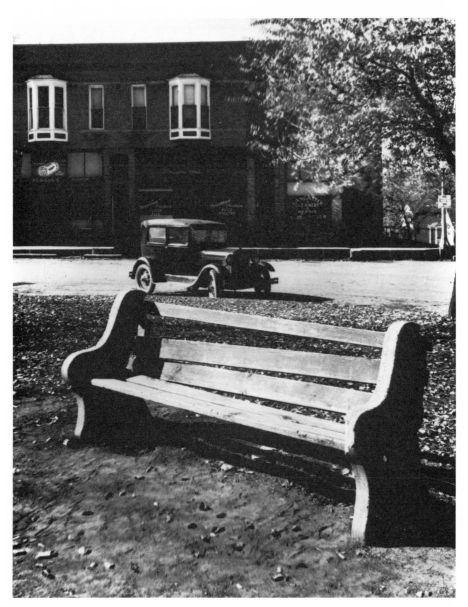

8. *Park Bench,* Indiana, 1951

Of Memory, Emotion, and Imagination

THE SMALL CREATURES OF THIS WORLD, and not a few of the large ones, are only at their ease under something. The cat crawls under the culvert, the infant under the table, screened off by the cloth that hangs like a curtain. In the Moldavanka ghetto of Odessa we have this self-portrait of Isaac Babel:

> As a boy I was given to lying. It was all due to reading. My imagination was always on fire. I read in class, during recess, on the way home, at night—under the dinner table, hidden by the folds of cloth that reached down to the floor. Reading made me miss all the important doings of this world.

In these few words much light is shed on the subject of fiction and the imagination. Not all writers burn with this fire, but many have their beginnings under something. Far from Odessa, in the Platte Valley of Nebraska, street culverts, piano boxes, the seats of wagons and buggies, railroad trestles, low bridges, the dark caves under front porches were all favored places of concealment. With Br'er Fox, I shared the instinct to lie low. Seated in dust as fine as talcum, my lap and hands overlaid with a pattern of shadows, I peered out at the world through the holes between the slats. A train passed, a tethered cow mooed, a woman collected clothespins in the hammock of her apron, thunder crackled, rain puffed dust in the road, the bell tinkled on the Jewel's Tea Wagon as it crossed the tracks.

One reason I see it all so clearly is that I have so often put it into writing. Perhaps it is the writing I remember, the vibrant image I have made of the memory impression. A memory for just such details is thought to be characteristic of the writer, but the fiction is already at work in what he remembers. No deception is intended, but he wants to see clearly what is invariably, intrinsically vague. So he imagines. Image making is indivisibly a part of remembering.

Not long ago I returned to the town I was born in, to the house I associated with my childhood. There were several, but *this* house was the house with the porch. From the concealment of this porch I saw the train pass, I heard the cow moo and the thunder crackle, I watched the rain puff the dust in the road.

To my puzzlement it proved to be a stoop less than a foot off the ground. A cat or a small dog might have crawled beneath it, but not a child. Brooding on this mystery, I began to recall under-the-porch furnishings I had conveniently forgotten. There had been a pair of stilts, a scooter made from a fruit crate and a skate, a sled known as a Flexible Flyer Junior Racer, the wheels of a dismantled tricycle. Not this porch. *That* porch, indeed, had been five steps up from the walk to the porch, where a chain swing creaked and banged the clapboards. There *had* been a crosshatching of slats at one end, but the view had been blocked by the second-floor windows of a neighboring house. How was that possible? That porch was on a steep hill in the bluffs of Omaha, and not in the flatness of the Platte Valley. It had been a superior porch for concealment and spying, and my imagination had shifted the scenery to suit the needs of fiction and emotion. I had substituted this more accommodating porch (with no loss in the quality of the dust, and a gain in furnishings and the height of the ceiling) for the one that my hometown had been lacking. I badly *wanted* that porch, and my imagination had obliged.

If I attempt to distinguish between fiction and memory, and press my nose to memory's glass to see more clearly, the remembered image grows more illusive, like the details in a pointillist painting. I recognize it, more than I see it. The recognition is a fabric of emotion, as immaterial as music. In this defect of memory do we have the emergence of imagination? If we remembered both vibrantly and accurately—a documentary image rather than an impression—the imaginative faculty would be blocked, lacking the stimulus necessary to fill in what is empty or create what is missing. This faculty of artful lying is image making, and not always confined to fiction writers. Precisely where memory is frail and emotion is strong, imagination takes fire.

One memory that is clear is that of a reader who took special pains to praise my memory, as evident in my fiction. He cited specific details from a number of novels: the white hairs from a mare's tail, a bent skate key, the cracked chimney of a lamp, a salvaged ball of tinfoil, and so on. I had heard this before. What led me to question it on that occasion? One novel in question, *Ceremony in Lone Tree,* was an assembly of parts from my own fictive archive. In the opening chapter, entitled ''The Scene,'' many of these stray, unclaimed pieces found their ultimate and appropriate place. Somewhere in the past, memory had done its work, recording details from a variety of sources. From that album of objects and places I had selected the pieces appropriate to the fiction. Artifacts were jumbled with sensations. The cracked lamp of the chimney, in one place, gave rise to the smell of singed hair in another. That in turn to the fragrance of freshly dampened clothes, and the scorched smell of the iron. Fiction writers are often obsessed with a sense of place, and perhaps I am somewhat more obsessed than others. Most places have for me, in James's phrase, a sense of their own, a mystic meaning to give out.

To the extent one thing is almost like another, we are able to grasp, to reaf-
firm, both things. The overlapping of accumulated impressions gives depth and
mystery to our experience with time. We have Proust's theme and variations
on the inexhaustible madeleine. The impressions of childhood, indelibly im-
printed on a mind open and eager for sensations before it is cunningly attuned
to ego satisfactions and evasions, are the ideal circumstances for the nature
destined to be an image maker. Adult impressions accumulate like the yearly
fall of leaves, providing both protection and compost, waiting for the moment
that the seedbed will sprout with its new growth. It will prove to be more than
the writer had in mind, and much of it will be new.

For the American writer, more than most, repossession may be an act of re-
creation. What was once there may have been little enough—or what was once
there may have been obliterated. The furnishing of the mind with artifacts and
symbols that began with Walt Whitman is increasingly a matter of salvage.
The shortage of appropriately *saturated* artifacts is part of the deprivation felt
by the younger generation. We all may miss, but hardly grow to cherish, what
is felt to be intentionally obsolescent, instant *kitsch*.

In the craft of image making there is much to be said for the slow grower.
The less culture-shaped child, accumulating experience before he does art,
when stimulated by the images of art will have recourse to his own unique re-
sources. From Twain through Faulkner this has been a characteristic American
experience. Those favored by a more cultivated background (like Henry James
or Edith Wharton) are felt to be less American. This is a narrow but telling
distinction. The mind of James was shaped by the images of culture, rather
than the rawer materials of experience. It is the purpose of culture to produce
such minds, but a democratic culture has not evolved an appropriate use or
place for them. Within the scope of a century, since Whitman, native raw ma-
terials have lost their rawness, and most writers of fiction have their begin-
nings as readers of fiction. It is the written image that now shapes writers in
their efforts to become their own image makers.

The observant child who grows up with paintings, the reflective child who
grows up with books, is already at an artful remove from the natural surround
of objects and places. Later he or she may well experience a confusion of
impressions. What was *real?* What had been imagined by somebody else? This
is a tiresome but durable dilemma. Young Isaac Babel assures us that his
imagination was enflamed by what he read, not by what he saw, but what he
wrote tells us otherwise. He was pollinated from both sources. From the read-
ing he received the emotional charge that fueled his feverish imagination. To a
remarkable degree art produces art, and writing produces writers. Lack of orig-
inality in most image makers has its roots in this imprinting. Only those with a
very pronounced talent manage to depart from what they have received, and
image what is their own. Cave painters also fell under this persuasion once

they had a ceiling of images to inspire them, drawing what they beheld on the walls of the cave rather than the confusion and disorder of the hunt. We know that mimicry is crucial to learning, but those who learn it too early, or too well, may end up as duplicators, not image makers. Image making as distinct from likeness making is illustrated in the description of a well-known public figure as one who has "a face like the bottom of a foot." This seemingly far-fetched comparison is an inspired piece of image making: an original, not a duplication.

In their more buoyant moments fiction writers know that there is fiction quite beyond their conception, and their practice, but implicit in the nature of image making. Of all this they have glimpses just beyond their grasping, teasingly beckoning and elusive. These glimpses go far to explain their romantic readiness for audacious gestures and strident manifestos—as well as their irksome suspicion that they are in chains. The captivity of custom is so comprehensive, the bonds that bind them also free and support them. Fiction writers are aware of the world behind the Looking Glass but seem powerless to step through it. Space probers and great image makers occupy the same void.

Almost a century ago Mark Twain greeted his readers:

NOTICE
Persons attempting to find a motive in this narrative will be prosecuted; persons attempting to find a moral in it will be banished; persons attempting to find a plot in it will be shot.

At the risk of being banished, few American writers have felt it safe to depart from the vernacular. All writers fell under the spell of the visible world, but only American writers had at their disposal a language seamlessly welded to their material—indeed, seemed to be the material itself, fraying away at the fringe of the immediate present.

. . . Whatever may have been the case in years gone by, the true use for the imaginative faculty of modern times is to give ultimate vivification to facts, to science, and to common lives, endowing them with glows and glories and final illustriousness which belong to every real thing, and to real things only. Without that ultimate vivification—which the poet or other artist alone can give—reality would seem incomplete, and science, democracy, and life itself, finally in vain.

So Walt Whitman, in a loving all-embracing, backward glance.

From *Earthly Delights, Unearthly Adornments,* by Wright Morris (New York: Harper & Row, 1978).

Time Pieces

A PHOTOGRAPH TAKEN IN 1838, wherein we see a Parisian having his shoes cleaned, has about it the aura of an image evoked in a medium's séance, at once earthly and unearthly. Who took it? The camera took it. No confusion at the moment in the credit column.

Less than twenty years later, on the occasion of the launching of the world's largest steamship, Robert Howlett took a portrait of Isambard Kingdom Brunel, "the little giant," a builder of railways, bridges, and oceangoing steamers. We see him, attired in the height of Victorian fashion, his stovepipe hat gleaming like a helmet, his hands tucked into the slit pockets of his trousers, his gaze inward, his expression brooding, a man of Empire at the moment of Empire expansion. Unmistakably we see that his trousers are besmirched, his shoes are soiled. The right leg of the trousers, by happenstance, is as detailed in its folds as an artfully draped sculpture, a sunburst of rays fanning out from the kneecap. More than a foot is added to his stature by the top hat. Stopped-time, the gift of the camera shutter, has made of this moment a time piece both timely and timeless. What might the author of the *Origin of Species,* soon to be published, have thought of this *homo sapiens* posed before the massive links of the *Great Eastern's* anchor chain?

"At the thought of the eye," Charles Darwin wrote, "I grow cold all over," and something of this prescient chill can be felt by the viewer who ponders Howlett's remarkable image. In it is layered something of the origin of this new species, but even more of its future. Whose age is it—if not the Age of Photography? No other likeness takes the measure of the twentieth century like the photograph.

An early enthusiast for the cinema would soon observe:

> When all are able to photograph their dear ones . . . with their familiar gestures, with speech on their lips, death will no longer be so final.

Of what other innovation can such an extravagant claim be made? Whether or not death is less final, even the lowliest of snapshots often speak to us more eloquently of our losses than the most artistic portrait. The portrait might well

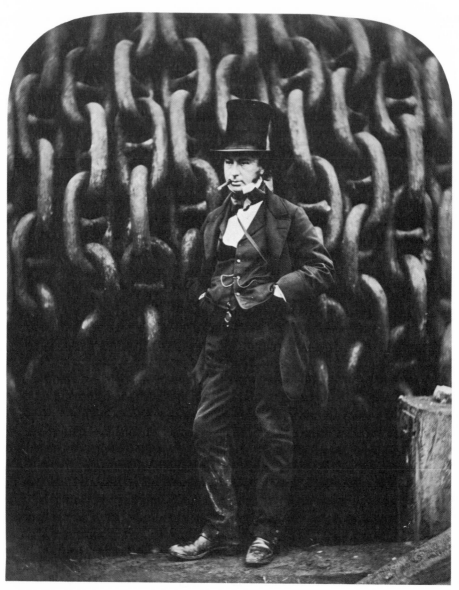

9. Robert Howlett, *Portrait of Isambard Kingdom Brunel
and Launching Chains of the Great Eastern*, 1857

be a Work of Art, but it is not art that we crave. Only in the photograph do
we get the likeness akin to life itself, akin to nature, as in this portrait of Isam-
bard Kingdom Brunel. Two years later, at fifty-three, he will be dead, yet un-
seen by the public for another century. The fickle finger of fate has now re-
stored the ''little giant'' to an image larger than life.

In the early 1930s, my room on Florianigasse in Vienna overlooked a garden
where the blind came to walk. When my bedding was aired in the morning I
would lean out the window and observe them. They usually walked in pairs,
stiffly erect, marching slowly to an unheard drummer. It shamed me to spy on
them in this manner, but I was young, each hour seemed precious, and I was
eager to be one of those, like Henry James, on whom nothing was lost. To
hold fast to what I saw, before it escaped me, what did I need? I needed a
camera.

 On a chill November day in a nearby open market I managed to ''snap''
three peasant women, their heads in babushkas, seated behind three fat,
plucked geese. That snapshot is one that I still have, somewhere. In what
would prove to be a longing for what was old, toil-worn, soon-to-be passing,
for what I hoped the photograph would salvage, I dimly perceived that time it-
self, scaled to human perception, was the time captured by the camera eye,
and why it awed, lured, and escaped me. ''Scrutable'' time, the time that is
money, the time that we can't seem to get enough of, has little in common
with the inscrutable time captured in a photograph. The secret heart of the
snapshot, beyond our peeping and spying, is the snippet taken from the reel of
time, in and out of time, timely and timeless.

In Susan Sontag's *On Photography*, more light than we have absorbed on a
muddled subject, the only photograph to illustrate, to supplement the text, is a
daguerreotype on the front of the jacket. The reader is encouraged to assume
that the author, a writer not a photographer, did not want the distraction and
ambiguity of photographs to muddle up what she had written.

 In *First and Last*, a final gathering of the photographs of Walker Evans, no
identifying captions are found beneath the reproductions. The reader is encour-
aged to assume that the photographer did not want the amibiguity of words to
muddle up the clear statement of the photographs. Both writer and photogra-
pher distrust the commingling of mediums, of competing powers of persua-
sion. To this extent they respect and affirm the commonsense notion of a
relatively pure, uncontaminated, medium of expression. Photographers applied
this notion to the ''straight'' photography of the f64 persuasion. These photog-
raphers distrusted the contamination of the candid camera and much that it

"stood for." What it stood for, however, what anything "stands for," is a matter of words.

If the first act of the viewer is to look at the photograph, the second is to turn it over to see *what* it is, *where* it is, *when* it was taken, and *who* took it. A day or a decade is more than enough to skewer the photograph's plain-as-day and ambiguous message. If the vital statistics prove to be present, there remains the troubling judgmental question—is it a work of art? Of these questions and answers we know there will not soon be an end.

The source of this ambiguity, as in all others, is in the eye of the beholder, an observation so time-tired and threadbare it is tiresome to mention. The first time it was brought to my attention, however, it was fresh as the egg of a sea bird. I had come from California—more of a fiction than a state—to show in Washington, D.C., a sampling of my photographs to Roy Stryker, chief of the remarkable crew of photographers of the Farm Security Administration. I got his message plain and unambiguous. "Where were the people?" he asked me. In his concerned and troubled eyes I saw that he meant to say, where were the suffering, the hurting, the humiliated People, of the Great American Depression? In the absence of such people he saw me as an impostor. Why would anyone take pictures of time-tired, life-worn structures, and not include the wasted, exhausted, brutalized people, with their rag-clad fly-bitten, half-starved children?

Did I try to explain? I was too dumbfounded. I had learned, the hard way, that in the presence of truly humiliated people I was incapable of taking photographs, either of them or their meager "possessions." This "failure of nerve" had much to do with my preference for the materials that took the blows of life with less bleeding, transforming them in both spirit and substance. How could *my* photographs prove to be so ambiguous? Without a supporting cast of depressed and beaten people, of which there was no shortage of supply, Stryker found my photographs of no interest. I also clearly perceived that their absence depressed him more than their presence. How—his silence cried to me—could an American photographer be so dumb?

This sobering lesson in ambiguity was underscored by a book published a few weeks later, the *American Photographs* of Walker Evans. The prevailing sentiment of the time, among sophisticated, literate people, who might appreciate the photographs of Walker Evans, was that Great Depression photographs *were* America. Alan Trachtenberg has clarified this state of the nation in his essay "Walker Evans' America, A Documentary Invention." Without a caption of words, without commentary, the mirror the camera held to the facts of life was as ambiguous as life. Like the Princess in Hans Christian Andersen's story, "The Shadow," it is best not to look at anything too closely, including a photograph.

I owed much of my assurance about the "facts" of life to a lyrical state-
ment by Thoreau, in *Walden*.

> If you [he meant me, of course!] stand right fronting and face to face to a fact,
> you will see the sun glimmer on both its surfaces, and feel its sweet edge divid-
> ing you through the heart and the marrow.

Exactly, just as I had felt it. Only to find that others felt *other*wise about it.
As we have come to know, if not to believe, this is also true of the photo-
graphs of Bergen-Belsen, Dachau, and other death camps and Lagers. These
were the very photographs, the confirmation of the facts, that Susan Sontag
felt divided her life into two parts, before and after.

This glimpse into the past, that foreshadows the future, is unique to the
powers and the properties of the photograph. One hundred years later, ad-
vanced units of the Russian and American armies would stumble on the re-
mains of the Holocaust at Bergen-Belsen, Dachau, Treblinka. What had been
rumored but found impossible to believe, the testimony of the camera would
authenticate. Without it, the Nazi practice of destroying, along with the vic-
tims, every shred of their deliberate and calculated practices, would lack the ver-
ification only the photograph provided. Even with this confirmation, material
and substantial, the passage of time, the ceaseless accumulation of further exam-
ples of atrocity, would find a French politician recently declaring that the Holo-
caust was a fiction of war propaganda. Primo Levi, a survivor of a Lager, believed
the attitude of *dis*belief would be the one to prevail. As we come to know we
are capable of anything, of everything, we are less and less inclined to admit
to it. Perhaps the admission is a greater burden than the guilt. Alive in the pres-
ent, our eyes on a conjectural future, deluged with media images hourly, if
we cannot be selective of the photographs we live with, we will become indiffer-
ent to them. For all of their horror, their veracity, they are only photographs.

Then there are other photographs, thousands of them, some more atmos-
pheric than factual, with a touch of cinema's illusion about them, that provoke
me to look at them more closely. To come back and look at them, again and
again, until I see their shadowy likeness on my mind's eye.

There is one in particular, somewhere on the treeless plains, of a street of
unpainted buildings, with varying false fronts, that huddle together for support,
as if blindfolded, not a glimmer of light in the dark windows, no visible sign
or advertisement on the walls to hint at the name of the town, or where it is.
The wide dirt street is crisscrossed with the tracks of buggies, the far side
lined with the stores that serve as props in "Western" movies. I stand gazing,
squinting my eyes, for the approach of a sheriff's posse on their well-lathered,
bit-frothing horses. I wait for the clop of their hooves, the sharp crack of their
pistols. In this scene so readily given over to *action,* there is, however, no ac-

tion. Nothing stirs. No eyes, in the shadow of a hat, return my gaze. A ghost town, perhaps? I narrow my eyes and look for ghosts. It is the emptiness, the palpable silence, the ineluctable hush of waiting, that leads me to notice the disturbance of air, like a bubble in glass, at the far end of the street, creating a blur like a drop of water, in which I see distorted reflections. If I strain to ponder this blur, to *resolve* it, a horse and wagon materialize out of the thin air. As in a mirage, the ghostly horse and buggy appear to float on a cushion of air. Is it vanishing or materializing? It is precisely this ambivalent state of its nature that has compelled me to see it more clearly. My eyes are stopped-down to the lowest aperture, an f64 squint. In time's timeless mode, where objects blur to confirm time's invisible passage, we experience a dimension of time so commonplace our custom is to ignore it, as we do the weather on the horizon. In the *blur* of the photograph time leaves its gleaming, snail-like track.

Around the turn of the century, somewhere west of the Missouri, a traveler by the name of Edward Steichen wrote the following to his friend Alfred Stieglitz:

> . . . I managed to see a lot of Nebraska, Colorado & New Mexico, and in a way I feel it is one of the greatest things I have experienced. . . . Somehow, since I have been west I almost regret going to Paris—or Europe. I tell you one builds up a big wholesome respect and appreciation of those early settlers—My God what men and women they must have been.

What men and women indeed! These were the feelings of a pioneer and homesteader on the plains by the name of Solomon Butcher. Much that he saw he found hard to believe. To reaffirm and confirm what he saw, he took up the practice of photography. He was provoked to this action by a breed of homesteaders, men, women and children, the live stock not forgetting, whose only shelter on the treeless, inhospitable plains was in houses constructed of slabs of sod, some of them like caves. The sod was there, several inches in depth, because the plains had never been plowed. Millennia of grass had created a pelt with an intricate, furlike, web of roots. Slabs of this stuff could be peeled off the surface and used like bricks. A roof could be covered with slabs of the plain with grass and flowers that were still growing. With the melting of the snow, flowers might bloom in the spring. The horns of steers might also be put on the roof to discourage the occasional curious coyote. With all due deliberation, and with both incredulous and compassionate eyes, Butcher applied himself to documenting this indigenous culture of sod-house dwellers in Custer County, Nebraska.

How was he able to persuade this new breed of homesteaders to bring from the dark privacy of their caves most of the objects they cherished? Sewing machines, a foot-pedaled organ, cages of canaries hung in open doorways, rocking chairs, galvanized pails, houseplants in tin cans, the family Bible. There they were, in front of their homes, the women seated holding infants, the men,

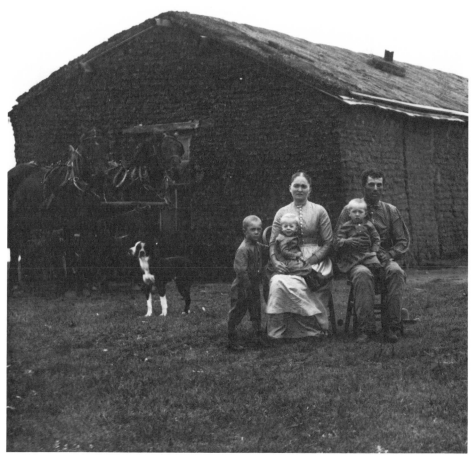

10. Solomon Butcher, *Charles Blakeman, West of Merna, Nebraska* (detail)

the children, the elders posed with a horse or a pitchfork, anticipating Grant Wood's *American Gothic,* dogs with blurred or double heads, teams of horses harnessed for travel, the facade of the soddy ornamented with objects in the manner of a "garage sale," the overall impression that of an occasion so exceptional *only* a photograph would bear it witness, and do it justice.

The willing collaboration of such independent and private men and women in such an open and public display testified to the great need they too felt to affirm and authenticate their unexampled existence. The women, in particular, would have endlessly pondered the primitive life in which they were captive, would have borne and raised children, and endured dreams that were doomed to fail. Only one in three of these "homesteaders" survived the three years of settlement necessary to justify their claim. The crudest survival was one thing; attempting to actually farm the bleak, arid, and windswept plain was another. The one in three, however, more than attested to Steichen's heartfelt testimony—what men and women, indeed, they must have been.

The example of Solomon Butcher, the documentary aspect of his vision, first led me to ask why some ingenious Yankee, on the cutting edge of westward expansion, had not been the first to discover the principles of the camera obscura. Everywhere that Americans explored or migrated, everywhere that they *looked,* they had reason to affirm what they saw, to confirm a world with such people in it, both the eyes and the imagination dazzled. The facts of life, of American life, much of it as new as a dream of Eden, lent themselves to the camera's field of vision. The photographs of William Henry Jackson, Timothy O'Sullivan, Carleton Watkins, and others would persuade the Congress of the United States to finance further western exploration.

Happenstance—an essential ingredient of Photography's promise—found Samuel Clemens, still a boy on the frontier he would soon celebrate, made the subject-object of a daguerreotype as he showed off a belt buckle with the word SAM cast in metal.

Among the Yoruba of western Nigeria, who adopted the photographic studio portrait introduced by the British, a popular feature is the portrait of twins, one of whom has just died. A deliberately conscious and skillful effort is made to deceive the observer, depriving death of what is lethal in its sting. Here again, big as life, is the twin presumed lost.

To postpone, if not to recover such losses, a Wisconsin photographer, at the turn of the century, took thousands of photographs of his neighbors. His obsession had much in common with Solomon Butcher's. He wanted confirmation of what he saw: he wanted to hold on to what was passing. We might say that to postpone what was vanishing was a very American photographic passion, a breed to which I, too, was a late comer. As documented in Michael Lesy's *Wisconsin Death Trip,* the photographer's eye was on the rural and small-town people he recognized as a threatened species.

One of his photographs features two beautiful infants, each in its crib. Each wears a garland of leaves and flowers appropriate to the occasion. What occasion? As we ponder the photograph we are subject to disquiet. Something invisible, but palpable, persuades us that these infants are out of time, rather than in it. Uneasily we perceive, in the details of their appearance, the flawless perfection of a dried arrangement. Both infants lie in caskets, not cribs, and their sleep is one from which they will not waken. We can no longer evoke the numbing grief of the parents, but the function of this photograph, as in an act of witchcraft, was to make this unbearable loss acceptable. In the serene sleep of the children, attested to by the image, we approximate a vision of peace and reconciliation that is more in scale with gains than losses. We can accommodate death, even welcome it on occasion, but we balk and hallucinate in the presence of extinction. In the photograph the infants are embalmed in sleep.

The photographs I have singled out for praise, for comment, are not considered to be "works of art." Photographers *make* pictures, as well as take them, and the photographs they make, in which they are a presence, are both something more and something less than the usual photograph. It is sometimes more, and to be valued as such, if the photographer has put his or her "self" into the picture. It is also less, since this contribution is not intrinsic to the photographs' unequaled powers. In being less than art, I find the photographs to be innately more. They are outside both the taste and the intent of art and have their appropriate place, as in life, in what is random, disorderly, and unforeseen. The crucial ingredient is the ineffable nature of time.

Transported to the barren surface of the moon, the camera witnessed the cloud-wreathed planet Earth rising on the airless, windless, lifeless horizon, an inexhaustibly ponderable image of what is awesome in the visible world. This photograph "shivers our timbers" even as it exceeds our comprehension, our wonder at what is timeless in our time-bound selves.

Isambard Kingdom Brunel, the "Little giant," builder of bridges, railways, and oceangoing steamers, one of the pillars of the emerging British Empire, would have been interested to see himself, as we see him, on an overcast day like so many in England, posed before the anchor chains of the *Great Eastern* on the day of its aborted launching (so much that is unseen to be footnoted, his health is not good, he will soon be dead, remembered if at all as an authority on railway traction), but even the Empire will lose face as this remarkable likeness retains it, in spite of all that has been done to disguise it. How time flies, we say, wherever it flies to! Every moment, everywhere, seen or unseen, but in a photograph.

1989, previously unpublished.

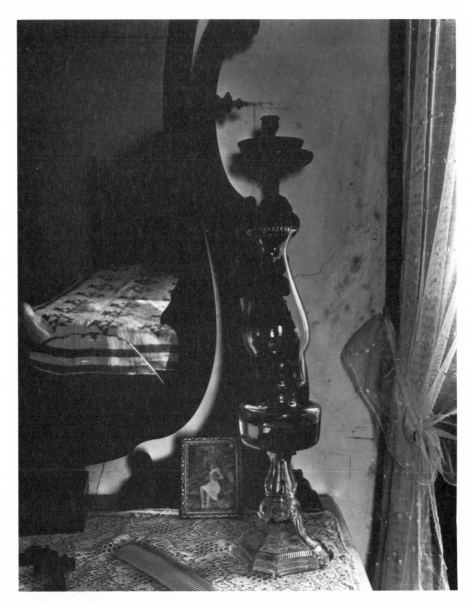

11. *Dresser with Mirror,* Southern Indiana, 1950

Technique and Raw Material

THE HISTORY OF FICTION, its pursuit of that chimera we describe as reality, is a series of imaginative triumphs made possible through technique. In *Mimesis*, Erich Auerbach has charted this course from Homer to Joyce. In aesthetic terms, *facts* are those sensations that have been convincingly processed by the imagination. They are the materials, the artifacts, so to speak, that we actually possess.

At the summit of technique we have such a craftsman as Joyce. There is so little craft in fiction on this scale that so much craft seems forbidding. Is the end result—we are inclined to asked ourselves—still alive? Is life, real or imaginary, meant to be processed as much as that? In Joyce the dominance of technique over raw material reflects one crisis of the modern imagination. Raw material has literally dissolved into technique.

In *Finnegans Wake* the world of Dublin happens to be the raw material that Joyce puts through his process—but the process, not Dublin, is the thing. It is the process that will give the raw material its enduring form. A parallel transformation is still taking place in what we call modern art. In Manet's portrait of Clemenceau the subject has vanished into the method—the method has become painting itself. Both Dublin and Clemenceau are processed into means, rather than ends, since the artist's problem is not to reconstruct the old, but to construct the new. It is characteristic of the mind of Joyce that the city of Dublin, shaped by his ironic craft, should not merely disappear but prove hard to find.

The brave new world has had its share of able wordsmiths, but with the exception of Hawthorne and James, both closely linked to the old, they usually lacked what we would call the master touch. Raw material, usually the rawer the better, seemed to be their forte. On certain rare and unpredictable occasions craft might break through this devotion to raw material, but the resulting masterpiece had about it the air of an accident; not so much a crafty human-made thing, as a gift from above. The author usually took pains not to repeat it, or to learn from his or her experience. *Walden, Leaves of Grass, Moby Dick*, and the *Adventures of Huckleberry Finn* have in common this sense of isolation. Something of a mystery to both the author and the public, they re-

semble some aspect of a natural force—a pond, a river, a demonic whale—rather than something cleverly contrived by a human being. They seem to have more in common with Niagara Falls, Mammoth Cave, or Old Faithful than with a particular author, or anything so artificial as art. They are wonders, but *natural* wonders, like the Great Stone Face.

This notion of the natural, the unschooled genius who leaps, like a trout, from some mountain stream, seems to be central to our national egotism. It reappears every day in the child—or the backward, untutored adult—who draws, writes, strums a saw or plays a piano without *ever* having taken a lesson. That lessons might corrupt his or her talent, and ruin his or her promise, goes without saying. We believe in doing only what comes naturally.

But those natural moments in which we take so much pride—*Walden, Leaves of Grass, Moby Dick,* and *Huckleberry Finn*—are, without exception, moments of grace under pressure, triumphs of craft. The men who produced them are artists, innovators, of the first magnitude. Each of these statements is a contemporary statement, and each is unique. They represent new levels where, in the words of D. H. Lawrence, the work of art can ". . . inform and lead into new places the flow of our sympathetic consciousness, and it can lead our sympathy away in recoil from things that are dead."

If we now ask ourselves under what pressure these moments of grace are achieved, I believe it is the pressure of the raw material itself. Each of these men felt the need to domesticate a continent. In his essay on Hawthorne, Melville observed: "It is not so much paucity as superabundance of material that seems to incapacitate modern authors."

He had reason to know. It was not lack of material that silenced Herman Melville. The metaphysical woods that he found mirrored in the sea, and which drew him to it, of all aspects of the brave new world were the least inhabited.

With the passing of the last natural frontier—that series of horizons dissolving westward—the raw-material myth, based, as it is, on the myth of inexhaustible resources, no longer supplies the artisans with lumps of raw life. All of it has been handled. They now inhabit a world of raw-material clichés. Their home-made provincial wares no longer startle and amaze the world. As writers they must meet, and beat, the old-world masters at their own game. In his "Monologue to the Maestro," Hemingway stated the problem in his characteristic manner:

> There is no use writing anything that has been written better before unless you can beat it. What a writer in our time has to do is write what hasn't been written before or beat dead men at what they have done. The only way he can tell how he is going is to compete with dead men . . . the only people for a serious writer to compete with are the dead that he knows are good. . . .

With this credo the Portrait of the Artist as a Young American is permanently revised. The provincial is out. The dyed-in-the-wool professional is in. Not only do we have to meet the champ, we have to beat him. That calls, among other things, for knowing who he is. Such a statement could only come from a writer who knows you have to beat the masters with style and technique, and it is on these terms that he has won his place in the pantheon.

If raw material is so bad, if it is the pitfall and handicap to the artist that I am suggesting, why is it that American writers, through, rather than in spite of, this handicap, are one of the germinal forces wherever books are read? Here, I think, we have an instructive paradox. It involves us in the problem of good and bad taste. Not the good or bad taste of the artist, but the good or bad taste we find in his or her raw material. Good taste—*good* in the sense that it is fashionable and decorative—usually indicates an absence of the stuff of life that the artist finds most congenial. Both the Parthenon and the urban apartment decorated with Mondrian and van Gogh resist more than a passing reference, usually ironic in tone. The overprocessed material, what we sense as overrefinement, is an almost fatal handicap to the artist: we feel this handicap in James—not in his mind, but in his material—and it is at a final extremity in Proust. Only a formidable genius, only a formidable technique, can find in such material fresh and vital elements.

Bad taste, on the other hand, is invariably an ornament of vitality, and it is the badness that cries out with meaning, and calls for processing. Raw material and bad taste—the feeling we have that bad taste indicates *raw* material—is part of our persuasion that bad grammar, in both life and literature, reflects *real* life. But bad taste of this sort is hard to find. Bad "good taste" is the world in which we now live.

In reference to Joyce, Harry Levin has said: "The best writing of our contemporaries is not an act of creation, but an act of evocation peculiarly saturated with reminiscences." This observation pertains to Joyce and Proust as it does to Fitzgerald and his dream of Gatsby, or to Hemingway's Nick on "The Big Two-Hearted River." In our time, that is, nostalgia is not peculiarly American.

But the uses to which the past is put allow us to distinguish between the minor and the major craftspeople. The minor artist is usually content to indulge in it. But the labyrinthine reminiscence of Proust is conceptual, *consciously* conceptual, in contrast to the highly unconscious reminiscence in *Huckleberry Finn*. Not *knowing* what he was doing, Mark Twain was under no compulsion to do it again.

Twain's preference for *real* life—*Life on the Mississippi*—is the preference Thoreau felt for facts, the facts of nature, and Whitman's preference for the human-made artifact. Something *real*. Something the hand, as well as the mind, could grasp. Carried to its conclusion this preference begins and ends

right where we find it—in autobiography. On this plane raw material and art appear to be identical. *I was there, I saw, and I suffered,* said Whitman, sounding the note, and the preference is still dear to the readers of the *Saturday Evening Post.* Wanting no nonsense, only facts, we make a curious discovery. Facts are like faces. There are millions of them. They are disturbingly alike. It is the imagination that looking behind the face, as well as looking out of it.

Letting the evidence speak for itself, the facts, that is, of the raw-material myth, the indications are that it destroys more than it creates. It has become a dream of abuse rather than use. We are no longer a raw-material reservoir, the marvel and despair of less fortunate cultures, since our only inexhaustible resource at the moment is the cliché. An endless flow of clichés, tirelessly processed for mass-media consumption, now gives a sheen of vitality to what is either stillborn or secondhand. The hallmark of these clichés is a processed sentimentality. The extremes of our life, what its contours should be, blur at their point of origin, then disappear into the arms of the Smiling Christ at Forest Lawn. The raw-material world of facts, of *real* personal life, comes full circle in the unreal phantom who spends real time seeking for his or her self in the how-to-do-it books—How to Live, How to Love, and, sooner or later, How to Read Books.

What was once raw about American life has now been dealt with so many times that the material we begin with is itself a fiction, one created by Twain, Eliot, or Fitzgerald. *From Here to Eternity* reminds us that young men are still fighting Hemingway's war. After all, it is the one they know best: it was made real and coherent by his imagination.

Many writers of the twenties, that huge season, would appear to be exceptions to the ravages of raw material, and they are. But it is the nature of this exception to prove the rule. In inspiration, the twenties were singularly un-American. An exile named Pound established the standards, and the Left Bank of Paris dictated the fashions. This lucid moment of grace was Continental in origin. With the exiles' return, however, it came to an end. The craftspeople who shaped and were shaped by this experience—Eliot, Fitzgerald, Crane, Hemingway, and so on—maintained their own devotion to the new standards, but they had little effect on the resurgent raw-material school. Whitman's barbaric yawp, which Pound had hoped to educate, reappeared in the gargantuan bellow of Wolfe and a decade of wrath largely concerned with the seamy side of life.

Once again that gratifying hallucination—the great BIG American novel—appeared in cartons too large for the publisher's desk. Once again the author needed help—could one person, singlehanded, tame such a torrent of life? If the writer caged the monster, shouldn't the editor teach him to speak? The point was frequently debated; the editor-collaborator became a part of the cre-

ative project, the mastering of the material as exhausting as mastering life it-self. In a letter to Fitzgerald, who had suggested that there might be room for a little more selection, Thomas Wolfe replied: ''I may be wrong but all I can get out of it is that you think I'd be a better writer if I were an altogether dif-ferent writer from the writer I am.''

Time and the river—was Fitzgerald suggesting they reverse themselves? That a writer swim against the very current of American life? He was, but the suggestion has never been popular. Tom Wolfe didn't take it, and the writers who do take it may find themselves, however homegrown, exiles. They swim against the current; and the farther they swim, the more they swim alone. The best American fiction is still *escape* fiction—down the river on a raft, into the hills on a horse, or out of this world on a ship—the territory ahead lies behind us, safe as the gold at Fort Knox.

Raw material, an excess of both material and comparatively raw experience, has been the dominant factor in my own role as a novelist. The thesis I put forward grows out of my experience, and applies to it. Too much crude ore. The hopper of my green and untrained imagination was both nourished and handicapped by it.

Before coming of age—the formative years when the reservoir of raw mate-rial was filling—I had led, or rather been led by, half a dozen separate lives. Each life had its own scene, its own milieu; it frequently appeared to have its own beginning and ending, the only connecting tissue being the narrow thread of my *self*. I had been *there*, but that, indeed, explained nothing. In an effort to come to terms with the experience, I processed it in fragments, collecting pieces of the puzzle. In time, a certain overall pattern *appeared* to be there. But this appearance was essentially a process—an imaginative act of apprehen-sion—rather than a research into the artifacts of my life.

The realization that I had to create coherence, conjure up my synthesis, rather than find it, came to me, as it does to most Americans, disturbingly late. Having sawed out the pieces of my jigsaw puzzle, I was faced with the problem of fitting them together. There is a powerful inclination to leave this chore to someone else. In the work of Malcolm Cowley on William Faulkner, we may have the rudiments of a new procedure: Let the critic do what the au-thors fails to do for themselves. As flattering as this concept might be—to both the author and the critic—it must be clear that the concept is not tenable. The final act of coherence is an imaginative act—not a sympathetic disposal of parts—and the person who created the parts must create the whole into which they fit. It is amusing to think what the mind of Henry James would make of this salvage operation, a surgical redistribution of the parts of a patient who is still alive. Mr. Cowley's service to the reader is important—what I want to put in question is his service to the writer. This is implicit, if unstated, in any

piece of reconstruction that attempts to implement what the writer failed to do himself.

This act of piety toward the groping artist—a desire to help with his or her raw-material burden—is one with our sentiment that the artist labors to express the inexpressible. Like a fond parent, we supply the words to his stuttering lips. We share with her, as she shares with us, an instinct that our common burden of experience, given a friendly nudging, will speak for itself. At such a moment the mind generates those evocations peculiar to the American scene: life, raw life of such grace that nature seems to be something brought back alive. Out on his raft Huck Finn muses:

> Two or three days and nights went by: I reckon I might say they swum by, they slid along so quiet and smooth and lovely. Here is the way we put in the time.

In what follows we are putting in our own time. We are there. Memory is processed by emotion in such a way that life itself seems to be preserved in amber. But we know better; we know that it is more than life, and it is this knowledge that makes it so moving—life has been imagined, immortal life, out of thin air. Not merely that boy out on the river, but the nature of the world's imagination, there on the raft with him, will never again be the same. But at the end of his adventures, at the point where the fiction—like the reader—merges into fact, Huck Finn sums it all up in these pregnant words:

> But I reckon I got to light out for the Territory ahead of the rest, because Aunt Sally she's going to adopt me and civilize me, and I can't stand it. I been there before.

So has the reader. Aunt Sally has the reader's number, but his or her heart belongs to the territory ahead.

From *The Territory Ahead*, by Wright Morris (New York: Harcourt, Brace, & Co., 1978).

Photographs, Images, and Words

IN 1889, IN CUSTER COUNTY, NEBRASKA, a pioneer who had failed at farming had the time to ponder the brave new world around him. What he saw cried for confirmation. In this treeless landscape, blazing with light, a frozen waste over the winter, baked by the sun in the summer, the inhabitants took refuge in sod houses, as other creatures burrowed into holes. These circumstances bred a new people, and made of the pioneer a photographer. Solomon Butcher was one of the first specialists. Taste had not yet decreed nor practice established what was appropriate as a photographic subject. Time was also needed, and much tactful persuasion, to lure these cave dwellers into the open. *Why* they were there would never be visible in the photographs. This overriding question, the first to be asked by those living elsewhere, was of profound interest to Butcher, but not one that he found puzzling. Being one of them he knew its answer, and this knowledge led them to trust him. We call them pioneers, a native breed of visionaries.

This vision is not self-evident in the photographs. We catch glimpses of it in the objects Butcher persuaded some of them to bring from their soddies, their treasured possessions assembled in the manner of a family portrait. One child will be in the mother's arms, another on the father's knee. In the middle ground, between them and the soddy, perhaps a few cows or pigs, or the team hitched to a wagon, all set off against the dark mound of the soddy, the black hole of the doorway, the grass on the roof blending with the sea of grass that surrounds it. About this "image" there is nothing candid. It is as posed and considered as a studio portrait.

The inhabitants have come from the house to stand in the pitiless glare of the light. The man is hatless. His face has been blackened by the wind and sun, but his forehead gleams as if scalped. He wears a collarless, clean white shirt; his wife a seldom-worn Sunday dress. It was not lost on Butcher that these portraits have the quality of icons. In many details they resemble crèches appropriate to a Holy Family. On this frontier all possessions are life-enhancing, and have their place. The photographer wanted everything in the picture but himself. He had by nature the "photographer's eye," but he did not have

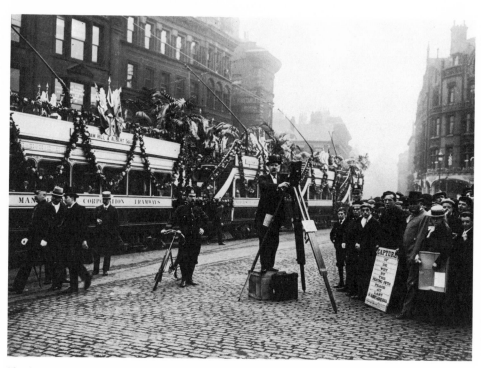

12. Anonymous, *The Inauguration of the First Electric
Street Car in Manchester*, England, 1900

his ego. We see in Butcher's work how the eye can function as an invisible part of the image.

Possessed by a similar obsession to record what he saw around him, Eugène Atget had begun to photograph the city of Paris. Both photographers used the camera to confirm what was visible. Each was a part of the life he photographed. In their practice we have examples that clarify some, if not all, current photographic dilemmas—such as what should come first, the photograph or the photographer.

These sod-house inhabitants, with their gaze on the future, did not see themselves as the camera saw them. They did not smile or mug. They did not wave to the man behind it. For them it was a moment of stopped time in a fevered dream. Can we say that the photographer's "eye" has its origin in this complex awareness of time? A piece of it is captured, but in the blurred image we see that it continues. An awareness of this gives every photograph its poignancy.

Let us imagine a photographers' tour making a field trip to the plains of Nebraska. We will choose a point in time in which we see it flowing in both directions. Nadar will be there, with his portable darkroom, and Diane Arbus with her minicamera. I would also like Stieglitz to be there, and Weston, as well as Dorothea Lange and Walker Evans, Cecil Beaton and Richard Avedon. They are all met and led by Butcher to a sod house in Custer County, a piece of time *in situ*. A pioneer husband and wife, with their shoeless children and what they have in the way of possessions, are assembled to be "shot" in the yard at the front. Just to one side, but sharing equal billing, is a team of white horses in black harness, hitched to a topless buggy. The sun shines. The light glares. A breeze stirs the grass on the soddy roof. In some of the photographs this grass will appear as a blur. At a signal from Butcher all the photographers begin to work.

Can we say there is something here for everyone? Time itself will prove to be more of a problem than the subject. Nadar is already at work on the archetypal portrait of the American gothic. The pioneer holds a pitchfork. His wife is reluctant to remove the bonnet that shades her face. Weston has turned from the subject to the sea of grass that waves in patterns of light and shade to the horizon. Lange and Evans are at ease with material they have mastered. While waiting for his turn to photograph the woman, Stieglitz contemplates the cloud formations. Cecil Beaton has begun an "arrangement" of the unusual artifacts available, while Avedon prepares a backdrop for a few clinical close-ups. The clicking sound that we hear is the camera of Diane Arbus, seated in the buggy, from where she takes candid snaps of the photographers at work. Only Bellocq—if he had come along—would not have troubled to unpack his

equipment, looking forward eagerly to Dodge City, Kansas, next stop on the
tour.

Among these diverse and contrasting points of view, the intrinsically unify-
ing element is not the subject, but the medium. They are all photographers.
What they are taking are photographs. Some seek confirmation, some self-
expression, some documentation, a few have in mind revelation; but so long as
they use the camera, what they are taking are photographs. On these discor-
dant impressions of the same subject, time will confer a touch of the miracu-
lous.

In 1900, in Manchester, England, on the day the first electric tram service was
inaugurated, a photograph was taken to commemorate the event. At the center
of the picture, high on its tripod, is a camera, with the photographer standing
on a box behind it. Since he is not the one who took the picture, his presence
within the picture indicates its importance. On the left are the trams, festooned
with garlands of flowers; a policeman, with two citizens, walks from the pic-
ture toward a troublemaker. On the right, densely packed, is a motley assem-
bly of citizens. The day is sunless. There is industrial smog in the air of the
new century. The eyes of the crowd are turned from the scene itself to look
toward the photographer outside the picture. A boy in his early teens, a cap
cocked on his head, grips his lapels, thrusting his chest forward like a politi-
cian at the word of victory. His glance toward the camera is at once assured
and self-appraising. Fame has touched him. Unmistakably he says, ''Here I
am!''

This is but one of numberless thousands of *anonymous* photographs that
give us a magical glimpse into the past, a fragment snipped from the film of
time. A more sophisticated, self-aware photographer would have been more
selective, found a less conventional point of view, and given us his own
impression of the event. This might have heightened its drama, its ''human''
interest, at the expense of what we now feel to be authentic—life mirrored not
by ourselves but by life itself.

Impressions dominate our myriad responses, testifying infallibly to our pres-
ence, but intrinsic to the photograph is an aura of detachment. However much
the artist may feign it, only the photograph, by its nature, *is* it. We see it most
clearly in that genre of photographs we have referred to as anonymous. Cam-
eras took them. In that lies their authenticity. The lad preening himself in the
right-hand corner may or may not have caught the eye of the photographer—
he catches ours.

Custom has staled our awareness that the photograph is magic. We see it,
but we do not grasp it. It is as commonplace and as mystifying as sight. The
first men to intuit its miraculous powers worked in secret, like alchemists, and
kept their records in code. In 1832 Nicéphore Niépce, long pregnant with he

knew not what, applied himself to giving the unknown an appropriate name. He did this in the hope that it would make familiar what was passing strange, and prove to be an act of possession.

1. Painting by nature herself
2. Copy by nature herself
3. Portrait by nature herself
4. To show nature herself
5. Real nature
6. True copy of nature

His instincts were that whatever it was, it was a *piece* of nature. In this list there is no mention of Niépce as the prime mover, or the creator. It is "nature herself" he wants to acknowledge. In the fullness of time (as might have been predicted) the camera holder will prove to be less awestruck. Instead of a portrait or a painting by nature *herself,* it will be by the photographer. He will see himself not merely as the picture taker, but increasingly as the picture maker. The results of this deliberate appropriation, as we see it in the photo-secessionist movement, is a notable gain in pictorial interest at the expense of photographic authenticity—that is to say, at the expense of the photograph.

This amounts to a welcome gain at the expense of an irreplaceable loss. Photographers were quick to recognize this imbalance, and set about recouping the losses. The collaboration desired, and achieved, is what is modern in modern photography but present and at ease in much that is old. The recognition of this quality we have enshrined with the word *image.* It was not one of the words Nicéphore Niépce had in mind, nor was it in the mind of his generation, being a perceptive and innovative way to relate the picture, the picture maker, and the subject. The *image* that results—if the maker has talent—we recognize as an original object. The recognition of this *image,* now a commonplace, makes an essential, rather than an incidental, distinction between photographs possible. This photo-image claims, with other human-made artifacts, a self-sufficient uniqueness. Rather than a likeness, it has become a thing itself.

Although the image's presence can be appreciated, it should not be formulated, since in the photograph *time,* even more than taste, influences our impressions and colors our judgments. The explicitly documentary photograph makes the best, and the most, of its warring elements and its reluctance to be judged as a "picture." This conflict between the pictorial and the documentary gives many photographs a dramatic tension that seeks resolution in a "decisive moment." A residue of unresolved elements will often heighten, rather than weaken, the resulting image. The photographs by Charles van Schaick, Lewis Hine, Jacob Riis, Walker Evans, Dorothea Lange, and numberless others are unavoidably more than social comments and provide us with more than a message. Pictorial elements—we might say happily—both corrupt and enhance the

most searing social statement. There is a remnant of the *image* in every documentary and the leavings of the document in every image. These inherent contradictions distinguish the photograph and need not be resolved.

The camera image differs from all others in the way it resists isolation. The word *bleed,* used to describe a photograph printed without margins, accurately conveys the cutting off, the excision, the amputation, of the photograph from its environment. The habit of "framing" pictures accustoms us to what is visually bizarre. *Where* is what is missing? In what mysterious way does it relate to what has been captured? The controlled conditions of studio portraits—the false environment of props and lighting—avoid the hard, bleeding edges and give the illusion of wholeness. There are no severed connections. Within the frame, as W. H. F. Talbot was the first to remark, there is often much that will prove to be new as the photographer ponders what he or she has done. It is not unusual for a photograph to be inexhaustible.

"At the thought of the eye," Darwin said, "I grow cold all over." And some frisson of this chill—like the motions of plants underwater—should pass along the nerves of those who take, make, and look at photographs. Anything so miraculous is compelled to become commonplace.

This rise in what is perceived, which is a rise in status, has its price. As an image, the photograph is defanged, in a way denatured, and made accessible to art. Photographs that are brutal, obscene, or merely disgusting can be exhibited as images. No one has yet (to my knowledge) mounted an exhibition of the photographs of Bergen-Belsen and Dachau, but our remarkable appetite for visual sensations makes it not only possible, but inevitable. If the option is open, someone will take it.

As a girl of twelve, Susan Sontag first set eyes on the photographs of Bergen-Belsen and Dachau. There is no confusion in her mind, or in ours, that she saw photographs, not images. She goes on to observe that to suffer is one thing, but to live with photographic images of suffering can be a corrupting experience. It is the "image" that makes this possible, even fashionable. Avedon's dying father challenges the observer to justify his or her own participation in his dying. The observer's shudder of overexposure attests to the photograph's validity, as well as to his father's own distressed and embarrassed humanity. Quantities of male and female flesh now attest to the current clichés of liberation. If we feel shame, embarrassment, or disgust, we have the assurance that the *image* has not obliterated the photograph.

A commercial photographer I know has been taking pictures for more than half a century, ever since he was given his first Brownie. Among the thousands of prints, the tens of thousands of negatives, are the jumbled contents of our life and times. If all others were lost, this archive might well serve as our portrait. But only on rare occasions do these pictures bring to mind the man who took

them. There are babies, kittens, old and wrecked cars; proud parents, glowing brides (flesh tones have been heightened, teeth whitened); summer outings, forest murmurs; oversize and undersize vegetables, eggs, and fruit; construction sites, burned and razed buildings, streets and houses, real estate offerings; locomotives, cabooses, pliers, wrenches, and gadgets; hippie weddings, prominent divorces, famous and infamous people; and the war in Korea while he did his stint in the army. In the context of the new and the ultramodern, some of these photographs are new as tomorrow. The shifting sands of fashion and taste have finally caught up with what he has been doing all his life. But there is no need to mention his name since he is not a "name" photographer.

My friend's passport photos sell for four dollars. Fancy portraits, in a frame, cost more. Cats like him. He is good with pets and children. If something is visible he will take a picture of it. The secret ingredient in all his photographs is time. The passage of time will confer on his archive much that now seems to be lacking. "Look at that!" they will say, whereas now they just look.

I thought of him some months ago when I came on the news that a photograph by Ansel Adams was offered for sale for $15,000. One of a kind, perhaps? Or one of a kind in the hands of a dealer? Considered as art, photographs are now subject to the fads and practices of the art market. An artificially created rarity is used to sustain or inflate market prices. The dealer who acquires a photographer's negatives is free to control or exploit this market. Since anyone can, and millions do, buy cameras and take pictures, the oversupply will always exceed the market's demand. Although photographic discussion might continue to be fevered, the buying, selling, and speculation in photographs must confine itself to a sampling of what is offered. It is time—before it is talent—that confers interest and significance on the photograph, and time cannot be speeded up to the dealer's advantage. If it were sufficiently profitable, most photographers could take or duplicate most photographs. In *Edward Weston: Fifty Years,* his wife Charis Weston wrote:

> The Guggenheim trips were like elaborate treasure hunts, with false clues among the genuine ones. We were always being directed by friends to their own favorite sights, views, or formations. . . . [Weston] knew my eyes were at his service, and that the moment anything with a "Weston" look appeared, I would stop the car and wake him up.

Today there would be little need to wake him. The recognition of a Weston picture could be followed by its taking. There is no trick to it. It is a matter of profit. If Weston-type photographs are profitable, if the market will absorb them, there might be no end to them. What the camera and the chemicals have done for one photographer, they will also do for another. It is a bit early to open this Pandora's box, but it is there and waits on the occasion.

As of the moment, the uses of photography, not to mention the abuses, defy the efforts of critics and scholars to make sensible distinctions. To accommodate the growing number of artists, and the multifarious activities now loosely described as art, distinctions necessary to intelligent discussion have been obliterated. In the vast accumulation of conflicting opinion there is one unifying element: all of it is in words. The artwork no longer speaks for itself. It is ironic to think, as the words flow, that the photograph was once thought to speak a more concrete, less abstract language. The slogan was that it was better than a thousand words. Thousands upon thousands of words now encumber a quantity of photographs. This flowering of writing about photography, much of it readable, informative, and innovative, is the latest example of the current cultural mania to transform one thing into another, and eventually into words. To *reside* in one thing or another appears to be impossible. On the evidence, the thing itself—the person, the object, the painting, the book, the music, the sunset, the operation—exists primarily as a point of departure, a launching pad from which we take off into an orbit of our own. The more controversial art becomes and the more heat it generates, the more words it requires. These deflections from the things themselves comprehend most of what we call culture. Book reviews, art reviews, movie reviews, sports reviews feed a greater and more ponderable need than does the book, the work of art, the movie, or the sporting event. Greater than our hunger for sensation is the need we feel to know of what it consists. We have read the book, attended the exhibit, seen the movie, and so on, but what they consist of are the images that have been put into words. Photographs, photographs of all things, were once believed to offer a point of resolution. They offered a stop in the flow of time as well as in the endless stream of our responses. The observer looked. The photograph soberly returned the gaze.

All criticism is in the process of becoming a new genre of fiction, as fiction itself seems to be threatened. The overgrazed world of experience, appropriate to the novel, can be reappraised and reexperienced as criticism. In the same way, the overgrazed world of visible artifacts and events can be recreated as verbal images.

In this practice the recognition of some photographs as ''works of art'' is less an infiltration of art by photography than an appropriation, on the part of art, of photographic authenticity. We see this in current art enthusiasms. Momentarily the abstract is exhausted. Every effort is made to incorporate the actual—the ''happening,'' the materials, including structures and landscapes. The painter's use of the photo-image in his or her conception accurately parallels the photograph's appropriation as a genre of art. All of this is extrinsic to the photograph itself.

With its rise in status, however, the photograph is ''read'' rather than merely looked at. Images of interest are scrutinized like poems. Predictably, the

verbal scrutiny will prove to be what gives the photograph its image. The "readings" will be as subtle, as filled with insight, as bizarre as the talents of the writer. It is hard to imagine a photograph that Susan Sontag could not verbally embellish. Of a W. Eugene Smith photograph, Walker Evans wrote: " 'Welsh Miners' is a memorable and improbable feat: a stroke of romantic realism. Something in the picture doubles back on artifice. The miners are in makeup; their pomade is coal dust. The men are actors, their act is in being themselves. The background stage set is a village you know is there in Wales today.''

No question, this commentary adds a new dimension to what we see. Perhaps there is something in all photographs that doubles back on artifice. But Evans would also be the first to say it is better that the photograph have no commentary at all than that it appear to be necessary to the picture. The ambiguity that is natural to the photograph lends itself to conflicting interpretations, but if the viewer's first impression is not the viewer's own, he or she may never come to have one that is. In the photograph this is a real loss for an imaginary gain.

In *First and Last,* a collection of 220 Evans photographs from some 20,000 negatives, words are conspicuously absent. There is no foreword or postword. There are no captions or comments beyond the brief remarks on the jacket. It is a clean, handsome, well-lighted book, appropriate to the photographs. The first was taken in New York in 1928, the last at Brighton Pier, England, in 1973. On turning the pages, however, I found that a few words would have been helpful. These are photographs first, before they are "images." We are legitimately curious about where the places are and whose face it is. This information is neither irrelevant nor distracting. Whenever we come upon a photograph that is not identified or captioned, the first thing we do is look on the back of it for what is not visible in the picture. In Evans's book we need words to clarify what it is we see and to inhibit much that we might imagine. The two photographs on the jacket are of Evans as a young man, at age twenty-nine, and as an old man, at age seventy-three. I would not have known that without the caption. There are identifying data at the back of the volume printed in type so small it discourages the curious. Words can be as intrusive in their absence as in their presence.

The volume might have been titled *Signs and Portents.* Signs spoke an intimate language to Evans, and I was told by Peter Bunnell that he collected them as objects. The sign and signboard spoke to him as "nature" did not. I first saw an Evans photograph in *Time* magazine: a graveyard of used cars at the side of a road in Pennsylvania. In different accents than it spoke to Evans it also spoke to me. The exact same photograph could be *read* in various ways. What the image maker needs, in all forms of image making, is the confirmation of her or his own intuitions, and Evans provided me, as he did nu-

merous others, with this reassuring shock of recognition. An Evans photograph
mattered to all of us.

Some of Evans's photographs are familiar to people who couldn't care less
who took them: the portraits in *Let Us Now Praise Famous Men*, the passport-
size mosaic of faces crowding the frame of a studio window, a couple on the
boardwalk at Coney Island. Evans also worked, for a limited time, for Roy
Stryker's Farm Security Administration program, and his ''images'' will never
be free of the aura of the Great Depression. Nor will the photographs them-
selves ever resolve or clarify their conflicting impressions. A field of junked
cars, a man in faded overalls, children in rags, a row of unpainted houses, an
unshaved farmhand do not speak to Americans of human realities but of social
conditions to be remedied. When the conditions *are* remedied, they are re-
markably less photogenic. There is a conflict of imagery in *Let Us Now Praise
Famous Men*, where the words soar into the empyrean, but the photographs,
happily, remain earthbound. To that extent, the counterpoint is more fruitful
than if the words and images were on the same plane.

The Great Depression was real enough in itself, but the hold it still has on
our imagination is largely a photographic triumph. These images of hardship,
of poverty, of human endurance impose on the recent fiction of history a reali-
ty that words can do little to modify or displace. As young photographers have
learned, the old and battered, the ugly and depressed are much more photogen-
ic than the new and affluent. Hard times are usually good times for photogra-
phers. This aesthetic is rooted in American experience and testifies to our
hunger for what is *real,* a word that vibrates in our consciousness more per-
sistently than the word *truth*. Photography, indeed, is such an American insti-
tution that it is difficult to believe we did not invent it. First and last, the
photographs of Walker Evans have helped shape our image of what is real,
and as this image hardens to a cliché, it now obstructs the emergence of what
is actually there. Much of what is there is now unseen in photographs that re-
semble other photographs.

In Michael Lesy's *Real Life: Louisville in the Twenties,* we will find the ar-
chetypal urban photographs for those taken by Evans and others in the thirties,
through Weegee, Robert Frank, and Diane Arbus in the sixties. The urban
scene, for all its vast complexity, provides a limited number of *images*. Time
will determine what we see of ''interest'' in them. Each of these photographs,
more than the photographer or the time-bound observer, *sees*. Compared with
the photographer's eye, the camera's eye is Olympian, and provides us—if we
can bear it—with our first glimpses from space.

On the jacket of John Szarkowski's *The Photographer's Eye,* a volume of
select photographs and well-seasoned comments, there is an anonymous photo-
graph of a bedroom interior at the turn of the century. It is rich with those de-
tails we consider revealing, including an optician's chart on the back of the

door. The *image* is crisply framed, the point of view as assured as a photograph of Evans, or one of my own. I recognize with a shock that this anonymous photographer was seeing through my eyes, and I through his or hers. The similarities of all photographs are greater than their real or imagined differences.

In Walker Evans's book there are no words; in Susan Sontag's *On Photography* there are no photographs. This bizarre polarity comprehends the current photographic scene, where picture taking and making is giving way to analysis and stocktaking. Many young photographers have found themselves more gifted with words than with the camera. In determining what and where photography is at, words are more in the ascendant than photographs. The photograph, after all, is just a photograph. Words will determine its meaning and status. Feverishly self-aware, photography now ponders its many selves. As John Szarkowski has commented, the role of the professional has diminished; the personal and the private has expanded. He sees the view as that of the mirror and the window. This is a useful verbal distinction that enshrines the photographer, not the photograph. Mirror, window, or wall, the photograph exists; it is a piece of the world's substance, and it is more than the source of our self-serving impressions. The true photograph confronts us with all the ambiguities of life itself.

The absence of photographs in Sontag's book is a well-considered decision. Both the writer and the reader are more at home with words. Once an activity of any kind reaches the level of public interest and acceptance, it will undergo this transformation. To *get into words* is the ultimate of critical absorption and appreciation. The breadth and depth of our awareness of photography can be gauged by the absence of photographs in a book on the subject. What we want, and what we get, are words. The photographs themselves—like the books, the art, the movies, the events—would complicate and impede the discussion. After all, we still do not know *what* a photograph is.

I assume it is a cultural, not a human, aberration that makes it impossible for us to *reside* in, to be at rest with, an image. Not long ago we may have thought, as some still do, that the invention of the photograph would remedy this tiresome situation. Yet we now find that photographs dissolve into words as readily as dreams do. What is it that forbids us from residing in what we *see?* Is it the fear that what we see, what we actually see, might be all there is? At this impasse a voice cries "God forbid!" and we turn with relief to our discussion.

It might prove to be a global, even a cosmic, dilemma, as the satellites send back their photographs from space. Just as we cannot accept the photographs of Dachau and Bergen-Belsen, we cannot *grasp* the image of planet Earth rising on the moon's horizon. There it floats (there we float, that is), chilling and awesome, instinct with the terrors of the first human nightmares. From the

first, the gift of sight has been the seedbed of our illusions. The photograph
both confirms and mocks us. That's how it is. But *what* it is cannot be photo-
graphed.

Our inability to grasp what a photograph is contributes to its emergence as a
"work of art." We don't know what that is, either, but in the context of art
we can label and discuss it. Even better, we can wheel and deal with it. It oc-
curs to me, however, that an alternative scenario may now be in the making.
Perhaps it will prove to be to the advantage of art to adopt the mass market of
photography, where the picture made by the camera can be appropriated as
one's own.

If Sontag's performance has a fault, it lies in the nature of words them-
selves. How they do go on and on. If the good writer is entitled to be carried
away—and Sontag is so entitled—there is still the problem of the benumbed
and bedazzled reader. Her facility is intimidating. Numberless photographs,
objects, and opinions come out of her hopper with a uniform texture. Words
accumulate to bury words, as images accumulate to bury pictures. In conversa-
tion there are pauses where what is questionable, or ponderable, can be tem-
pered with a silence or a rebuttal. It is to the reader's disadvantage, curiously,
that Sontag lacks or conceals the prejudices of a picture taker. Names, images,
and associations enrich and confuse our impressions. What is she saying? She
is saying what she has said. Like many good books, *On Photography* justifies
more rereadings than it will receive. Ignored, if not forgotten, in this perfor-
mance is the fact that the photograph was once empowered to deal with
impressions that words cannot: the ineluctably visible, eye- and mind-boggling
world. This image is there before words, even as words strain to create a new
image. It seems apparent that a frailty in our word-bound culture compels us
to reduce *everything* to words. Photography's unique contribution, the mirrored
image of actuality, proves to be, like life itself, merely a point of departure for
further speculation. If all we can do is *look* at something, perhaps we would
rather not look at it at all. The ultimate inhibition would be to see no more,
and no less, than what the camera eye sees.

I find it strange, however, to hear Sontag say, "The main difference be-
tween painting and photography in the matter of portraiture still holds. Paint-
ings invariably sum up: photographs usually do not."

Great portraits may well sum up the painter, but they seldom sum up the sit-
ter. What photographs usually do, more than anything else, is authenticate per-
sonal appearance and existence. Authentication, not enlargement or inter-
pretation, is what we want. This is sufficient to explain the sudden decline in
portrait painting since the first daguerreotype. Manet's portrait of Clemen-
ceau is a painting before it is a portrait, in which "characteristics" have been
obliterated. The same is true of Picasso's Stein. The painted portrait neither
has nor will displace the photographs by Julia Margaret Cameron, Nadar, Da-

vid Octavius Hill and Robert Adamson, Albert Sands Southworth and Josiah John Hawes, as well as numberless, often nameless, others. What would we give for a few fair-to-middling album snapshots of Achilles or Helen of Troy or Potiphar's wife or Attila the Hun or the Wife of Bath or any human countenance once part of the faceless past? Whose portrait of Lincoln would we prefer to those left us by Mathew Brady and Alexander Gardner? The sitter might well like to be flattered, but the observer craves reality. In portraiture, once the photograph existed, authenticity takes precedence over talent, and the decline of the painted portrait can be dated from the first one taken by Daguerre. The photo likeness is a piece of nature, like the subject itself.

Puzzlement as to what a photograph actually is still handicaps both photographers and observers. No theory or aesthetic adequately comprehends the ever-widening spectrum of photographic practice, but the discreet use of the word *image* makes essential distinctions possible. An image is what some photographers are after, and we experience their delight when they get it. Rather than another likeness, it has become a thing itself.

It is appropriate that these new images take their place among the objects we value, since they both reveal and enhance our shared awareness of the visible world around us and the invisible world within us. Those photographs that combine the impersonality of the camera eye with the persona of the camera holder will usually commingle the best of these hard-to-reconcile elements. While we continue to grope, like Nicéphore Niépce, for the precise words to capture what a photograph is, we should also acknowledge that the highest praise may be found in the way it eludes us. The ultimate triumph will be to recognize the photograph for what it is.

The most remarkable photographs of our time mirror and probe the macrocosm around us and the microcosm within us, and if a new human is to emerge on this planet, some such image will provide one of its icons, a confirmation of the wonder and the shudder of terror that signal an expanding consciousness. We sense in it, and we fear, the necessary destructive element. What it has in mind for us may not be what we have in mind for ourselves.

In the sea of photographs that now surround us, and increasingly threaten to engulf us, photography might be likened to the glow of phosphorous where the ship's prow splits the water. Thanks to it, we do see more than the surface. Thanks to it, we do not see more than is there. Not to see more than is there, we learn from photographs, is to see more than enough.

The American Scholar, Autumn 1979.

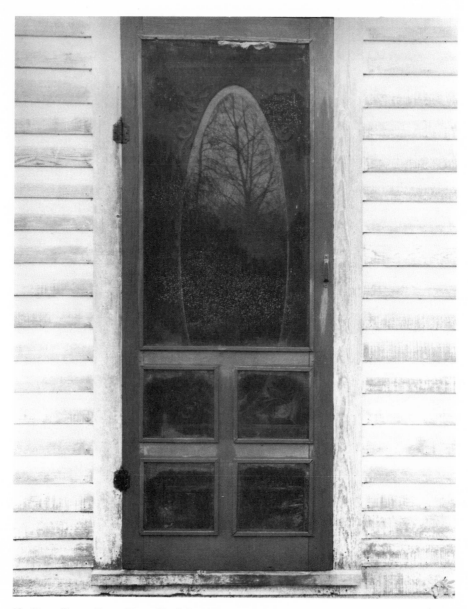

13. *Front Door, Home Place*, Norfolk, Nebraska, 1947

Unearthly Adornments

THE WORD *DREAM,* for most Americans, does not describe hallucinations occurring during sleep, but a normal, euphoric state of waking. Daydreaming may well inhibit our interest in night dreaming. We find wakeful fantasies (I can dream, can't I!) more gratifying than inscrutable hallucinations. Night after night in deep slumber, or bobbing on sleep's undulant surface, the stage of the mind is the scene of a ceaseless and mystifying drama. The performance has neither a beginning nor an ending. It is at once a masque ball, a charade, a burlesque, an extravaganza, a miracle play. Unmistakably it is also always a dream. In spite of varying claims, of ceaseless interpretations, the scenario defies explanation. They are our first and will prove to be our last fictions. Predictably, the tormented and obsessed mind will deploy its energy in dream production, but the nontormented and playful mind also dreams to sleep, and sleeps to dream. Here is the original and never-ending theater of the absurd. In the imagination of a few people of genius we find a world of comparable splendor, but of limited resources. Dreams have access, as nothing else, to the inexhaustible. The study of dreams, understandably, has diverted both dreamers and observers from the heart of the matter. It is the *nature* of dreaming, the imagery of dreaming, not its burden of meaning that concerns the artist. Each dreamer is the sorcerer's apprentice in this production of images, a dazzled and compliant witness of the random and the involuntary.

Conceivably, if asked about his dreams, Hieronymus Bosch might have replied, "What dreams?" In the mind of his age, more visual than verbal, the lunatic, the lover, and the painter were of one imagination compact. Bosch is merely one of many to have singular visions of earthly delights and torments. In the workshop of his imagination there were no separate compartments of suitable materials. Images were made out of everything at hand. With the increase of self-awareness, of analysis, the wakeful and the dreaming mind were seen in opposition. Shakespeare is at this watershed in the winds that blow in *The Tempest.* But this comes almost a century after *The Garden of Earthly Delights.*

The medieval imagination, as revealed in Bosch, combined technical advances of the greatest refinement without a loss of "such stuff as dreams are made on." He is at once sophisticated and naïve, the happiest of circumstances for the obsessed image maker. Was he able to marvel, as we are, at what he hath wrought? Or was it all in a long day's painting, a fabulous interweaving of the real and the imaginary? Nowhere else is the "real" world so prophetically foreshadowed in the dream world. In the lower right-hand corner of the triptych, a partially concealed crouched figure defecates coins into a cistern where other sinners are submerged. It is a minor detail, one of the numberless many easily overlooked.

We are dreamers, but few of us are good retrievers. Retrieving, unfortunately, is a talent in which the conscious image maker plays a part. The retriever usually finds what he or she presumed to be lost. The dreams told to analysts, requiring interpretation, constitute a separate world of fiction. These recitals invariably lack what might prove to be of interest to the outsider. A parallel exists in moviegoers who compulsively, and in detail, report on all that they have seen. Part of the problem is technical: the verbal report is not visually commanding. We hear it, but we don't see it. At its point of origin this loss of detail may have given impetus to the arts of fiction. Everybody dreamed, but only the storyteller was able to hold the listener's attention.

As a writer of fiction and a wakeful-type dreamer, I am reluctant to give myself over to dreaming. It has made me a notably poor dream retriever. At best I salvage a few receding impressions, like those of a swimmer about to go under. I have been able to note, however, that these partially salvaged images resemble, in their intensity and vagueness, the images of conscious memory. Not in the bizarreness we recognize as dreaming, but in the way I sense that they come from the same workshop. In sleep, another hand deals the cards, but they are from the same deck.

Memory and dreams, in their conflicting needs, have access to the same archive of stored impressions. In the dream this confusion calls to mind an amateur theatrical production, featuring Goodwill costumes and remnant-sale handouts. It is still a moot point as to whether the dreamer has, or might have, access to inherited impressions, along with those personally acquired. It seems plausible, in such a mind as Bosch's, but it has not proved demonstrable. Much in our natures is genetically coded, but not in the context of images. We need not question, however, that dream fabrication contributes to conscious image making and that in the medieval imagination this contribution was overwhelming. Recently, the surrealist painters have exploited these resources, but in the modern writer, with few exceptions, the dream is not a dream but a device that no longer serves its purpose. When the character says "I had this dream—" the reader is best advised to skip it. Actual dreams do not lend

themselves to fiction, but the faculty of dream image making is sorely absent from modern writing. Obsessed with what is *real,* with what they think to be real, writers have little sympathy for what remains to be imaged. They are skeptical of the imagination, idolatrous of the facts. Until recently writers have not been disturbed by the way the ''real'' recedes as they are about to grasp it, but an awareness is slowly emerging that the real world is a fiction awaiting the appropriate demonstration. In dreams begin the images of responsibility.

Those we call savages dance the wakeful dreams that Bosch paints with such remarkable detachment. The discipline and abandon of his imagination have encouraged study but discouraged imitators. One of his children might have asked him, ''What is the world like, Papa?'' and looked to his paintings for an answer. A few years after his death the question was asked: What is the meaning, Hieronymus Bosch, of that frightened eye of yours?

The reasonable man, in both Bosch's time and ours, searches the painting for the dream scenario. There are numerous conflicting theories and speculations. In a century open to symbol hunters, there is no preserve for hunting the equal to this one. The problem is to fit Bosch into the world, rather than the world into Bosch. Four centuries after this dream of earthly life was portrayed as realistically as a peasant wedding, the study of dreams became an analytic and aesthetic obsession. Freud's description of money as human excrement is still too strong for sensible people, but the lunatic and the poet, if they were dreamers, might have guessed it.

The example of Bosch is so overwhelming that the lesson of the master has been counterproductive. Much of surrealism might be tucked into one panel of his triptych. My interest is not in the enigma, the elusive meaning of his painting, or the use he made, if any, of astrology and witchcraft, or the liberties he took with traditional symbols, but in the faculty he exhibits to use all of these resources in his image making.

The fantastic is often achieved, as a child might, by a simple inversion of scale: a cherry proves to be large enough to sit on, or carried about like a lantern. A single strawberry proves to be as large as a tree, a blackberry the size of a bush. Some birds are enormous, realistically painted; others fly and flock in their customary manner. Fish are everywhere; a few swim in the sky and others are carried about like trophies. This mingling of the commonplace and the bizarre, in both natural forms and hybrid creations, is the source of Bosch's enchantment. We feel it might all be an act of nature, observed by, but not invented by, the painter. So Adam and Eve might have felt if they had witnessed the first day of creation. God's intent, if not his argument, is not as yet codified and formulated. It is still a world of pure sensation. The grotesque forms impress us as organic, a form of life as real, or more real, than we are.

They hold free sway over our imaginations because they are based on forms of nature. In his imitators the hybrid forms are too often merely fanciful, fantastic but lifeless, mechanical as the inventions of science fiction.

The magical ingredient in Bosch's creation is that it flows from an undivided imagination. There is not a real and familiar world by day, and an unreal suppressed world by night, but a universe in which these conflicting realities mingle, as they did in the minds of his contemporaries. We know that medieval life had its tableaux of horror, and that monsters were real as well as imaginary. In nearby Antwerp, Brueghel would soon be painting a world as universal as that of Bosch, but even more disorderly and threatening, his painterly eye focused on the actual. Bosch's vision, like that which we find in the Bayeux tapestry, is meant to enchant as it instructs. Of the Italian painters of the fifteenth century Carpaccio might have marveled the most at his genius. He, too, combined the visionary with the earthly in a manner that effaced distinctions.

There is no precedent for the landscape in which *The Garden of Earthly Delights* is established. The horizon resembles the world he saw about him, the familiar and congenial face of nature. The visible horizon is broken, however, by two fantastic structures, one coral pink in color, the other of a steel blue, metallic in appearance. The hybrid mixture of forms, funguslike and organic, blends with the purely bizarre and imaginary. A profusion of marinelike ornaments, seed pods and spiky growths, gives one a festive air: it might be an ornament carried in celebrations, or waved by a child. Three similar but even more bizarre growths, larger because they are nearer, are set in or adjacent to the body of water that extends across the width of the panel. We are able to see that these structures serve as dwellings, and to guess that they also function as machines in the control or the flow of water. They are alike in combining forms that appear to be organic, crowned with flowers and curling tendrils that are leaflike, with details that suggest human-made constructions, yet having no parallel elsewhere. One is pierced near the base by hollow glass tubes, suggestive of receptacles or retorts for laboratory experiments; another, capped by a tower of marble and crystal shafts, appears to float. The most remarkable, gunmetal in color, resembles a land mine or some machine of war, with screws that protrude like the barrels of guns. In the shadows at its base a tribe of monkeys seek for food. Topping this structure, like an enormous sundae, or the flower and fruit forms to ornament a hat, is a composition at once enchanting and demented. The luxuriance of fancy seems perverse. As his dazzlement cools, the observer asks, Is this a true creation or some trick of sorcery? Why these bizarre, fantastic eruptions? Has Bosch, in this way, succeeded in asking a larger, more disturbing question? Putting man aside, is it nature itself that has gone berserk? What we sense in these forms is a bacchanal in which na-

ture is the victim, a ballet of forces and perversions in which the ailments of humankind are prefigured. These fantastic creations dominate the central panel and provide the clues to the drama unfolding in the middle and the foreground, God's world in a state of disorder having fallen from grace. The spirit of these forms is that of delight and abandon, but what is made visible is remarkably chaste. The swarming throng of nude humanity seems innocently appropriate to the landscape. Although a painter of realism comparable to Brueghel, the conventions of a painterly morality limit Bosch to the use of symbols where he means to be explicit. The profusion of cherries, berries, and strawberries symbolizes erotic and sensual delights. A courtly lady of refinement might have pondered this tableau with some misgiving but with a minimum of shock. The dream books of the time are detailed and explicit as to the meaning of berries and grapes, as well as the birds and sea fish signifying lewdness, lust, and anxiety.

Has anyone since Bosch been so implicitly suggestive, and so explicitly chaste? The symbols of his Garden, like everything else, are subject to metamorphosis and mutation. This matchless portrayal of sexual suppression is equally in praise of sensual pleasure, nor is there any hint that the mind of Bosch took prudish delight in his swarm of sinners. Before they have fouled themselves, through weakness of the flesh, he seems to take delight in their prospects. It is a vision of humankind more charitable than the one that prevailed in his century: there is more of Erasmus and *humanitas* in it than the revenge of God. These are *earthly* delights, and his depiction of hell, in the third panel, is more prophetic of the facts of the twentieth century than a Dantesque horror chamber. Everything has gone from bad to worse, but we are still on earth. Fire and destruction loom in the background, where anonymous masses swarm about in disorder, a spectacle so common to modern people it is more familiar than horrifying. At the lip of this inferno, where the temperature is cooler, we pick up with what is left of the Garden of Earthly Delights. Beams of cold light flash on the sky like beacons, providing a suitable pallor for the tongues of hellfire. But life still goes on, however chaotic. The central figure of the panel is a huge, egg-shaped monster with two treelike limbs peeled of their bark. The rear end of the egg gapes open to reveal, like the mouth of a cave, those who have found shelter within it. Nude, dark-skinned creatures sit at a table, and a peasant woman, fully clothed, takes ale from a barrel as if she means to serve them. On the chipped rim of the shell, leaning on it like a bridge rail, a man pensively meditates, his head resting on his hand. Is it Bosch? No other figure has such a resigned, contemplative posture. The head of the monster, however, the same pallor as the eggshell, is twisted about to look back along his body. To our amazement it is not the head of a monster, but might well be one of the painter's neighbors. His glance is more

reflective than agitated. What he sees does not appall him. Of the numberless faces in this Garden, this one has the rudiments of a likeness. The expression is detached but observant, and I would guess him to be the painter.

As a rule, we might agree that hell is better depicted than described. The painter is able to convey an instant impression, as well as one that can be studied and pondered at leisure. Ultimately, however, both are pictures. What is described must be *imaged*. The writer takes the greatest pains that we *see* what he or she tells us. "Let me show you," says the writer, and the reader replies, "I see!" As profoundly as the mind may be coded for language it is in the interest of image making. Dante and Bosch were both image makers, recording their special triumphs. If Bosch had been under the thralldom of "reality," his imagination would have been blocked. Fortunately, there was no one at his painterly elbow to ask, "But is it real?" In his concerted effort to know what is real, or what he thinks to be real, the modern writer knows less and less of interest. The unicorn was real enough for the medieval mind, as the Loch Ness monster seems to be for some moderns. Both observers seek the confirmation of an "image"—the one seen in tapestries or paintings, and the other seen, or presumed to be seen, in photographs. For both, what is "real" is a matter of imagination. It is the image that matters. Does it enchant us, move us or mysteriously stir us?

At the start of the film *2001: A Space Odyssey*, we see primates hovering at the mouth of a cave, resembling one cowering beast with many small blinking eyes. This very real and visual image is supplemented by the surging swell of Strauss's music, an immaterial embodiment of the sensation of dawning, of something transfigured. The moment of terror and enchantment is brief, but impresses us as real. The film has this many-faceted capability and makes the most of it. For most of this century, the writer of fiction has willingly cut back on the supplemental music. The wick of his or her imagination has been trimmed to the scale and fashion of a realistic image. What has been done is extraordinary, but it is no longer enough.

In American practice our obsession with the "real" has had a depressing effect on the imagination. In assuming we know what is real, and believing that is what we want, we have curtailed the role of the image maker and measurably diminished "reality." If we ask how Bosch, a master of the bizarre, habitually blends the real and the imaginary, the commonplace and the unheard of, the clue is provided in the word *garden*. All that we see has grown, or is still growing. The fertility of his fancy is organic. Hybrid forms sprout and multiply like sports of nature. We will never know from where, and in what manner, his talent was nourished with such visions, but the technical means to his ends is there to be contemplated. The modern novel, with its unqualified freedoms, is not so free as Bosch to be imaginative. If we compare it with *The Garden of Earthly Delights*, where the incongruous harmonizes with the ordi-

nary, the exhaustively detailed fiction is but one panel of the triptych. The delights are diminished. The earthly increased. The soaring imagination leashed and hooded, like a falcon. It makes for more and more of what we know, and what we have, less of what we crave.

Of necessity what we seek is elusive, an image more life-enhancing than the one we have exhausted, an enlargement of delight, a shrinkage of drabness, whether made up of angels, grotesques, or the shards of the commonplace. A poet's way to put it is to speak of imaginary gardens with live toads in them, imagery that memorably links the present, through Marianne Moore, to the gardens of earthly delights.

From *Earthly Delights, Unearthly Adornments,* by Wright Morris (New York: Harper & Row, 1978).

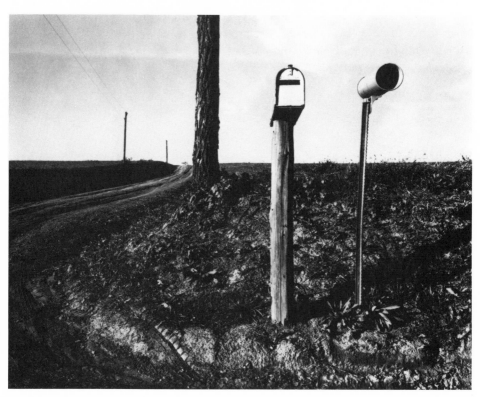

14. *Mail Boxes*, Western Nebraska, 1947

Origins
THE SELF IMAGED

THE TELLING IMAGERY of our memorable writers is rooted in memory and emotion. The whiteness of the whale, the lineaments of death, the speech of groping hands, water purling over rocks, the recurrent voices of impotence and rage provide us with the clues to the writers' obsessions, the chimed notes of their emotion. In this wise, reader and writer are joined in a profound yet impersonal comprehension.

Before imagination supplements memory, it derives its energy from emotion, which is either positive and life-enhancing or negative and life-negating—in praise of life, or registering the first of many complaints. As the writer accumulates experience, craft and observation will enlarge memory, but the first impressions to emerge in his or her consciousness will often prove to be the last. They grow out of the compost of his nature, and prove to be a new species.

Much of my own plains-based fiction grew out of my need for an experience I came too late for. The town of Lone Tree itself, observed, in passing, in *The World in the Attic,* rose out of the need of a dwelling place for the likes of Tom Scanlon. Once that fact was apparent, the appropriate details assembled about his person—a hotel, a lone tree, a railroad and a cattle loader, objects that were destined to serve as icons. These artifacts constituted the "scene" in the way movable props served to "locate" a Western movie.

Like Uncle Fremont, in *Cause for Wonder,* I came too late for God and too early for the Farm Security Administration. A boy of nine, I left the Platte Valley ignorant of the fact that my hometown of Central City had once been called Lone Tree. This name had been abandoned as planted trees grew, and the town was well shaded for my boyhood. The fictive town of Lone Tree is an assemblage of parts testifying to my own homesteading program. Some of this fabrication is rooted in fiction, much of it my own, but all of it had been processed by the memories and emotions of my boyhood. The emotion would make of the shards of memory all that it could.

When we say "How well I remember!" invariably we remember poorly. It is the emotion that is strong, not the details. The elusive details are incidental,

since the emotion is what matters. In this deficiency of memory do we have the origins of the imagination? To repossess we must imagine: our first memories are as dim as they are lasting. Until recorded history, memory constituted history and memory processed by emotion was our only means of repossession. When this is done with talent, we define it as art.

The faculty of memory, and the quality of emotion, varies from person to person and from writer to writer, making certain that what is remembered is a continuously expanding spectrum. The mind is often at play, like the summer night buzzing with insects, but to imagine, to make an image, to shape, assemble, and structure experience, differs from the play of fancy and invention through the energy it receives from emotion. The image-making characteristic of science and fantasy fiction is largely free of this charge of feeling. The most remarkable events, inconceivable disasters, unheard-of creatures and identified flying objects pass through the mind without distressing the emotions. If the charge of feeling is present, it is no longer merely science-fantasy fiction. Those novels that once went along with hammocks, perhaps still described as ''light summer reading,'' were crafty in the way the imagery was free of memory processed by emotion.

Image making begins in earnest where memory fades. The skein of memory is often so frail we see right through it, and it frays at the edges. Invoking memory's presence may prove similar to a séance. Is it really *him,* we wonder, or an impostor? Imagination can be lured, but not willed, to do this restoration for us. In good fiction we can usually distinguish those portions that are craftily constructed from those winged with imagination. Without the gossamer of memory it is less than life; with it as a ground it proves to be more. First we make these images to see clearly: then we see clearly only what we have made. In my own case, over forty years of writing what I have observed and imagined has replaced and overlapped what I once remembered. The fictions have become the facts of my life.

One of our necessary illusions is that we see things as a ''whole.'' If we look at a map we see a confusion of crisscrossing lines, boundaries, and colors, in which the large details often prove to be the least noticeable. What country is it? This may prove difficult to determine. We must learn to read the map, as we do a face. We get a general impression, lacking details, or we get the details without the larger impression. A trained eye, of course, hopes to get both, as when the critic observes a painting or the artist studies a landscape. What we see on the mind's eye of memory is seldom clearly one or the other. An overlapping of many impressions, as in a cubist painting, creates a vibrant but jumbled image. The mind is an archive of these sensations. In their infinite variety they still exhibit individual and general characteristics. Nabokov says, ''Speak, Memory!'' But memory is not Hamlet's ghost. It is Nabokov

who speaks. On this gauzelike memory tissue, and from those competing fragments, the writer chooses and reassembles his or her own pictures. The reader exclaims, "What a memory you have!" But it is what escaped memory that stirred the writer to write.

In the clutter of what is remembered and what is imagined some things prove to be symbolic objects. They gather lint. They wear in rather than out.

A bent skate key
A needle with a burned point
A ball of tinfoil
A streetcar token (found among coins in a city without streetcars)
The cracked chimney of a lamp
A medal won for not smoking

Artifacts mystically quickened with sentiment await their reappearance in the imagination, a reenactment and a confirmation. Each time these tokens are handled they give off sparks.

. . . On the dresser in the bedroom, where it ticked loudly, he would put out his railroad watch, on its chain, with the small gold knife that he used to clean the grease from his nails. Until he shaved at the kitchen window where just his lathered head showed above the curtain, he wore his snug whipcord pants with the straps of his braces dangling, his underwear unbuttoned to expose the crinkly hair on his chest. Nothing could have been more commonplace, but it left on Cowie a lasting impression. No ordinary mortal arose so late in the day and walked around as he did, wearing harness, as if unhitched from the work he had accomplished while asleep (One Day).

I was reluctant to surrender myself to this scene, feeling that I was spying on my own imagination. Unmentioned, but sharp to my senses, are the surrounding presence of a summer morning and the scorched smell of the iron on the draft from the kitchen. These memory fragments of separate, dispersed impressions have been filtered through a cherished emotion. At the window the swing creaks, the blind sucks in against the screen; water drips in the pan under the icebox.

The American writer, for self-evident reasons, often beginning with the disorder of creation, is "subject to the superstition that objects and places, coherently grouped, disposed for human use and addressed to it, must have a sense of their own, a mystic meaning to give out."

This testimony links Henry James to the object-and-place-obsessed imaginations of Whitman and Twain. Image making exorcises this obsession. The crackle of singed hair, stretched across a lamp chimney, around which memories and emotions cluster, waits on the moment that imagination will release it from darkness. How appropriate it is that the fledgling writer tests his faculties

on these first impressions. Soon enough he will see more than he remembers, and observe more than he imagines, but the clue to his image making will be found among the objects with a mystic meaning to give out.

> When he was a kid he saw the town through a crack in the grain elevator, an island of trees in a quiet sea of corn. That had been the day the end of the world was at hand. Miss Baumgartner let them out of school so they could go and watch it end, or hide and peek at it from somewhere. . . . They stretched on their bellies and looked through a crack at the town. They could see all the way to Chapman and a train smoking somewhere. They could see the Platte beyond the tall corn and the bridge where Peewee had dived in the sand, and they could see T. B. Horde driving his county fair mare. They could see it all and the end of the world was at hand.
>
> The end of the world! he said.
>
> HOO-RAY! said Dean Cole *(The Man Who Was There)*.

Memory's chief contribution to this scene was the mood of apprehension and exhilaration, shared with a companion. School was dismissed, a priceless boon well worth the world's loss. Miss Baumgartner was a borrowed detail, as so many were, from my school days in Omaha, where I was older and more observant. I did not go up a ladder, as reported, since I feared all heights more than humiliation. Peewee and the bridge were a cherished rumor at the time of writing, but the scene grew out of a boy's elation at the prospect of a mind-boggling disaster. In this brief fiction I gained a shameful triumph over lost time.

Somewhat earlier in time:

> . . . That stovepipe came up through the floor from the coke burner in the room below, and where it bulged like a goiter it would get hot when the damper was down. He could hear the coke crackle and settle when he turned it up. . . . All he wanted to do by turning the damper was to bring up the woman who lived below, the way the genie in the picture would rise out of Aladdin's lamp. She would come up with her lamp, the wick swimming in oil, and cross the room like the figures in his dreams, without noises, without so much as taking steps. Holding the lamp to his face she would see that he was asleep. He would feel the heat of the chimney on his forehead, catch a whiff of the oil. She would first open the damper, then turn with the lamp so that the room darkened behind her, but her snow white hair seemed to trap the light. During the day it would be piled on her head, but when she came up with the lamp it would be in braids. With a silver-handled comb that rattled when she used it, facing the mirror that no longer had a handle, she would comb out the tangled ends of her braids. Out would come, like the burrs in a dog's tail, the knotted hairs. When all the hairs stood up, like a brush, she would pass the ends slowly over the chimney, where they would curl at the tips and crackle with a frying sound. Then the smell, as when she singed a chicken over a hole in the range, or turned the bird, slowly, in the flame of a cob dipped in kerosene *(The Man Who Was There)*.

It is difficult for me, so long after the event, to penetrate the fiction to the original memory. I lie in bed under a sloping ceiling that seems to smoke and waver with looming, hovering shadows cast by a lamp. Out of my sight a woman hums snatches of hymns as she brushes her hair. The crackle I hear is made by the brush. On another occasion I watched her test the height of the flame in the lamp chimney by stretching one of her white hairs across the opening at the top. I still fancy I see its burning glow, like the filament of a light bulb. This simple scene has the primal elements that stir both the emotions and the imagination. There is light and darkness; there is mystery, wonder, and a nameless apprehension. In her voice there is a comforting assurance. The moment is a ceremony. My child's soul is hushed with awe and a tremor of dread as I anticipate her mumbled, sonorous prayers. If I attempt to recall this actual occasion, the image blows like smoke, yet something hovers and protects me as if I were cradled at the mouth of a cave. The details are indistinct, but the emotion is inexhaustible.

To what extent is this true of later events, when the observed details are clearer? In the mid-fifties I visited Mexico, and spent a memorable week in Matamoros. Some years later this experience was the basis of a crucial chapter in *One Day,* published in 1965. A caged bird is intrinsic to this experience.

> A species of canary, Cowie's first impression had been that it was an object, made of cork and pipe cleaners. Artful, perhaps. No question it was horrible. There were quills, but no feathers, below the neck. The head with its lidded eyes was elevated on the neck like a lampshade. The legs and claws were twisted bits of wire. Cowie took it as an example of the Mexican taste for the macabre: the skull-and-bone cookies eaten by children, the fantastic birds and animals made out of paper. When he glanced up to see it headless, he simply thought the head had dropped off. But no. Nothing lay in the bottom of the cage. The head, with its knifelike beak, had been tucked under the quills of one wing. Fly it could not, lacking the feathers. Sing it would not. But on occasion it hopped *(One Day).*

Mexico is inexhaustibly exotic (for Americans), at once intoxicating and harrowing. The sensible and the absurd overlap, the grotesque is commonplace. For the writer this garden of macabre delights is both an inspiration and a disaster. In admitting to the surreal quality of his impressions, the writer must maintain the stance of a sober observer. Malcolm Lowry achieved this in *Under the Volcano.* My own hallucinated experience in Matamoros featured a large cage without a bird. Gazing at it and through it, over many days and nights, it became for me a symbolic object. Almost a decade later, repossessing it in fiction, Cowie's experience called for a bird. I imported one I had observed on a previous stay in Querétaro. The perfect setting for both the bird and the cage were provided by Matamoros. Cowie's Mexican adventure provided the author with the overview of many previous visits, as well as arrest-

ing and insoluble reflections that arise from the dismaying overlapping of
extremes that are both life-enhancing and appalling. Without Matamoros none
of this would have happened, but little of it actually occurred in Matamoros.
The perfect cage had been found for the imagined bird.

In a recent novel, *A Life,* an old man returns to the New Mexico homestead
where he had once raised sheep. As a young man, in 1929, I had visited such
a spot. My Texas uncle had wanted me to see the shack where he had brought
his bride and made his start in life—as an example to a citified youth about to
go to college in California. The site had impressed me as bleak, godforsaken
and romantic, full of promise if the bride had been well chosen. In the deep
ravine at my back the sky was reflected in the Pecos River. On the low rise
before me, the color of rusted machinery, a two-room shack sat in a clearing.
There they had lived. Everything else, he took pains to assure me, had died.

My actual memory of that visit is like a bad colored slide held to the light.
Above a low dark horizon, without details, a brilliant metallic sky. At my
back the purl of shallow water over rocks. That landscape of emptiness, joined
to my inscape of emotion, furnished the scene with the artifacts that were lack-
ing, appropriate to the old man's homecoming.

> The path he followed dipped sharply toward the river, then rose to the rim of the
> bluff where he had once bailed for water when his well dried up. At that point,
> as if a machine had collapsed, he found an assortment of iron wheels, one of the
> largest mounted on an axle across two wooden horses, a gulley trenched in the
> earth beneath it so the wheel would turn freely. To the outside rim of the wheel
> cans of various sizes had been bolted or wired. What did the builders have in
> mind? . . . Had they planned to irrigate? . . . He walked on to where a blowout
> had widened the trail at the top of the rise, a fine powdering of sand blowing
> into his face as he approached. Through half-lidded eyes, his gaze partially
> averted, he peered over the hump into the hollow where the sheep and their
> ewes often gathered to get out of the wind. It was now grassless, like a play
> yard, and strewn with the bodies and parts of wrecked cars. The colors of black
> and rust, in the morning light, made him think of prehistoric monsters, this hol-
> low a place where they came to die. Beyond, just above his eye level, the slope
> below the house had been terraced in the manner of rice fields. Where water had
> settled and evaporated it gleamed like exposed rock. A few shrivelled plants
> were supported by sticks; others had collapsed to lie in the dust. The house was
> there, or more accurately the cabin, to which lean-to shelters had been added,
> open to the yard. These stalls faced the southwest, were roofed with boards and
> tin, and sheltered parts of car bodies that served as furniture. The door of a se-
> dan provided one room with an up and down cranked window; he could see that
> it was down. Torn strips of material that once might have served as awnings
> stirred in the breeze that always followed the sun's rise. The bands of color
> looked festive, like banners at roadside stands. Where was everybody? Was it so
> early they had not got up? He peered around for a dog before moving closer.

The wind brought him the tinkle of glass chimes. Light glinted on the strips of glass and tin suspended on wires in the open doorway. A cart made of buggy parts, using the tree and the axles, featured old tire casings wired to the rims. Lengths of rope, attached to the front axle, were tied to a yoke that could be pulled by men, rather than horses. Directly fronting the house, where the terraces began, large cylindrical objects, like metal jars, were suspended on wires between heavy posts. The jars were graded in size, and put Warner in mind of the pipes of an organ, or something to be hammered. There was every sign of life but life itself, which he felt must be just out of sight somewhere, as if out of mind. At the top of two long tilted poles, reaching into the sun's rays, several gourds were hung from a crossbar, one of them slowly revolving. As it turned to the sun he saw a small bird enter one of the egg-sized holes *(A Life)*.

The fragmented ruins of a hippie commune, where more than sixty years ago his own life had started, provide a suitably ironic setting for Warner's last impressions. All of these details are fictive, conjured up by the mingling of memory, imagination, and emotion, ingredients that waited, like the old man, for their appropriate transformation.

The proliferating image of our time is the photograph. It is rapidly replacing the "abstraction" as the mirror in which we seek our multiple selves. Paradoxically, it was the photograph that inspired the emergence and triumph of the abstraction, freeing the imagination of the artist from his or her obsession with appearances. A surfeit of abstractions, and abstracted sensations, although a tonic and revelation for most of this century, has resulted in a weariness of artifice that the photograph seems designed to remedy. What else so instantly confirms that the world exists? We need this daily reassurance. Objects and places, whether coherently grouped or not, constitute the ambience in which we have our being. The photograph reaffirms, the cinema enshrines "the ineluctable modality of the visible." That also includes its abuses, the violence that functions as pornography of sensation. The film has also obscured, momentarily, that its representations, its imitations of life, are an old rather than a new form of image making, and that the viewer is back to the startled point of his departure, the need for further image making. In the dark cave of the theater, like the child under a porch, he must reimagine what it is he thinks he sees.

As we now know, language has its own purpose, and distorts in the act of being lucid. To a measurable degree, lucidity falsifies the truths of image making. The emotion that fuels the imagination, and is in turn put to the service of individual experience, departs from the notion that the real world is there to be seized rather than reconstructed. The primal experience to which God might refer, as to a clear snapshot of the Garden of Eden, is precisely the image that is lacking. Adam and Eve have become image makers out of necessity. The dreaming cat may have a clearer picture, to his own purpose, than the dreamer

in whose lap he is curled, but he lacks the faculty of reassembly that distinguishes and terrifies the species homo. Nothing is, but image making makes it so.

We see and document the microcosm of the atom, and we see and document the macrocosm of space. The likeness of one to the other is striking. It is not hard to imagine a point in space-time where these extremes met and joined. Fabulous, but not unimaginable. Not too long ago, if we can believe what we see, we saw planet Earth rising on the moon's horizon. Real as it appears, this image resists our abilities to grasp it. We might describe it as an object fallen from the sky, for which we lack the appropriate emotions.

Before we made fire, before we made tools, we made images. Nor can we imagine a time in which man has not had imagination. In the deep recesses of caves at Lascaux, Altamira, Peche Merle, and elsewhere, prehistoric people proved to be image makers of baffling sophistication. Horses and bison, the woolly mammoth, the reindeer are *imaged* in a manner we think of as modern. The audacity of the conception is matched by the refinement of the execution. Over a gap of twenty thousand years of silence they capture, as we say, our imaginations. We might guess that these artists' talents increased their self-awareness, their sense of uniqueness, distinguishing them from their companions, this in turn burdening their souls with an enlargement of their sense of wonder. The caveman and woman, the lunatic, the lover, the poet, and the child under the porch, if he or she can find one, have at their instant disposal the inexhaustible powers of light and darkness, the ceaseless, commonplace, bewildering interlacing of memory, emotion, and imagination. That's where it all comes from, and of the making of such fictions there will not soon be an end.

From *Earthly Delights, Unearthly Adornments,* by Wright Morris (New York: Harper & Row, 1978).

Photography and Reality

A CONVERSATION BETWEEN
PETER C. BUNNELL AND WRIGHT MORRIS

MORRIS: Peter, let's work around your idea of the photograph as a mirror and some of the modifications you made in playing with it. The mirror is one of the durable and inexhaustible metaphors we use in the interpretation of what we think constitutes reality.

BUNNELL: The nineteenth-century way of looking at the photograph was as a mirror for the memory, and at that time the photographs almost looked like a mirror, with their polished and metallic surfaces. But really the photograph presents a kind of reality that isn't a mirror. It reflects yourself. You see in the photograph what you are. You recognize content only as you have ability to identify and then to interpret.

MORRIS: To what extent do you feel that might have been a reasonably common impression in the nineteenth century? Weren't most people overwhelmed just by the seeing of the self? Didn't they see the standard daguerreotype image as an object reflecting reality?

BUNNELL: Yes, they saw it as presenting the facts. Talbot's book, published in 1844, was the first to be illustrated entirely with photographs, and it was called *The Pencil of Nature*. The image seemed to engrave itself without intervention. In effect, I think they didn't interpret at all. I think they saw in the photograph what they would look at in some of yours: the artifact, the thing itself. Only later, after the daguerreotype process was superseded by more manipulative processes and the potentiality of altering the picture was known, did the idea of the photograph as a new object really come into general understanding.

MORRIS: Was there anyone preceding Atget who seemed to be aware of the possibilities of transposing what is commonly accepted as the actual over into a possessed object separate from a mirror reflection? What about the French photographer, Niépce?

BUNNELL: There were hundreds of photographers who saw, as you did, possibilities of transposing reality, but most of them are anonymous today. I think

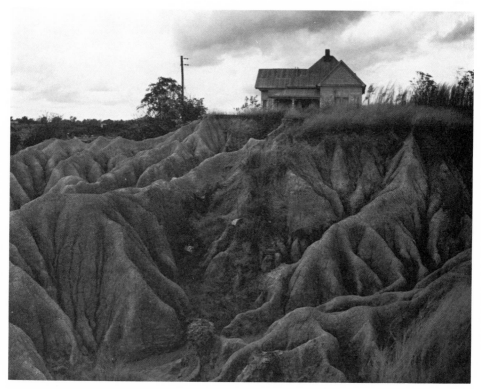

15. *Eroded Soil, Faulkner Country,* near Oxford, Mississippi, 1940

we must look for schools or bodies of photographic works rather than individuals. I've always felt, for instance, that in American daguerreotypes—specifically in the portraits but in photographs of objects as well—the clarity and precision indicate that the photographers sensed a joining of process and object. There is always this sense of moving toward a more pictorial sensibility, where the photographic object supersedes in effect the fundamental integrity of the subject photographed.

MORRIS: The inclination is always to supersede.

BUNNELL: A lot of daguerreotypists didn't know that they were doing this. Their early manuals are fascinating because they told you everything. They are cookbooks. They told you how to get to the point of making one of those pictures but never what to make. In a way, they really had no other option than to respect the integrity of what they took the picture of. It really was only later that they began to see for itself what they had made.

When did you first know of Atget, Wright?

MORRIS: I think I saw my first Atget photographs in 1939 or 1940. An art editor from the *New York Times* gave me a group of them. I had had this little show at the New School for Social Research, which he had seen, and he asked if I would be interested. There were hardly any prints of those photographs available at that time, and I had no sophistication whatsoever. But I did know of Atget, and yes, I wanted the photographs. It absolutely startled me that anybody should be seeing in such a manner at that time—that sense of being plagiarized before you are born!

BUNNELL: But were you conscious after that time that Atget influenced what you were seeing and doing?

MORRIS: He gave me reassurance and a sense of persistence. Now I think maybe five of those first pictures may have been portraits of women, his whore series, you know, which were extraordinary because they were so absolutely, beautifully detached and yet so good. The person is there, the situation is there, and they provided an effect of extraordinary bleakness by their sepia tone in contrast to the Paris atmosphere: it's bloodchilling. And then there were a couple taken out in the woods. There was one of a tree. I also had a picture of a tree and roots; and I felt, given the same circumstances, Atget's was a picture I would have taken. That simultaneous existence at different times of the same sensibility has always fascinated me. What I later came to was a kind of metaphysical conviction that we really don't possess anything—we are merely the inheritors of a sensibility that moves among us. This awareness of a common sensibility gives the reassurance that I think we seek in immortality.

BUNNELL: The photograph has a strong sense of that, of immortality. In the introduction to your Venice book, *Love Affair: A Venetian Journal* [1972], you talk about salvaging the experiences of the city. This suggests the transitory nature of the thing itself and that the photograph serves to salvage, to monumentalize, to make permanent.

MORRIS: The word *salvage* is quite misleading and needs to be taken out and honed and broken down and reconsidered. Like any writer, I fall into a period when a word seems fresh and I grab onto it and it's gratifying, and then I wear the word out, and I come back to it, and I say, this word is bearing the burden of half a dozen other words and I don't like it so much any more. I'm beginning to have that feeling about *salvage*. I am just about prepared to turn it in for a retread. I am about to fall under the persuasion of my own rhetoric, so to speak; but it has an origin in an impulse that is authentic.

As an American of a certain period, I have built into me a certain sensitivity to "the arrears of our culture." I have an instinctive rejection of the fact that we constantly replace. We can speak of this habit as destroying or we can speak of it as progressive replacement, but I don't like it. There is operative in me an effort to put back the sandpile after the water has come in and washed it away. But that tendency does not serve as a real point of motivation. It is merely one of a variety of responses. When I use the word *salvage* in too general a way, I allow myself to oversimplify and turn what is a very complex relationship with an artifact into something that is quite misleading. If somebody says: Really, man, you're just trying to hang onto things that naturally have to be replaced; a kind of nostalgic mania and, basically, although this has a certain attraction and will keep you preoccupied when you're not suffering from migraine, it really leads nowhere; and furthermore it does not constitute what your photographs really seem to be concerned with—I would have to say, Correct. Nostalgia is merely one ingredient.

Only at a certain point am I concerned with a holding action. You remember the Beckett quotation in the front of *God's Country and My People:* "From things about to disappear I turn away in time. To watch them out of sight, no, I can't do it." That speaks deeply to me. Very deeply. We're dealing here with the *zeitgeist*. Perhaps everyone in this century is insecure about the persistence of the past. But there is something different, too. In all artists there is something operating deliberately which is ordinarily concealed. I think there is present in any construction an effort to replace what is disappearing. I think it is like the replanting of crops.

BUNNELL: Is the photograph the replacement?

MORRIS: No, I'm thinking simply of any act that is imaginative or creative. That act appears simply to emerge, out of our nature. I talked about this to

Wayne Booth the other day. I am myself convinced that the imaginative activity is organic and that the mind thinks just as a plant gives off buds, and that the depression of the faculty inhibits a person and destroys something basic in him or her. It is an absolute necessity for the mind, like the hands, to replace what is wearing out, to replace the cost of living. We can think and talk about art, talk about all its infinite labyrinthine experimentation, and forget that it comes out of this need to hold on to what is passing. The artist says, ''Don't give up! Keep ahold!'' Now the photograph cuts through the aesthetic of some of the more inwardly turned and inwardly developed crafts—like, let us say, contemporary painting. Just as writing resists some of the worst forms of erosion, I think photography resists them, too. With both photography and writing, beyond a certain point what you do just isn't comprehensible, and you have to come back to the point of departure.

BUNNELL: You mean that the photo and writings are alike in that both are things in themselves and also refer to a reality aside from themselves?

MORRIS: These two sides of photography are something of a mania with me, and I've repeatedly talked about it. There's even a passage in *Love Affair,* if you remember, about giving up one picture to get another. That was as tactful a way as I could find to say that the camera is the first obstruction between us and experience. I think this is both subtle and almost inevitable. When you begin to be lens-oriented, the object itself is secondary and you wait to see later what it is you've done. On repeated occasions I have been very vague about what I have done, knowing that I'd see later, or I wouldn't see at all, why I had taken the picture. I waited. I *had* had a shock of recognition, but what it was, I would learn later.

And sometimes I have learned from the photograph—that is, in the photograph I frequently learn the possibilities of the photograph. This is what happened, precisely, with the intrusion of my shadow in the picture of the Model T Ford. In the foreground you can see the shadow of the photographer and his camera between the edge of the picture and the car itself. At first I wanted to eliminate that shadow. It was a distraction toward which I had no ambivalence at all. I just wanted to get it out of there, and unable to get it out satisfactorily, I put the picture aside as one that I was not going to try to get into the book I was writing. It became a kind of secondary picture. Then coming back, about three years later, I saw that picture for the first time, and I said, Well! and I looked at it and I attempted to make an adjustment to the variety of impressions I was having from it. Gradually it began to win me over.

BUNNELL: Another of your photographs has exactly the same kind of intrusion. The photographer's hand and his box get between us and the haystack and house which are the subject of the picture. That was made in 1940.

MORRIS: I'm in sympathy with what I learn from the scene itself, and I do not reject what I found in that picture, saying, My God, there's another intrusion! We'll just cut it off up here.

Under different circumstances something like this could have led me into a very different area of photographic experiment. But obsessed as I was with my material, I thought of it only as an incident. The possibilities and the limitations of photography can be almost summed up in this type of encountered reflection. If you are a photographer, you are obsessed with some concept of actuality. You do not want to diminish the essence of your statement, and then gradually it comes upon you that you are working as a picture maker. And so you have to reconsider and become a little less inflexible about what the medium really should be doing. At first you think you have rather clear ideas about this; it is the so-called straight photography approach. Getting away from that would have taken me considerable time, although it was inevitable—if I hadn't been diverted by the demands of writing. I did not at that point have to make the next step photographically because I was completely preoccupied as a writer.

BUNNELL: Does anything analogous occur in the writing? Do you face that shadow image when you are writing fiction?

MORRIS: Yes, the problems of the craft of fiction are not necessarily concerned with the intrusion of the writer, but they are similar in that the writer must move from one level of dealing with his experience to another level. I've never had to deal with the craft of photography as with writing, however, because by the time I reached the end of that first photographic statement, I was faced with a do-or-die challenge to simplify and make my way as a writer independent of my photography.

BUNNELL: You began your career in the thirties, and anybody who had to live through the thirties unfortunately acquired a kind of social-realist tag. You got it, but I don't think it is applicable, even though you must have been aware of the realistic photographic activity of agencies like the Farm Security Administration. Did you meet Roy Stryker of the FSA and offer to go out on tour, taking pictures of the country as they hired photographers to do in those days?

MORRIS: I was prepared to lay my hands on money if I could. I went to see Stryker, though I had at that time begun to be reasonably suspicious of his eye. He looked through a portfolio I had brought in—flipped through the pages the way a man does who has looked at too many photographs—and commented that the sort of thing I was doing was not at all what they were doing in the department. I said I knew that but I simply wanted to show him my stuff.

BUNNELL: Were you ever in fact primarily concerned with the social implications of your pictures?

MORRIS: I still have this problem. The similarity of my subjects—abandoned farms, discarded objects—to those that were taken during the Great Depression, and were specifically taken to make a social comment, distracts many observers from the *concealed* life of these objects. This other nature is there, but the cliché of hard times, of social unrest, of depression, ruin, and alienation, is the image the observer first receives. Perhaps it can't be helped. All, or most, photographs have many faces. The face desired is revealed by the caption. I do not have captions, but the facing text reveals the nature of the object that interests me: the life of the inhabitants whose shells they are, as Thoreau said. The social comment may well be intense, but it is indirect, and not my central purpose. These objects, these artifacts, are saturated with emotion, with implications, toward which I am peculiarly responsive. I see many of them as secular icons. They have for me a holy meaning they seek to give out. Only a few, of course, speak out with this assurance, but if the observer is attentive he or she will be attuned to my pictures and how it is they differ from most others. Once that is clear, they do not need captions. The observer is open to the same responses I am.

Although that problem is always present, the photo-text confronted me with many others. Chief among them is that some people are readers, some are lookers. The reader becomes a more and more refined reader, with less and less tolerance for distractions. In my own case, I cannot abide illustrations in a good novel. They interfere with my own impressions. The pictures I need are on my mind's eye. Now the relatively pure *looker* will subtly resent what he or she is urged to read. The looker wants all *that* in the picture. Each of these sophisticated specialists resents the parallel, competing attraction. As you have pointed out, Peter, the photograph requires a "reading," as well as a looking—its details scrutinized in a knowledgeable manner. In my case, this was a crisis. If the photograph overpowered the text, or if the reader treated the text lightly, I had defeated my original purpose. It was also crucial for my publisher, who considered me a novelist. *The Home Place* was well received, but pointed up this dilemma. I was losing readers, picking up lookers. Several reviewers asked why this ex-photographer was writing fiction. There was only one way to clear this up. Stop the photo-books. And so I did.

BUNNELL: What was your present publisher's motivation in coming back to the photo-text book?

MORRIS: Me, I was on the verge of changing publishers, along with my editor, and I used the occasion to slip in *God's Country and My People,* a reconsideration and reappraisal of my photographs.

BUNNELL: In *God's Country* you use the same photographs that are in *The Home Place* plus obviously more. This is a different, explicitly autobiographical kind of text. Could the photographer's shadows in some of the photographs be a kind of self-portrait presence like the autobiographical text of *God's Country?*

MORRIS: You are getting very close to why I felt it necessary to do that book, and why I did it in that manner. It's a reconsideration of material from a later point in time, using essentially the same techniques and the same body of photographs. It was the quality of the repetition that was necessary to this book. Both the writing and the photographs undergo a sea change in the overview taken by the writer. I didn't know what problems I would have with readers who understandably might take offense and say, What is he doing in repeating himself! But I couldn't go out and make a new world for myself to photograph, and it wasn't advisable. This is a revisitation. In fact, a repossession. But there weren't enough such readers to make any difference. Nobody raised this problem at all.

BUNNELL: Now that you are back in Nebraska, in a real revisitation, you must be challenged to deal again with things that you dealt with before, after, or through another point in time. One might ask, Why doesn't he try to find if the values which he tried to exemplify in the barber pole of 1940, say, are really of value now. What is Nebraska now? In other words, what does a writer and an artist who has this time span, do? It's something that a person my age can't answer.

MORRIS: I think this is not only a number-one problem for me, I think it's also a number-one problem for people of your generation. There is a diminishment of value in the artifact itself, and there is a limited way in which a photographer can deal with the diminished values of the contemporary artifact. There is a statement to be made about them, but it will be relatively shallow, soon exhausted. Young photographers, of course, orient themselves toward this problem much more positively, but I think aesthetically they face the same problem that I am aware of, the poverty of significance in the artifacts themselves. And when I come back into this old environment, I am startled by the relative richness of the old and the lack of it in the new. We call it progress. We make it new, but we do not love what we make.

BUNNELL: Judging from a photograph of your own house, you are not yourself much of a collector. I mean your house doesn't seem to be filled with artifacts, with objects. You don't seem to need things, however much you describe and photograph them.

MORRIS: What photograph did you see? Our house is bulging, but it's not a museum. Our friends get a contrary impression—or is it the difference between the actual room and a photograph of it?

BUNNELL: Here is a reinforcement of a kind of parallelism and divergence that I was setting up between yourself and Walker Evans. Evans collected like a maniac. When he photographed the neon pop sign in Alabama, he brought it back home with him. The photograph transformed it and he knew that he dominated it. Though he loved the subject, it wasn't of interest to him in his art. The picture was important, not the subject of the picture. So he brought the neon pop sign home. Look at a photograph of his place and of other photographers', and you find more than just lived-in clutter. They're surrounded by collectible artifacts, actual things. You are not.

MORRIS: I'd say it works in reverse with me. If I have the photograph, I can dispense with the artifact. The mobility of my life has made it impractical to hold onto more than books. But not showing in the photograph of our living room is an entrance and a hallway which has a group of my photographs. These constitute artifacts. In a sense they hang there by accident, not design. They were framed and put up for a Guggenheim exhibition; and when the show was over, they were sent back to me. Now it fascinates me that Evans would have had a need to latch onto actual artifacts. It's idle for me to speculate, but I wonder if there's a difference in our backgrounds. Was he mostly a city man?

BUNNELL: Yes.

MORRIS: I think that would make a big difference.

BUNNELL: I don't mean to say that what he collected was necessarily remnants of Alabama tenant farmers' houses. He was a great Victoriana collector—paperweights, and white marble rubbings—bric-a-brac I guess you'd call it. Coming back to Nebraska now, have you gone or have you any inclination to go back to these places that you lived in and photographed?

MORRIS: My God, yes. But our car was banged up soon after our arrival, during the period we had both the time and the weather. We did get over to Central City, my home place, with the local television people; incidentally, they are doing a piece called *Repossession*—we will see if it works. The Home Place, lock, stock, and barrel, was bulldozed out of existence in the late fifties. Nothing remains but what we have in the book, which does speak up for salvage. For a few days I did take a few pictures to see if there was a change in my way of looking at similar artifacts. But it was not noticeable. Much that speaks personally to me is still around, but I see little that is new that attracts

me. I assume that younger photographers see it differently, but local work that
I have seen is past-oriented, reflecting the vogue in nostalgia and "antiques."
I sense there is a quandary in what they should "take." And if they take *that*
today, what will they do tomorrow? The vast number of photographers, feed-
ing on anything visible, overgraze the landscape the way cattle overgraze their
pasture. As in the novel, there is overproduction and underconsumption. You
would know about this, and I wouldn't. In the way of *artifacts,* which is close
to my experience, what is it that the young photographer loves?—or that he or
she hates to the point of revelation? Revealing what that *is* is the one thing
that still doesn't come with the camera. Or will that be next?

From *Conversations with Wright Morris* (Lincoln, Neb.: University of Nebraska Press, 1977).

Photographs:
A SELECTION

16. *Haystack,* near Norfolk, Nebraska, 1947

17. *Landscape, Rolling County,* Eastern Nebraska, 1947

18. *Barber Shop Interior, Cahow's Barber Shop*, Chapman, Nebraska, 1942

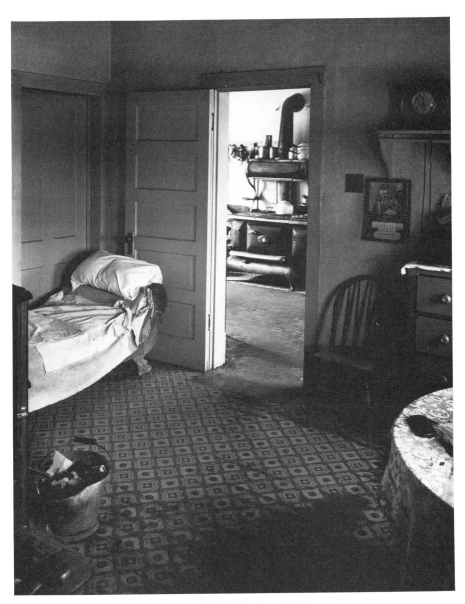

19. *Living Room, Ed's Place*, near Norfolk, Nebraska, 1947

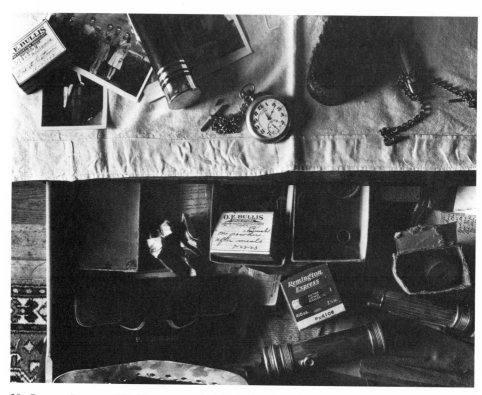

20. *Dresser Drawer, Ed's Place,* near Norfolk, Nebraska, 1947

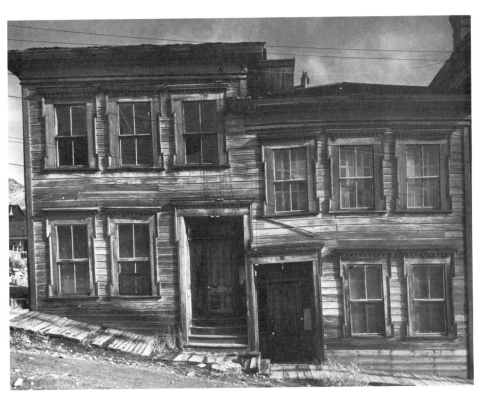

21. *Houses on Incline*, Virginia City, Nevada, 1941

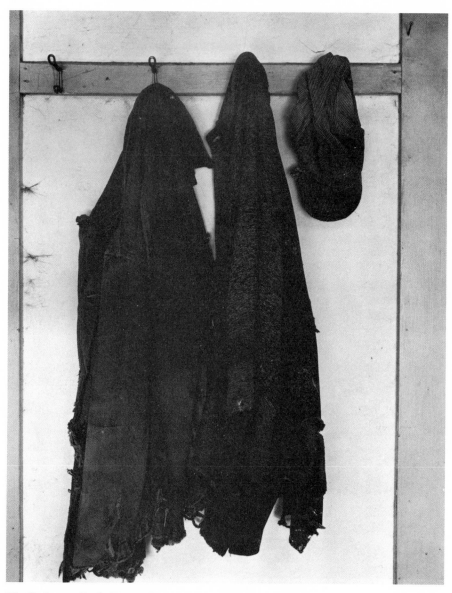

22. *Clothes on Hook, Home Place,* Norfolk, Nebraska, 1947

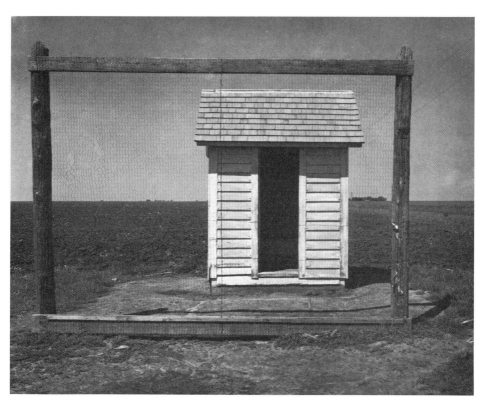

23. *School Outhouse and Backstop*, Nebraska, 1947

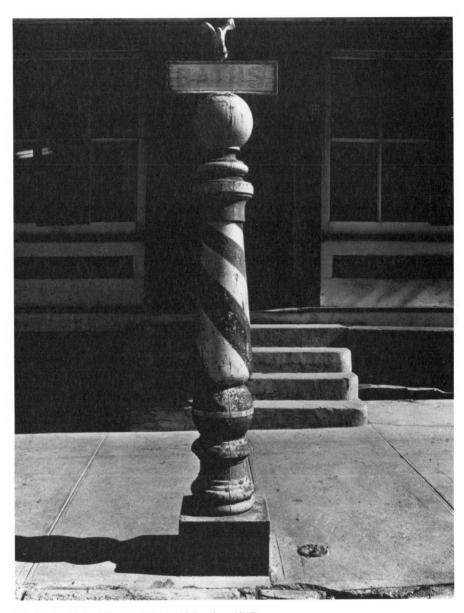

24. *Barber Pole,* Weeping Water, Nebraska, 1947

About Fiction

WE ARE A PRACTICAL PEOPLE, down-to-earth, fact-minded, ill at ease
with abstractions and highfalutin language, the all-American grain of our
minds being one we either sand down or polish up. Although we attempt to
face up to and live by the facts, we carry on the business of living in fiction.
We do because we can't help it. Only fiction will accommodate the facts of
life.

Before they made tools, perhaps before they made trouble, men and women
were busy at the loom of fiction looking for clues to becoming more human.
The proven facts of our lives take one line on a tombstone, but the fiction may
well fill many volumes. Our choice, in so far as we have one, is not between
fiction and fact, but between good and bad fiction. Watergate is bad fiction.
Misleading facts and bad fiction govern our lives. If it's a matter of words, if
it's a function of language, if it's concerned with what it's like or not like to
be human, it will prove to be some sort of fiction.

We make to ourselves pictures of facts. The picture is a model of reality.

These are words of a philosopher, Ludwig Wittgenstein, but the fiction writ-
er could not have put it better. Writers are picture makers of facts. Their pic-
tures are models of reality.

In the light of this fiction, most of our distinctions are largely a matter of
convenience.

What would librarians do without a clear distinction between fiction and
nonfiction? What they do is resort to numbers. In this way a distinction that is
arbitrary is made to appear perfectly natural. Fiction is over there on the wall
to the left, nonfiction to the right.

Those who appreciate facts assume that nonfiction is real in a way that fic-
tion is not. They buy with confidence books of nonfiction: fiction they buy for
children and convalescents. Who can say what novels are really about? Non-
fiction is plainly about history, about war and peace, house repairs, vitamins,
and how to make love. Nonfiction is by nature about something that might
prove to be useful. Fiction, if it is good, will often prove to be useless. "What

good is reading *that* going to do?'' is invariably an unanswerable question. The powers of fiction, as distinct from its uses, are believed to align themselves with the occult, and should be labeled: ''Let the Reader Enter at His or Her Own Risk.'' It has to do with spells, and we are inexperienced with spells for the good.

History, for example, is a good solid subject, but we can print most of the facts on one flap of the jacket. *What* happened and *where* is history—how and why it happened is fiction. If it is good fiction we accept it as history. To have been the general, the soldier, the statesman, the spy in from the cold or one of his victims, is merely to establish the point of view from which fiction can be written. We sense, as we read, that the facts elude us: to have merely been there only adds to our confusion. The small amount of truth we might glean from the report will come about through the shaping of the imaginaiton. The vast fiction of Gibbon persuaded our forefathers that they grasped the decline and fall of Rome. Gibbon read up on Rome, he lived and breathed ruins, he imagined himself and others as Romans, and he wrote the first massive historical novel.

So what about biography? The real life and times of the great and the lowly? In biography the fiction is compounded, since the author presumes to know the unknown, the unknowable: what the subject felt, what he or she *actually* thought, what he or she *really* said. If all this impresses readers as true, they are reading the work of a good writer of fiction. Anything might be his or her subject. The writer's problem is to give it the semblance of life.

That still leaves us with autobiography, the honest-to-goodness confessions of the person himself or herself. Cellini and Rousseau, along with numberless others, assure the reader they are sticking to the *facts*. Thoreau tells us:

> I should not talk so much about myself if there were anybody else whom I knew as well.

How sensible that sounds! Each of us a fount of knowledge about ourselves. Montaigne, also, is at pains to assure his readers:

> . . . that no man ever treated of a subject that he knew and understood better than I do this that I have taken up: and that in this I am the most learned man alive.

Brave words those! Curious how insistent these fellows are that in speaking of themselves they speak only the facts. It testifies to a deep concern on this subject. Today we know the concern is justified. The person who strains to tell us all, whether Rousseau or Hitler, tells us less what he or she knows than what his or her talent makes possible. To confess up a life requires the same imagination it takes to create one. It does if what we confess is a matter of *words*. Where the talent is great, *any* confession is of interest; where it is small or nonexistent, a report from heaven or hell itself will soon have the

reader yawning. One reporter on his own life understood that. Goethe described his research into himself as *Truth and Poetry*. It is either truth and poetry or it will prove to be very little.

But there must be *some* facts—what about those documents that record forever the crucial events in human history? Here is one on which the ink is still drying, signaling the cease-fire agreement in Vietnam.

> Immediately after the cease-fire the two South Vietnamese parties will achieve national concord and reconciliation; end hatred and enmity; prohibit all acts of reprisal and discrimination against individuals or organizations that have collaborated with one side or the other; ensure the democratic liberties of the people—personal freedom, freedom of speech, freedom of the press, freedom of meeting, freedom of organization, freedom of political activities, freedom of belief, freedom of movement, freedom of residence, freedom of work, right to property ownership, and right to free enterprise.

The reader of fiction might well feel that this is black humor, a parody of the very concept of a cease-fire. Where facts, of necessity, should have prevailed, we find that fiction has taken flight. In the guise of a treaty the winner-losers devise a contract that declares them winners—wars in which *all* sides are losers are reassembled in this manner. Only fiction—monstrous fiction—makes it possible for a good and just war to prevail.

The compulsion toward fiction is so great among those who believe they are writing *history* that only the self-aware fiction writer should be trusted with the drafts of these statements. He or she alone, at such moments, knows what fiction is, and what it is not. Not a little of it, described as black humor, is written out of despair of this world as a joke, and not a little of it, admitting to the joke, is written out of the healing need for laughter. The joke is one of the facts writers of nonfiction overlook.

To stick to the facts is a respectable goal, but no writer of interest has long achieved it. Vital statistics are notoriously brief. It is a fact that we are born and die, but in between it is all a tangle of fiction, rounded with a sleep. It is a fact that the president of the United States each year gives a report on the State of the Union. The president, the report, and the Union are facts, but the speech will invariably prove to be fiction, most of it bad. We are long accustomed, having no choice, to this commingling of data and experience, pictures of facts that provide us with false models of reality.

From *About Fiction,* by Wright Morris (New York: Harper & Row, 1975).

25. *Rear Porch, Home Place,* Norfolk, Nebraska, 1947

The Question of Privacy

ONCE UPON A TIME, for artists, writers, and photographers, there were restricted areas. Signs were posted on trees, fences, doorways, panes of frosted glass, etc., warning the public to KEEP OUT, touching on the sentiment of No Trespassing. The line to be drawn, if possible, was that between the public domain and the private: the nature or condition of being private. Did the boy come with the pants or the pants with the boy? In the fullness of time this would lead to ineffable distinctions between bare-faced and bare-assed people, between photographs to which we are accustomed and those to which we are less accustomed—those it is agreed we are shocked by. There may be a dozen or so words, give or take a few gestures, to define a decent, respectaable *image,* but a picture that is judged *indecent* may require several pages of scrupulous copy and involve large negotiable sums of money. Money and privacy share a bottom line. Has privacy become a genre of photography?

Not long ago—perhaps not long enough—both writers and photographers thought they knew "where to draw the line." The line itself seemed clear and unquestioned: the point of interest where to draw it. I first saw this line clearly, sharp as a crack in a mirror, on the ground glass of a camera I had set up in the bedroom of a farmhouse. The iron frame of the bed, with the deep impressions the sleepers had left in the mattress, the string that dangled from an unshaded light bulb to where a groping hand might reach it, and beneath the bed, in the strong north light of an uncurtained window, a nightpot polished with the use of a lifetime.

I had come back to this farmhouse, after a lapse of thirty years, to a farm I had known as a boy, to document the lives of a man and his wife who had homesteaded the plains in the 1890s. At that time, among other distinctions, a remarkably clear line was drawn between the public and the private. That May morning I perceived, as I had not before, that this somewhat blurred and indistinct line was there on the floor before me, like a ray of sunlight, and that the camera eye had overstepped it. My eyes were wide open. How had that been possible? I had been given "right of passage" by the woman of the house, a model for all that is inviolably *private,* to take those pictures that would speak

26. *Bedroom, Home Place*, Norfolk, Nebraska, 1947

for the pioneer lives she and her family had led—of which I had one summer
been a part. What had led me to take it? An extravagant respect for what we
describe as the *facts of life*. My own early respect, as a native, had been con-
firmed and enhanced by a lyrical passage from Thoreau's *Walden,* spoken to
me, as a writer, in private. In the privacy of the darkroom, however, as this
image emerged from the developer, I felt remarkably ambivalent about it. A
fact it was—but on the scales of value it was all exposure, and little revela-
tion. Both of these facts were very much in the American grain. Thoreau's lyr-
ical cry—"if we are really dying, let us hear the rattle in our throat and feel
the cold in our extremities: if we are alive, let us go about our business."

And how is our "business"? Is it still business as usual? That Thoreau
should have judged the weight and value of the word appropriate to the con-
clusion of such a passage, speaks to how profoundly the American grain is
fractured on this subject. If it's a matter of business, is it still business as
usual?

This pioneer fact—a nightpot polished by use, under a bed sagging with in-
visible sleepers—did not appear in *The Home Place,* published in 1948, but
would find its place in *God's Country and My People,* published twenty years
later. My own ambivalence testifies to what is a matter of "custom" in the
blurred gap between revelation and exposure. When in doubt, and the revela-
tion seems thin, exposure can be relied on to clarify the distinction between
fact and fiction.

A few weeks ago, in a local newspaper, I read that men were not lacking to
"model their penises" for an upcoming film. Why not? Surely this male
"member" constitutes a fact? In the stimulating area of "What is New?"—
the photographer would appear to be a groundbreaker, previous uses of the
penis largely limited to envy. But that's just an opinion: it's not an area where
I can claim to be well exposed.

More than forty years ago, as I crossed a cornfield toward a barn I hoped to
photograph, the owner of the barn fired a singing hail of buckshot over my
head. This gesture was not unusual in the rural South. The crack of a gun—in
Georgia and Alabama—was something to which I had become accustomed.
On this, and other occasions, the gunman had missed me, but scored a bull's-
eye on the target of privacy.

Has it been left to photography, more than avant-garde art or the modern
novel, to bring clearly to focus the abstract-seeming issue of privacy? On the
ground glass of a camera, or in the dim light of a darkroom, esthetic dilemmas
pop into sharp focus. The writer, at the front of a novel, confuses the issue in
this manner:

> The characters in this story are wholly imaginary, and have no reference to ac-
> tual people, living or dead.

This disclaimer, like Confederate money, is no longer negotiable. Implicit in it, however, was the admission that a person's *own* person was private property, but as everybody who is anybody knows, it is the *private* person the hunter is after. The writer wants, and will have, the photographer needs and will get the picture, nothing less than the whole enchilada. Ways of serving up the whole enchilada are what is new.

If it is still desirable—and it is, it is—to rope off areas of privacy, photographers will prove to have a vested interest in precisely what is roped off.

1989, reworked from an article in *Magazine of Art*, February 1951.

Photography in My Life

SOME FIFTEEN MONTHS AFTER taking my first photographs as a twenty-three-year-old on his *Wanderjahre* in Europe, I applied my Zeiss Kolibri to the purchase of a Rolleiflex. I was a writer—what need did I have for a camera? For some four or five months I had been obsessed with a childhood, previously of no interest to me: my own. Page after page accumulated as I tried to recover my Nebraska boyhood. Most of these impressions were little more than sketches, verbal pictures of places, of time-stopped moments.

> She wiped the table with the dish rag then leaned there, propped on her spread arms. A few leaves rattled in the yard. Some dirty leghorns clucked and waited at the screen. She left the rag on the table and emptied the pan toward the leaky shade. She stood there awhile, her hands pressed into the small of her back. Turning, she looked down the trail bright now with copper leaves at an old man's knees, white in the sun. She watched his brown hands lift Monkey Ward's, tear out a page. She watched him read both sides, very slowly, then tip his head. As he rose his overalls came up with a sigh and one strap hung swinging between his legs. She watched him step into the sun and hook it up. From his hat he took a feather and passed it through the stem of his pipe, then turned to strike the match on the door *(God's Country and My People)*.

As I gathered these impressions it became apparent that I was making images with the characteristics of photographs, such as the eye for detail and the aura of detachment, of impersonal observation. It was clear to me, however, that a writer who wanted a *picture* of something might well *take* it rather than describe it. The pictures I wanted were back in the rural Midwest, but I saw similar objects in the alleys and streets of southern California. With the Rolleiflex camera, on a tripod, I began to search them out. Stoops and doorways, windows and screens, the tubs, tools and utensils of daily living, fences and gates, the patterns formed by light and shadow, verticals and horizontals. My assurance in this matter was puzzling. Except for the image on my mind's eye, I had no example or precedent. I had seen a few of Weston's photographs, but nothing by Dorothea Lange, Walker Evans, or the photographers of the Farm Security Administration. Nor did it cross my mind to take pictures of people. I

made enlargements of the prints that seemed more interesting than others, and from the deficiencies of what I had done I learned to see the limitations of what I was doing. One limitation was technical. I had yet to learn about the view camera and wide-angle lenses. On occasional trips to Los Angeles I saw tructures that excited me more than the familiar fragmets, but I lacked the equipment to deal with such subjects. My first wife Mary Ellen and I were part of, but only moderately aware of, the Great Depression; she gave piano lessons, I worked part-time for the WPA and continued working on a long novel. We thought we lived quite well on an income of sixty-five dollars a month.

In the summer of 1938 my wife accepted a position to teach at the Westover School in Middlebury, Connecticut. We went east by car, and had our first good look at the Pueblo culture of the Southwest. Along the way I took a picture of a fire hydrant and barber pole in Needles, California. Pueblo structures were popular at the time with both photographers and artists, and I ran a fever of excitement on seeing the ruins of Mesa Verde. Adobe walls and textures, patterns of light and shadow, the dominance of the past in all aspects of the present, the palpable sense of time as a presence, made me more fully aware of what I was seeking in the transient ruins of my own culture. I wanted evidence of humankind in the artifacts that revealed individuals' passing. I was also instinctively drawn to forms that were traditional and impersonal. My need to take up a position *fronting* these forms, as if they were symbolic facts, I accepted without question. Where these elements combine in a single photograph I take the greatest pleasure in the resulting image. There are numerous examples. Some structures impress me as icons, with a sense of their own—in the words of Henry James—a mystic meaning proper to themselves to give out. The Gano grain elevator in Kansas is an example of this expressive form. Objects share this quality, singly or in groups, where exposure to human use has shaped them. The simplest snapshot will bear it witness, and we feel this directly, without mediation. In the Pueblo country I was able to sense more of my own inscrutable purpose. The worn and abandoned aroused me. Ten years before I returned to the home place, the farm near Norfolk, Nebraska, I was prepared to appreciate homegrown American ruins and to attempt to salvage what was vanishing. Nothing will compare with the photograph to register what is going, going, but not yet gone. The pathos of this moment, the reluctance of parting, we feel intensely.

After the years in southern California the green landscape of New England seemed overwhelming. We spent the summer in Wellfleet, on the Cape, where I was seized with the desire to paint. Some of my California friends were painters, and predictably I attempted to paint what I would have photographed. Cape Cod houses and churches, the dunes of Truro, the white on chalk white, in a shimmer of sea air, would take a lifetime to fathom and another life to

master. I was pleased with my bundle of amateur watercolors and stopped to show them to Lewis Mumford, who tactfully inquired about my photographs. I spent that winter in a cabin on Quassapaug Pond, working on a novel, and the following summer, back in Wellfleet, I took pictures with my first 4×5 view camera. The bellows leaked, but I was able to see the beckoning promise on the ground glass.

In the fall, working on enlargements in a Middlebury farmhouse, I glimpsed the connection between words, my own written words, and the photographs I was taking. Rather than ponder the photograph, then describe my impressions, I found in what I had written the verbal images that enhanced, and enlarged upon, the photograph. The unexpected resonance and play between apparent contraries, and unrelated impressions, was precisely what delighted the imagination. I saw that this was often equally true of the pairings of friends, pets and lovers. In the unanticipated commingling of opposites the element of surprise was life-enhancing.

I made a selection of the prints and mounted them with the related text attached. Learning that James Laughlin, of New Directions, was living nearby, I drove over with some examples to show him what I was doing. It did seem to be a new direction. After some reflection he agreed to publish a selection. The introduction I contributed has the tone of a futurist manifesto, one of many that left the waiting world unchanged.

Laughlin's interest in my photo-text project, along with the results I was getting with my first Schneider-Angulon lens, led me to put my writing aside and to concentrate on *The Inhabitants*. I had in mind a volume of structures and artifacts that would represent the nation as a whole, having seen enough of them in my travels to know how diverse yet characteristic American structures would prove to be. Thoreau's comment is pertinent:

> What of architectural beauty I now see, I know has gradually grown from within outward, out of the necessities and character of the indweller, who is the only builder—out of some unconscious truthfulness, and nobleness, without ever a thought for the appearance and whatever additional beauty of this kind is destined to be produced will be preceded by a like unconscious beauty of life . . . it is the life of the inhabitants whose shells they are. . . .

The Midwest and the Southwest, rural and urban, the marvelous houses and barns of New England I had just discovered, but I had seen little of the South except through photographs. Those of Walker Evans, in *American Photographs*, had profoundly confirmed my own responses. I did not see through Evans's eyes, but I was captive of the same materials. The Great Depression was spectacularly photogenic, and in *Life* magazine I had seen examples of the unmatched power of the camera eye. I also felt the urgency of the true believer about to voyage among the heathen. So many structures (souls) eager and

willing to be saved might otherwise be lost! I had watched a barn collapse
while I hastened to set up my camera. A strong whiff of missionary zeal
fueled my enterprise. My ambitions were large but fortunately my means were
small, or I might still be lost in the streets of Charleston or the back roads and
trails of the Smokies.

In realistic terms, I planned a trip of some eight or ten thousand miles, be-
ginning in the fall of 1940, going south to Georgia, west to Mississippi, north
along the river to Nebraska, then southwest through Kansas, New Mexico, and
Arizona, to California, where I would spend the winter. In early spring I
would head east, through Nevada, Utah, Idaho, and Wyoming, crossing the
plains while the trees were still barren, following the back roads through the
farms of Iowa, Indiana, and Illinois. I hoped to take as many as a thousand
pictures selected from thousands of subjects. I wanted the representative struc-
ture that would speak for the numberless variations. I had in mind not one
book, but a series, each dealing with a phase of our national life as I had ex-
perienced it. Rural, small town, urban and the open road. This first book, *The
Inhabitants,* would be a survey of the state of the Union in terms of its threat-
ened symbols. How well I visualized it! There was no limit to my confidence,
my enthusiasm, and combined with my sense of mission I was a formidable
supplicant, able to persuade Louise Dillingham, the head of the Westover
School, where my wife was teaching, to contribute $500 to this new direction
of photographs and words. A '34 Ford coupe, with a rebuilt motor, the seat
wide enough for me to curl up in, was fitted out with recapped tires and a
South Wind heater. In October, with a carton of film packs, a $3\frac{1}{4} \times 4\frac{1}{4}$
Graphic View, fitted with the Schneider-Angulon lens, I stopped along Route
I, in New Jersey, to wait for a break in the flow of traffic to photograph the
gleaming facade of a white church. As so often before, another traveler was
about to discover America.

In Washington, D.C., I stopped to see Roy Stryker, of the Farm Security
Administration. I had fancied I might get a roving assignment from him, or at
least wangle a supply of film. He looked at my examples with interest, but
without enthusiasm. My conception of words and photographs puzzled him,
and he was profoundly bemused by the absence of *people*. People, he said,
were what it was all about. I agreed. Having seen thousands of exceptional
photographs, those that I showed him did not overwhelm him. I tried to ex-
plain that the presence of people in the houses and barns was enhanced by
their absence in the photographs. He had heard many things, but nothing so
far-fetched as that. A profoundly compassionate man, increasingly aware of
the sufferings of millions of Americans, he had little patience for what he felt
to be suggestively "arty" in my photographs and texts. His programs hoped to
correct social abuses, not serve as an excuse for personal experiment. He was

not so blunt, but I understood his meaning. He was also correct in sensing that my purpose was not in the interests of social justice. I wanted the *persona* behind the social abuses, one that would prove to be the same with or without them. We were each right, in terms of what we wanted, and I left his office empty-handed.

For reasons Stryker would not have approved, I took pictures of the boxlike Civil War-period houses in the capital's slums. I felt, thanks to Stryker, some embarrassment in the pleasure these shabby, dilapidated, lean-to dwellings gave me in the light of the social abuses they revealed. This dilemma, like so many, is part of our complex inscrutable human natures and will not be resolved by legislation or discussion. The way I see what I photograph is to me life-enhancing. Other ways of seeing are equally valid, but they are not mine.

With my interest in the old, the worn and worn out, the declined, the time-ravaged, the eroded and blighted, the used, abused and abandoned, as well as the structured volumes, the contrasts in texture, the endless gradations from black to white in stone, shingle, clapboard, painted or peeling, such as the rows of wooden and marble stoops in Baltimore, after the first extended day of photographing my problem was more practical than esthetic. There seemed to be an inexhaustible bounty of material. I had a finite supply of film. I would have to be selective, wherever I looked, or my march through the South would end up like Sherman's in North Carolina.

The overrich compost of Southern life and history, which I had sampled in the pages of Faulkner, was visible on the surface, in stratified layers, even for a traveler as ignorant as I. Southern atmosphere, as dense and pungent as leaf smoke, to be breathed in and savored like pollen, was in such contrast to my previous experience that I found myself in another country. The surface hospitality, the inflection of the language, the suspicion that there was less just below the surface than on the surface, the provocative sexuality that was a matter of custom, of tradition, not intended to incite more than a flirtation. The warm Southern nights, the music, and the black voices seemed as exotic to me as I had found Mexico the previous summer.

Soon enough I discovered I was seen as an intruding alien. The camera, and the camera eye, is justly looked upon with suspicion. I tramped about with this machine, mounted on its tripod, and set it up to conceal myself beneath the hood, invariably pointed at some house or doorway judged to be of no pictorial interest. Why would I take *that,* except to reveal what was better concealed? I could only have in mind the exposure of whoever lived there, a blot on the peeling Southern escutcheon. As their attention turned from me to my car, with its out-of-state license, the picture seemed clear. I was a Northern snooper out to disfigure the troubled, dilapidated Southern self-image. Black and white both felt it, the black with less malice but a more profound discomfort. My presence testified to their worst suspicions about their own condition. The

separate yet commingled cultures of black and white that make the South a unique and a tormented culture were at once unavoidably visible and subject to instant falsification. The impoverished black, the debased poor white, had been well exposed in books and magazines, and such distinctions as might be made were in the eye of the beholder, not the camera.

At the edge of Culpeper, in West Virginia, I found a house and dead tree, equally husklike, both appearing to date from Lee's surrender, that seemed to speak directly to my troubled state of mind. Was it a portrait or a caricature? Did it reveal a state of soul or a state of abuse? I could see now one, now the other, by merely blinking my eyes. But in the basking sunshine of a Blue Ridge October I felt the ripeness and warmth of survival more than I felt the chill of inhuman custom. The meaning this structure had to give out was a many-layered, many-voiced passage of history, too dense and complex to do more than acknowledge, but in this surviving husk it was more life-enhancing than life-defeating.

But that was not all. What I had made, when the shutter clicked, was a photograph. It would be weeks before I saw the negative, and many months would pass before I made a print of what I had seen on the ground glass. Would that image restore my original impressions, or would they be replaced by others? To what extent would this new image, cut off from its surroundings, constitute a new structure? How much of the "reality" had it captured? How much had it ignored? Whether or not it had been my intent, I would end up with something *other* than what was here. It would be a new likeness, a remarkable approximation, a ponderable resemblance, but not a copy. This new image would testify to the photographer's inscrutable presence. I was not appreciative of these distinctions at the time I took the picture, and believed that what I had seen on the ground glass would surely be what I had captured.

I was working on the faith and enthusiasm that what I saw on the ground glass would prove to be the photograph I wanted. Once a week, if possible, I would stop in a town where my film packs of negatives could be developed, and I could be reassured as to what I was doing. Ideally, I would have carried the developing equipment and periodically done the work myself. I had thought of that, and briefly tried it, but my interest in the chemistry side of photography was even less than my talent for it. I had neither the experience nor the confidence to do this crucial work myself. With few, and infrequent, exceptions, the method I had chosen proved to be the right one.

I made my way south along the foothills of the Smokies, the blues of the mountains to the west transparent in the hazy light, deepening to purple as the sun set behind them. The warmth of the season, the golden October light, the harmony that prevailed between people and nature (people and people was another matter) seemed to clarify for me, in an instant, the attachment of the

Southerner to where he or she had come from. A balladlike sense of peace, if not plenty, seemed as palpable to me as strains of music. I was subject, as my experience had proved, to a lyrical euphoria when exposed to such places. I had felt it repeatedly in Europe, and to the point of dazzlement in Mexico. If something unearthly had occurred, I would have been an eager and willing witness. This mood was both so tangible and so fragile I was reluctant to dispel it. I stayed away from the larger towns and avoided photographing what might arouse comment or suspicion. I confined myself to farmhouses and outbuildings, and to the look of fields and fences in the slanting light. I noted how frequently a coat of whitewash would accent a weathered wall, gate, door or brick chimney. Most of the natives I saw were black, deferential to whites, and eager to be helpful. I soon found that their answers to my questions of where I was, and where I hoped to be going, were less concerned with information than with a desire to be cordial. Was this the right road? Yessuh. Was it a good road? Yessuh. If place names were mentioned I might not understand them and this increased my assurance of strangeness.

Later, on a Saturday night in North Carolina, I watched the town fill up with old cars, buggies, and wagons that were full of denim-clad poor white country people and their children. It was new to me to see a real "tribe" of people, the men and women in separate groups, the kids roving about like unleashed pets, the men inclined to hunker down on their hams like Indians, their forearms on their knees, their hands dangling. It amazed me to see that they might crouch like that for an hour or more, silently smoking, or in animated talk. The women were never part of this commingling of the men. I liked the drawling speech, the turns of phrase, and the breeding I saw in the lean faces and work-honed bodies, their postures and gestures acquired from the daily habits of a lifetime. I feared to intrude on them, but I liked spying on them as I would have gypsies in my hometown. They seemed more interesting and intense than the people I had known. The women were lean from work and child rearing, the skin of their pale faces tight to the bones as if to emphasize fundamentals, thin-lipped, given to uneasy glances that might be quick to take offense. To watch them as intently as I cared to, I sat in the car pretending to read a paper. I wouldn't have dreamed of trying to take a picture. I had always felt the camera eye to be intrusive, but never so profoundly as when I contemplated directing it toward such private people. The barefooted children, in hand-me-down clothes, ran about beneath the wagons. How was it that I, a native of the plains, should feel that here I was, at long last, among my own people?

In South Carolina, near the state line, I stopped at the edge of a sun-baked bean field. At its center, raised off the ground so high that a small child might walk beneath it, was a large, one-storied clapboard house with a shingled roof

and high windows without glass. The windows made deep pockets of shade, and crisp shadows accented the unpainted clapboards. The yard around it was hard and swept clean as a floor, and between me and the house was a covered well with a pulley to raise and lower the galvanized bucket. Not a soul or a dog was in sight; in the high noonday heat I assumed both might be napping.

The patterns of light and shade, the colors of earth and wood, the shimmering flame of light at the edge of the shadows, compelled me to try and get the picture. In all of its weathered and human-shaped details it fulfilled my idea of the beautiful. But I would have to intrude on private property. Stealthily, picking my way along the furrows, extending the legs of the tripod as I approached the house, I set up my camera, stooped beneath the cloth and saw the blurred image on the ground glass. Beads of perspiration seeped into my eyes. I backed away, shirt-tailed my face, then once more focused on the ground glass. Just to the left of the house, perhaps ten yards behind it, in colors that appeared designed to conceal him, a black giant stood in a posture of resting, his hands clasping a hoe handle. A narrow-brimmed hat, tilted forward, shaded his eyes. I pretended not to see him. It made my movements more assured and casual. I was deliberate and open in what I was doing. I moved the tripod, I took several pictures. I felt the passing of time would prove to be to my advantage. On the ground glass I watched him approach me until beads of perspiration burned my eyes. Too late to cut and run, I was paralyzed.

"What you see?" he asked me.

Out from under the cloth I peered up, and up, at the ivory smile in his black face. He was curious. "What you see?" he repeated.

"You want to look?" He did. He crouched low, I hooded him with the cloth, and for a long moment he was silent. Backing away, he shook his head, puzzled. "You don't see it?" He did not. I checked to see if the glass was in focus. It was beautiful. Then it occurred to me it was upside down. "It's upside down," I said, apologetic. That was more mystifying. He had another look at it. What he saw led him to stoop, slapping his knees, then straighten up with a bellow of laughter. Why the image was upside down was something I did not want to go into. We moved to the shady side of his well where we both had a drink from the bucket. He took deep audible swallows, his Adam's apple pumping. When he had finished, he emptied the bucket over his head, the spill of water darkening his shirt. The drops that fell to the ground did not soak in, but rolled into balls of dust. If he had worn a sheet, I would have felt in the presence of the Lord in *Green Pastures*. Near where we stood, a wire-supported pole I had not noticed went up about twenty feet to dangle four or five gourds, the narrow ends chopped off. Small birds, nesting in the gourds,

darted in and out. He watched this with such delight and concentration I walked away, not wanting to disturb him, and when I looked back from the road he was still there, his wet hair gleaming.

In 1940, World War II had begun, but we were not yet in it. A slight war fever was palpable among those who might be drafted or felt themselves threatened. In Greenville, South Carolina, I was picked up as a vagrant and charged with being a possible spy. My camera was there beside me and I had obviously been taking pictures. Of what? Of critical installations, surely. The excitement of having captured a spy soon gave rise to a sense of exhilaration. The chief of police, a short, fat man with a nervous hysterical manner, leather straps, ammunition belts, pistol in a holster, might have served Mack Sennett as a model for the comical, as opposed to the beefy and brutal, Southern cop.

I was fingerprinted and questioned, and all of my gear was inventoried. Then I was taken to the second floor of a jail behind the buildings facing the main street. This was a single large room, with bars at the windows, cots placed around the walls, with a windowless cell, the door heavily barred, in the room's back corner. A local desperado, by the name of Furman, was kept in this cell.

On the strength of hoping I was a spy, a plainclothes official, a kindly elderly man with whom I briefly discussed Stark Young and Faulkner, came over from the capital, Columbia. He looked at my papers, heard my story, and recommended that I spend at least a week in Charleston, then advised them to release me. I had a long day and night to brood if that advice would ever be taken. On the third or fourth morning, shortly after the chain gang rattled its way down the alley, I had a tin cup of coffee with the chief. He had for me, he said, no hard feelings. He gave me my camera and the keys to my car, and advised me to get the hell out of South Carolina. That advice I took. Along with me went a large colony of bugs, some who took up fairly permanent residence. I drove without stopping, but with the greatest of care, the eighty miles or so to the Georgia state line, then another fifty miles or so to Athens. In the Athens YMCA I took a long, long shower and washed myself repeatedly with Lifebuoy soap, scrubbing my scalp and hair. The profound relief I felt—to be free of incarceration, of a sense of helplessness that is traumatic— had little or nothing to do with the relatively comical incident. I had known it earlier, in Grosseto, Italy, where I was picked up as a threat to Mussolini; but the jail in Greenville, the character of the law and order, the "outside" world that I could see and share through the windows, left on me a ponderable impression. Two months later, in Santa Fe, I put it into fiction. A year later it would become the closing chapter of a novel, *My Uncle Dudley*.

I was understandably reluctant to take pictures while in Georgia. I had heard about Georgia, I had read *Tobacco Road,* I had seen the chain gangs in the movies. I kept a low profile. I had recently read *The Heart Is a Lonely Hunter* and heard that Carson McCullers had lived in Columbus. I could believe that. The basking Southern heat, the soft golden light, the way structures and people appeared to be saturated with the scent of a past as dense as leaf smoke, smoldering and druglike, in which everybody was a willing complaint victim. Walking the dusty streets I envied the writers fortunate enough to come from such places, still sticky with the pollen that clung to them. It seemed to me they need only close their eyes, open their pores, and inhale deeply to possess their subjects. The sorghumlike richness of Southern life was both on the surface and fermenting beneath it. Through the dusty lace curtains at my hotel room window I spied on passersby I secretly envied, as Sherwood Anderson spied on his neighbors in Winesburg. They were dream-drugged, these people, and I envied the depth of their addiction.

In the nearby countryside, as I was driving around, I saw the glow of lights that I thought might be a fire. It proved to be a small carnival, with a rocking, clanking Ferris wheel, one or two dangerous rides, and sideshows of freaks. It had been set up in a field of trampled grass, the air smoking with the savor of barbecued meat. No carnival or Chautauqua of my boyhood generated so much excitement and expectation. These countryfolk, with their throngs of small fry, were the crackers I had read about in Erskine Caldwell. I was amazed at the visible kinship linking the cartoon grotesqueries of Li'l Abner or the figures in Faulkner's *Spotted Horses* to the people I saw around me. In the context small occasions provided, larger than life figures and sentiments materialized. Given a throng of expectant, deprived rural people, a mythic South might emerge from their shared expectations. Its sensuality aroused me. I felt the surrounding darkness would soon be cluttered with amorous couples. After the engines had coughed and died, the crowd had dispersed, and the tents had collapsed, a cloud of dust so thick I could taste it hung over the field where it had all happened. I spent the night in the car not far from a banjo that repeated, and repeated, the same chords. Now and then the player cried out in the manner of a flamenco singer. I largely owed to these few weeks of Southern exposure my feeling that hardship, and hard times, if not destructively brutal or prolonged to the point of negation, are necessary to a density and richness of emotion that seems noticeably absent in happier situations. I did not say to myself that my life had changed, but with the morning light I felt that it had. Missing from my life had been the emotion that finds its fulfillment and release in the ballad. I had discovered the emotion, but how to cultivate it would prove to be the work of a lifetime. A few years later when I had read James Agee's *Let Us Now Praise Famous Men* and had seen Walker Evans's accompanying pho-

tographs of the sharecroppers, I would fully appreciate the wide range of impressions I had just experienced.

In Pike County, Alabama, I crossed a field of corn stubble to get a clear view of several barns and a house, weathered to the color of dead branches. I moved in closer to get the shingled roof of the house, shimmering with heat. Under the hood of the camera, focusing on the ground glass, I heard an angry, bellowing voice. I uncovered my head and looked around. I saw no one. The voice spoke again—it seemed closer—and the corn stubble crackled as if trampled by cattle. The blast that followed was that of a shotgun behind the barns. In the morning stillness the air seemed to tremble, and so did my legs and hands. I ran for the car, the tripod legs dragging, and some moments later I saw, with wide, staring eyes, the film of perspiration on my face in the rearview mirror. Could one smell of fear? I thought I could detect it.

In November, driving north from New Orleans, I stopped to see a friend who was then living in Jackson, Mississippi. He took me to meet one of his friends and neighbors, Eudora Welty, and among other things we talked about William Faulkner. Faulkner's town was Oxford, on my route north, but I had no intention of intruding on his privacy. I was encouraged, however, to intrude, if possible, on his old friend Phil Stone. That also seemed unwarranted to me, as a writer who had as of then published nothing, so I spent most of the day in Oxford sitting in the square waiting for history to strike me. It did not. Late in the afternoon I screwed up enough gall, mixed with courage, to appear at the door of Stone's law office. He was there. On admitting my interest in Faulkner, I was taken in tow. Phil Stone was a fluent and accomplished talker, and like most talkers he craved a fresh and good listener, which I proved to be. I was directed to the house down the street, centered in a large lot, which now looms in my mind like a Faulknerian mansion, but unfortunately the details are blurred, and I took no pictures. My car was parked in the driveway approaching the house, where I assumed I would be spending the night. I would meet his wife. I would be modestly feted. I would be gorged with tales beyond the telling, and I would be dimly aware, during the long evening, of the ghostly passage of black figures and the musical murmur of black voices. Some time after midnight, not asked to stay, I inquired if I might spend the night in my car while it was parked in their drive. I had told them of my adventure in Greenville, South Carolina. I was given permission to sleep in my car.

I lay awake until daylight seeking a clue to my pleasurable but disordered impressions. In the light of these impressions, Faulkner's fiction seemed both controlled and understated. The soul of the South, as I was privileged to perceive it, seemed to me more complex, and bizarre, than the reports I had read about it. More incredible to me, I found its strangeness wondrous and life-en-

hancing, rather than merely monstrous and grotesque. I owed these impressions to Phil Stone's remarkable relationship with black people—*his* Negroes, who deliberately chose not to be free. A few were servants in his house, others occupied barns and outbuildings. Something in Phil Stone's nature cultivated and responded to this reversal of historical roles, the master who became the captive of his slaves. I had been greatly impressed by Melville's profound grasp of this dilemma in his novella, *Benito Cereno,* which I saw worked out with even greater refinement in the way the blacks dominated the Stone household. A marvelous "mammy," deep and broad as a scow, served the food she had prepared on a schedule of her own making, her eyes rolling, her lips parted in a litany of *yessuhs* and *yesmaams*. With each serving I exchanged knowing glances with the master and the mistress of the house, eager to share their predicament. An old black man named Blue, asked to fetch wood for a fire, appeared in an hour's time with a stick, no more than a piece of kindling, on his crossed arms like an offering. Thanked for that, but urged to get more, he almost collapsed with contrition, then appeared, an hour later, with two pieces of the same size.

I had been eagerly brought to the Stone house to share its hospitality, so that I could bear witness to this drama of the slaves who were now the masters, and seemed even more fawning in their service. The role reversal had been so complete, so lovingly achieved, that Stone felt compelled to share it with someone, even a profoundly ignorant youthful Yankee. He had become captivated by his own captivity. I doubt that this was true of his young wife, preoccupied with a squalling infant, but Stone took me off to his study for further comments on his condition. He was a friend of FDR and other national figures; their signed photographs ornamented the book-lined room. We smoked stogies imported from Pennsylvania while he brought me up to date on his pleasurable torments. They were many. Periodically he sent the young black men to Memphis, with stakes of money, but once separated from the money they returned to his house. The external world did not appeal to them. Besides, they loved the master and the mistress. The top exhibit—for which I was slowly prepared—was a satin-lined case full of silver goblets, each goblet twisted on its stem by powerful hands. Who had done it? The loving Mammy. It just seemed to happen and she couldn't help it. She was just giving each one of them a polish, and lo and behold it just seemed to happen. Two dozen goblets. It was clear to both of us that Mammy's twist had made them priceless.

Shortly after midnight his wife appeared to call him to bed. He bid me goodnight, wished me luck as a writer, and showed me to the door. Before I passed through it, I managed to ask him again If I could sleep in my car, while it was parked in his driveway. Yes, that I could do. More than that, if I

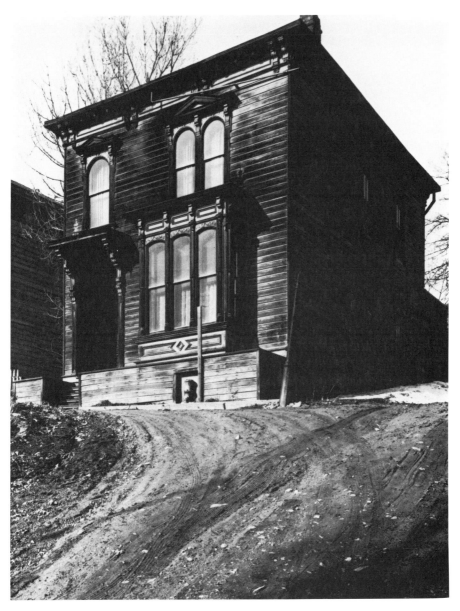

27. *House,* Virginia City, Nevada, 1941

delayed my departure I might have breakfast with them in the morning. As I made myself comfortable in the seat of the car I wondered if this, too, was a decision that the slaves had made for the masters. A sleeping guest was a bother. There would be a bed to make, and sheets to be changed. By morning it was drizzling, and just after daylight I opened my eyes to see the aging, half-blind Blue at my window, peering in, muttering to himself. Did he see me? I pretended to sleep. When he shuffled off, in a parody of the gait of Step-in Fetchit, I decided to take off rather than weaken or dispel the incredible events of the evening. I had breakfast in Oxford, grits with my eggs, then drove north to where a bank near the road had eroded to leave a raw gully, red as a bleeding wound in the drizzle. I badly wanted this image for *The Inhabitants,* and even as I worked to get the photograph I began to ponder a suitable text.

Perhaps an hour later, raining much harder, I passed a field where a harness-patched plow horse, white as Moby Dick, stood luminous in a piece of overgrazed pasture, his heavy head bowed. I should have stopped to photograph it. That I did not is why I have forever borne it so vividly in mind.

In Arkansas the rain-washed air dried as quickly as a watercolor. I took pictures of barns, mostly hog farms, the pens black and muddy, the hogs happy, the smell of the ripe manure as rich and juicy as chewed tobacco. I drove a long day, feeling the need of a change. Late at night, near the Missouri line, I parked off the road to sleep. At sunrise I awoke on the rim of the world. The shadow of the car stretched out before me, the light spreading like surf, splashing on objects. It may have been the first time I saw the plains as a metaphor for the sea, a place to be possessed by the imagination. I no more than saw it, I did not feel inspired by the sight to possess it, but coming out of the woods, literally and figuratively, where I had been wandering for more than six weeks, I experienced the prodigal son's elation at the sight of the homeland. I think it amused me. My view of the plains had always been dim. My sentiments on the occasional cross-country drives were expressed in my early fiction, where Nebraska was the place one drove all night while your companion slept in the seat. That had been the impression of my friends in the East.

As the sun rose, I found much to photograph, anything that stood up so the light would strike it—an almost audible clamor at sunrise—houses and barns, fences and telephone poles, clusters of trees and dwellings, and like a sail at sea, the occasional gleam of a grain elevator. I saw, but did not fully sense, that these constructions were pathetically temporary on the vast exposed landscape. In this I found their appeal, their life-enhancing poignancy. My instinct was to celebrate the eloquence of structures so plainly dedicated to human use and to salvage those that were on the edge of dissolution. The plains provided a scenic prop that was free of obstruction, where the sun was sufficient to delineate the object. I took my subjects on the run, as the light fell on them, fre-

quently not at all to their advantage, since I was eager to see what beckoned down the road and was apprehensive about a change in the weather. A rural schoolhouse, near Goodland, Kansas, with its crisp volumes of white contrasted with deep shadows, spoke to me in the same classical terms as the white house in Wellfleet, on the Cape. No need for poignancy here, only visual delight, a clear statement of Protestant principle and practice.

The roll and dip of the plains increased as I drove west, reminding me that my boyhood in the flat Platte Valley of Nebraska had given me a mistaken notion of the high plains. They were remarkably sealike, the towns sunbaked and windblown riding the crests of the waves. Near the Colorado border—it might have been Goodland—I found a row of stores with curtained and blind-drawn windows and slightly tilting false fronts, that would provide me with an inexhaustible image of plains character and experience, mute, implacable and yet expectant. Stubbornly and irrationally optimistic.

On the crests of the rise, as I drove south, I caught glimpses of an arrow that pointed at the sky, like a rocket on its pad, the moon its destination. As I moved closer, I saw the staggered tiers of a grain elevator approximately in scale with the landscape. The freight train at its base was hardly visible. Only when I saw it enlarged and printed would I have a sense of its proportions. An almost high-noon light, filtered through an overcast, revealed the ripple in the sheet metal attached to the structure's surface. This enhanced the reflected shimmer of light. Near the top, appropriately enigmatic, the four-letter word GANO.

From the edge of the highway, several hundred yards away, I studied the image on the ground glass and took several pictures. My appreciation of what I judge a great image reveals itself in my concern that I might flaw the negative in the taking or in its development. Fortunately, this negative was not flawed, and the print is one I find gratifying. It speaks to me like an icon of the tensions that are overwhelmed by the scale of the landscape and seek release in flight. It can also just be looked at. The photograph, that is, since I am sure the structure itself is long gone. Grain is now stored in huge concrete silos that give a space-age accent to the surrounding plain, and frequently blow up.

Going over Raton Pass, south of Trinidad, Colorado, I recovered the excitement I had felt as a youth on my first car trip to California in the winter of 1926. From the mountains I could see the great blue and rose mesas, like camouflaged ships anchored on the high cloud-dappled New Mexico plateau. The emotions I felt would reassert themselves when I arrived in Los Angeles and found myself nostalgically pondering my early days and wonderful times on the open road.

In the winter of 1940, Santa Fe was still the town of old adobe houses, hot

sun, cool shadows, a bandstand in the square, blankets and silver in the shops, and Pueblo Indians crouched under the awning of the Palace of Governors building. Most of the artists and writers had moved on to greener pastures or trickled back to Greenwich Village, but the lobby of the La Fonda Hotel thronged with trend-seeking tourists and self-proclaimed old-timers. I listened to their stories. Mabel Dodge Luhan was at home near Taos, where the natives were reduced to Sears & Roebuck blankets. The air was like wine, the light shimmered like tinsel, and I marveled how I had dreamed of living anywhere else.

I found a room a ten-minute walk from the square for five dollars a week. The detail is part of the period's aura. I spent the sun-struck days visiting the pueblos, San Ildefonso, Santo Domingo, etc., or following dirt roads wherever they led me. Gas was cheap. My problem was conserving film. I watched Maria Martinez shape and fire her pottery, and bargained with Fred Kabotie for one of his paintings. In the evening I looked for a seat in the La Fonda lobby, fragrant with piñon fires and the smell of Mexican food. I loved the slap and creak of new and old huaraches. I had been in Oaxaca and Mexico City and felt myself one of the chosen.

The big event of the season was the world premiere of Errol Flynn and Olivia de Havilland in *The Oregon Trail*. This trail did not come to Santa Fe, but Hollywood did. The ceremony took place in the floodlit square white with the first snow, and ringed with Christmas lights. The Indian men and their women viewed the white man's fiesta with their customary resignation. Carols were played. Errol Flynn brushed against me as he made his way into the La Fonda lobby.

In a few weeks I had shot more film than I should have, and suffered from a bad case of Pueblo country enchantment. I had bought some old pottery, some new blankets, and before the fever maimed me, or abated, I managed to take off. I drove through a starry night to Needles, California, where I had a fine breakfast in the Harvey House in the railroad station, one of the first and last sanctuaries of great coffee. As I drove west out of Needles I felt the resurgence of the old attraction. California, before I set eyes on it, had been for me the sanctuary of my great expectations, and my years at Pomona College had fired the clay of these impressions. Once I had crossed the mountains, and from Cajon Pass saw the haze of smudge pots over the valley, through which the tan eucalyptus trees thrust up like feathers, I was hooked. Old Baldy gleamed with a snowcap, and the trees were freighted with oranges and lemons. I stopped to drink my fill of orange juice for fifteen cents and ask the price of avocados. They were a dime. In Claremont I drove slowly around the streets and thought the students attractive but extremely youthful. How long had it been since I had been one of them? Not quite five years. In the post office, with its WPA murals painted by Milford Zornes, a classmate, an old

friend was so startled to see me I let myself pass for an imposter. In the mail I had received the New Directions volume with the selection of my photographs and texts, along with a brief review from *The New Yorker* in which my name was mentioned. A first on all counts. At the Sugar Bowl café I was recognized, and experienced the sensation of being interviewed. Fame, surely. I was treated to a piece of pecan pie. To prolong this occasion I sought out Hal Davis, one of my English teachers, who was very kindly and favorably impressed. In that far time, publication was a singular event. Many were called, but few were chosen. I stayed with Hal for two days, smoking his cigarettes and giving him the lowdown on South Carolina hoosegows. The sight of my words in print had stirred banked fires and started other juices flowing. I was eager to write. What? The writing would flow out of my aroused nostalgia, the boy who had arrived, fifteen years before, with his father in the sidecar of a motorcycle.

In Los Angeles I found a light housekeeping room near Echo Lake Park. I put aside what I had begun in Santa Fe, an effort to recapture my days and nights in Greenville, and started a book that began:

> When it was cold we walked around. When it was morning the pigeons came and looked but when nothing happened they walked away. When it was warm we sat in the sun *(My Uncle Dudley)*.

That was the way it had been in 1926, and the passage of time had given it vintage. Would it prove to have the bouquet—on the green side—of my own wine? In two months I would write what would prove to be the first 150 pages of *My Uncle Dudley,* stopping where the car collapsed in Arkansas the morning the Mississippi broke through the levee. With a stint of writing done, I was both free and eager to turn back to photography. I should have waited several weeks, until a touch of spring had softened the weather east of the Rockies, but I was anxious to rejoin my wife, who would meet me in Cleveland at the home of her parents, then set up a darkroom in New York and make my first prints from the negatives of the previous months' work.

I headed east in early March, driving northwest from Las Vegas through the mining and ghost towns to Virginia City. Overcast skies, strong winds, and freezing cold discouraged much picture taking. I put up in the Comstock Lode Hotel in Virginia City, until a half day of brilliant sunlight gave me the half dozen pictures I was determined to get. One was a pair of weathered houses on an incline, preserved in every detail like the mummies in Guanajuato. The other an abandoned church and Hudson-bracketed house stark against a landscape of desert and sky, more in the style of the baroque than American gothic. With these trophies hopefully in the bag I headed northwest for Boise, Idaho, to visit my Aunt Winona, one of my mother's Seventh Day Adventist sisters. A single day with her, and other members of the clan, helped to re-

store the ties I had with my Nebraska boyhood. Near Pocatello, in a galelike
wind that twice toppled my camera, I managed to get a picture of a cattle shel-
ter in a barren, forbidding landscape. Had the settler found water? There was
nothing, anywhere, on which the eye could rest or the body find refuge. In
such places I felt the settlers' implacable commitment, like a symptom of mad-
ness, to self-destruction. They took on the elements. Anything less would not
have gratified their consuming rage.

Blowing snow plagued me across Wyoming, piling up like confetti on the
windshield wiper, and I lay awake on the whistling nights fueled by the day's
eight or ten cups of coffee. Nebraska, too, was snow covered, but thawing,
and I stopped frequently along the route to photograph houses lapped by waves
of dirty snow. The planes and patterns of dormers and gables, in wraps of
dirty ermine, were like winter portraits. Just east of Lincoln, on a rise north of
the highway, I crossed a field of stubble to take a farmhouse against the blow-
ing winter sky. The roof tilted the snow in such a manner that it reflected a
more intense light than the field. The warmth inside the house had helped to
thaw a black rim around the roof snow that set it off like a frame, but I would
not see these details clearly until they emerged in the darkroom, five or six
weeks later.

Through friends I had discovered Brooklyn Heights on the East River. The
brownstone houses on Columbia Street had apartments at the rear that over-
looked the river and the Brooklyn Bridge. It seemed to me few landscapes
were comparable. Hart Crane had lived on this street with other writers and
poets, and I found a ground floor apartment that had just been repainted, at
196 Columbia Heights. In a few days it had been furnished with a set of
springs, boxes for books, and some cushions. Chairs would wait on success.
The first order of business was to set up a darkroom. I made the first 8 × 10
prints of the new negatives, using amidol as developer and Velour Black for
my paper. I thought they looked pretty great.

I worked a long day, stopping in the late afternoon to walk across the
Brooklyn Bridge to City Hall Square, where I could find great bargains in pan-
atela cigars. I lolled at my ease, Whitman style, savoring the smell of the leaf
and the passing throng. I had learned about cigars the previous summer in
Mexico and smoked them in the manner of Thomas Mann's Hans Castorp, ap-
preciating the aroma of the leaf wrapper and the way the veins remained visi-
ble in the long white ash. I can't imagine how a well-primed dreamer, feeling
his oats, could have had it better. I felt very much in tune with my obsessions
and assured about what I was doing. Edward Weston had recently won a Gug-
genheim Fellowship in photography, the first, and it had occurred to me that I
might do the same. Such confidence is born of ignorance. I knew virtually
nothing about photography but what I saw in the magazines. I was fortunate to

have enough technique to make good prints from excellent negatives, and to know what I considered a photograph of interest. As the prints accumulated I expanded my collection of *Inhabitants* and worked on new texts. I wanted the volume to suggest the range and variety of the country. I was also rewriting the draft of the novel I had begun in Los Angeles. I liked its tonal consistency and the range of characters, but was it a long story or a novel? It seemed to trail off, into the debris and confusion in the wake of the Mississippi flood. What I needed was an experienced reader. I found one in Lambert Davis, an editor at Harcourt Brace who had once seen some of my photographs and texts. After several weeks, and the opinion of a second reader, he said Harcourt Brace was interested in the novel but felt that it needed a new conclusion. I agreed. It occurred to me, on reflection, that the experience I had had in Greenville, and had attempted to recapture in Santa Fe, might well serve as the basis for a conclusion to *My Uncle Dudley*. On days when I needed a rest from the darkroom I applied myself to reworking the novel.

In the early fall of 1941, with a portfolio of photographs and texts, I appeared at the Guggenheim Foundation and met Henry Allen Moe. In my allotted time, perhaps fifteen minutes, I tried to compress the facts and the fiction of my commitment to photographs and words. A keen and sympathetic listener, a matchless chain-smoker, Mr. Moe gave me warm friendly glances through the veil of smoke between us. Did he feel I might try for a fellowship? He thought I might. I went away in a fever that found some release in the lyrical statement that went along with my application. I have been spared reexposure to my enthusiasm, but I suspect it embraced a passionate desire to salvage the barns, houses, and structures of America before they dissolved into thin air. I had no idea, at the time I wrote it, how quickly it would happen.

In the dark winter of 1941–42, I served as my building's air raid warden, and spent many evenings on the roof watching the lights of Manhattan blink off during the blackouts. The few that persisted glowed like planets. I often sat there with my friend Sigmund Bekersky, a giant from the Ukraine who made his living as a nightclub bouncer. Bekersky had the talent to share the lives of many people with a few words of greeting and affection. He would come to the apartment with two quarts of milk, a loaf of whole wheat bread, and a piece of smoked pork butt he would eat like a hot dog. He'd sit sprawled on a chair, his shirt unbuttoned; the two kittens would tunnel and crawl about his huge torso, licking greedily at his armpits. How he would roar! An ad in the *Times* lured him to Ohio where a handyman was wanted to help with chicken farming. In this way the wily Odysseus adapted to modern times.

In March I learned I had received a Guggenheim Fellowship. This news marked the summit of the great expectations I had been possessed by for several years. The long apprenticeship I had spent as a writer, and the increasing enthusiasm I felt for the prospect of joining photographs and words, prepared

me for the elation I felt in this recognition. Like others before me, I pondered
how to live to the fullest extent on this huge bounty, a sum of $2,500. Having
lived well for years on less than half of that sum in California, that was where
we headed.

On our previous trip west, if we were crossing Nebraska, I would drive most
of the night while my wife slept in the seat. On this trip I felt the stirrings,
however reluctant, of my plains boyhood. My father's death had awakened in
me an interest in the past. In Omaha we drove past the places I had lived in as
a boy. The houses seemed smaller, the hills and streets less steep, as if they
had shrunk in my absence.

From Omaha we drove northwest toward Uncle Harry's farm, near Norfolk,
where as a boy I had once spent two weeks of a summer vacation. On the dirt
road south of town I stopped a passing car to ask if they knew of Harry Mor-
ris's farm.

"Do I *know* of him?" he replied. I nodded. He turned to spit into the ditch
grass before replying. "Where you people from?" he said, unable to see the
car license. I said that I was originally from Central City. "I didn't think you
was from around here," he said, and let out the clutch.

I found my uncle's farm where he said it would be, but from the graveled
road it looked abandoned. The porch and stoop were lacking from the front of
the house, but I recalled that it had never had either. The only door to the
house that was used was at the rear. I drove down the shrub-lined driveway to
the back and parked the car in the chicken-scratched mounds near the barn.
The long yard between the house and the barn, once green as a billiard table,
was a thicket of matted grass and half-buried croquet wickets. Doors tilted in
shed doorways, fences were down, the dead trees of an orchard stood in weeds
near the house, every visible object, wagon, implement, and structure seemed
to be at the end of a losing battle. The peeled branches of long-dead trees
arched over the house. Never before had I set eyes on such a mockery of my
remembrance. If my wife had not been with me, I might have sneaked off. A
few mangy bare-bottomed old hens clucked nervously as I walked toward the
porch. The screen door, although poked full of holes, was latched. A water
pail, floating the handle of the dipper, sat on the table to the left of the door.
A draft smelling of pickling beets assailed me from the kitchen. Flies buzzed
on both sides of the rusty screen. I called out, but nobody answered. I called
again and heard one of the plates shift on the kitchen range. In a moment she
appeared, a woman thin as a lath, a faded frock hanging limp from her shoul-
ders. Over the frock a beet-stained apron, the ties dangling. Over her left eye
she placed the fingers of one hand. The other stared at me unblinking. It
seemed she did not recognize me, but I knew her.

"You don't remember me?" I asked. She didn't seem to. "I'm Will's boy, Wright," I said. It took a moment's time and effort to place me. Her tongue passed slowly over her store teeth.

"You've grown," she said flatly, and unlatched the screen. As she shooed out the flies she noted the car, and its passenger, parked near the barn. "Why don't you folks come in out of the heat?" she said, and waited until I had gone back and fetched my wife. "How's your father?" she said when I entered the house, but she did not wait for my answer. She had never liked the man who had once sent her three crates of cholera-exposed Leghorn pullets. She had never liked Leghorns. Her idea of a laying and stewing chicken was the Plymouth Rock.

I can no longer distinguish between that actual meeting with Clara, in June, and the fiction I wrote about it that winter in California, the sentiments and nostalgia as palpable as the smell of pickling beets in the kitchen. I know we sat in the parlor, facing Clara in her rocker, and that the two women talked. Only her fan stirred the air in the room. It was of interest to her that I was married, and she inquired about my wife's people. Ohio she knew, having crossed it on her way west from Massachusetts. In the glare of light from the newly graveled road her face gleamed with perspiration. The rocker creaked. I noted the holes it had worn in the Axminster rug.

Some moments before he appeared, my Uncle Harry stopped on the back porch to skim flies off the bucket of water and toss them through the screen. Clara identified who we were, and reminded him that I had once spent some time on the farm. His watery blue eyes gave no sign of recognition. That I was seated in his chair confronted him with a problem only resolved when I surrendered it to him. He silently gazed at the light glare over the fields. We sipped warm water from the amber glasses that were usually stored on the top shelf in the cupboard.

This brief afternoon, during which I said little, listening to the voices of the women, would leave on me an impression from which I would never fully recover, repeatedly returning to the images, and the beet-pickled emotions, of that sultry summer day. In the car was my camera, but I could no more take photographs of what I saw around me than arrange for snapshots of the Second Coming. Images and emotions had saturated my limited responses. I was drugged by feelings that both moved and disturbed me. Had my father's death left in me a core of sorrow that would be responsive to these revisitations?

We drove south from Norfolk to my hometown of Central City, becalmed in the heat and the continuing Great Depression. Idle farmers sat in the gloom of a tin-roofed pool hall. Five-cent cigars were selling for four cents. I seemed unaware of ties or attachments. Down the road ten miles was Chapman, where

my mother was buried, and I stopped at the barbershop to inquire if anyone might have known my mother or father. My father had once been an agent in Chapman, for the railroad, and my mother had been born on the bluffs just south of the river. As I entered his shop the barber studied my face in his wall mirror. "Don't you tell me," he said, "I'll tell you. You're Will and Grace's boy, aren't you?" I said I was. To my knowledge he had never before set eyes on me. His name was Eddie Cahow. At the turn of the century he had come up from Texas on the Chisholm Trail, but found he liked barbering better than trail riding. In the shop, waiting his turn at the chair, was Mr. Applegate, a farmer who had once courted one of my mother's sisters. For more than forty years he had kept the house she lived in in good repair.

Eddie Cahow was agreeable to my taking pictures inside his shop. I worked fast, fearing that so much of my visible past might disappear before I had caught it. Everything in the shop proved to be of interest. The mirror, with its chalked menu of services and prices, the tonic bottles and brushes on the chiffonier, the case of razors and towels, the postcards sent to Cahow from traveling natives, tucked into the mirror's rim, the barber chair, the sink with its platter for hair massages, the peanut machine, the benches with the plywood seats, the wall of calendar pictures of prize beef and kittens. At the back of the shop, shipped out from Kansas City, was an elegant oak and iron grill that served as a bank, with its teller's window, the top ornamented with cans of flowering plants with trailing vines and tendrils. I took several packs of film, the light being good from the large half-curtained window. Later we followed Mr. Applegate to the top of the bluffs where we saw the house my mother had been born and raised in, with its cupola affording a view of the river valley. Mr. Applegate's sisters, who had kept house for him since he had been spurned by one of my mother's sisters, brought a shoebox out of hiding to show me photographs of my mother's family. The sentiments this one day aroused are still fresh in my mind.

This meeting with Eddie Cahow, his barber shop, and his friends, would lock me into a pact with the bygone that I had begun on the farm near Norfolk. By the time we left, early in the evening, the setting sun burning on the windshield, I was committed to the recovery of a past I had only dimly sensed that I possessed. I was blissfully ignorant of any awareness that this would prove to be the work of a lifetime.

Time has an elusive shimmer in southern California, both dazzling and insubstantial. One day follows another, one tremor follows another, it is hot in the sun but cool in the shadows, dark in the movie palace, dim in the rooms where the shades are lowered, a basking void of sunning, shopping, waiting, agreeable to those with a life to remember, but disquieting to those with a life to be lived. I spend my time working on the text for *The Inhabitants* and a

novel, *The Man Who Was There*, that grew out of my impressions of the home place and Eddie Cahow's barbershop.

In the summer of 1944 we headed east, for Bryn Mawr, where my wife would teach at the Baldwin School for Girls. Along the way, in the high country of Colorado, we came on the general store in Kokomo—like the house in Culpeper—sitting for its portrait. More pictures were taken in Silver Plume, a mining ghost town, the silence filled with the murmuring purl of water music visible through the cracks in the wooden sidewalk.

Crossing the plains to the east it's all downhill. As the long and empty freight trains clattered by us, with their litany of towns, states, and places, the Baltimore and Ohio, the Burlington and Quincy, the Atchison, Topeka & Santa Fe, I began to dream of a series of books that would deal with the migration of Americans, a subject I knew something about. From the farm to the village, the village to the town, the town to the city, the city to the BIG town, and then once more—as I had lived it—back to the open road, irresistibly drawn westward. The farm at Norfolk would be the point of origin, then a small town like Central City, or Chapman, with a barber like Eddie Cahow, then a bigger town, then perhaps New York, and then—but much of that would wait on living, rather than planning. With such landscape in mind I did not feel pressed to make *The Inhabitants* a more inclusive volume, greatly increasing its size, and its production costs. With each mile we moved eastward I recovered the excitement that the stay in California had put on the back burner. Time had slowed, with the absence of the seasons and the light glare at the windows, but once we had crossed the Missouri I could once again hear its pulsing, driving, life-enhancing tick. Just twenty years before, my father had also heard it, crossing from Omaha to Council Bluffs, where it had ticked off for him a passage that was inescapably downward. In the nature of things—as the scenario would have it—the son should share this passage with his father. And soon enough, in the writing of *The Works of Love*, he did.

On one of my visits to New York I met Maxwell Perkins, of Charles Scribner's Sons. He turned his profile to me, his hearing aid, and occasionally he beamed on me his shy avuncular smile. I liked him immensely. I also sensed that my disorderly novel, *The Man Who Was There*, both pleased and distressed him. He liked novels that were longer, and less experimental. Still palpable to me, in his curtained office, were some of novelist Thomas Wolfe's great and endless expectations. I felt them as a burden. How did one fill such enormous shoes?

A year or more later I appeared in his office with my portfolio of photographs and texts, *The Inhabitants*. He seemed interested, but the format was unwieldy, the relationship between the words and images obscure. I peered around at the walls of his curtained office. High windows gave a view of the

Child's restaurant on Fifth Avenue. With his permission, I took a handful of paper clips from his desk and began to clip the mounted photographs with the texts to the office curtains. The stratagem seemed to work. He watched me with an indulgent, bemused smile. I managed to put up more than half the volume, and I promised to take them down on my next visit. Two weeks passed before I returned, but the photographs and texts were where I had left them.

What did he think? He tilted back in his chair, thumbs hooked in his vest, the wide-brimmed hat pushed back on his head. A familiar and often remarked posture. The smile he gave me needed no elaboration. He said he had no choice, regrettably, but to publish *The Inhabitants*. It would be done inexpensively, so that the host of readers he anticipated could afford the book. I feel that one of the book's signal triumphs was the impression it made on Max Perkins, and his decision that it should be published by Scribner's. There was no precedent for such an undertaking there, and this may have worked to the book's advantage in that I had a voice in all of the production decisions. I wanted the photographs to "bleed" rather than be enclosed by the page. A suitable paper was lacking at the time, but several coats of varnish gave the pages the appearance of glossy prints. The large format of the book pleased me immensely, and I am still staggered to read on the jacket that is sold for $3.75! At such a price Perkins was confident it would sell.

The Inhabitants was "well received," with excellent reviews, but the public did not buy it and the booksellers had no place to *put* it. Only the art book table would accommodate the large format. A year later, in a shop on Twenty-third Street, I bought remaindered copies for seventy-nine cents, and *Let Us Now Praise Famous Men* for thirty-nine cents. I still have the last of ten copies I bought at that time.

In 1946 I applied for a second Guggenheim Fellowship, and was fortunate enough to receive it. I exchanged my $3\frac{1}{4} \times 4\frac{1}{4}$ view camera for a 4×5. In early May of the following spring I drove back to the farm near Norfolk. The depression-ravaged dirt farm of my previous visit was partially concealed and softened by the growth of spring, weeds concealed implements, a gone-to-seed overripeness seemed appropriate. I found my Uncle Harry at his ease, smoking a cob pipe, tinkering with an inner tube. Clara was more resigned than bitter. I found her seated in her rocker, her lap full of eggs, chipping at the dung spots with her thumbnail. To my suggestion that I would like to take pictures they expressed no objection. Did they know what I had in mind? They had seen *The Inhabitants*. Feeling the need to justify, rather than explain, I said I wanted to capture what it was like to have lived on a dirt farm for half a century. There was no comment. I recall Clara moving her head from one side to the other, to see the room she sat in. Her shoes were unlaced. The ties of her apron dangled on the floor. I could hear mice stirring in the kitchen's basket

of cobs. ''I don't know why,'' she said, ''but if it's what you want to do,
you're free to.''

It had never crossed my mind that she would give me leave to the *inside* of
her house. I was about to reassure her, *You can trust me, Clara*—trust me to
do what? Wasn't I too greedy to be trusted? Didn't I privately feel I had
earned this access? Just a few weeks before I had come on a statement, by
Henry James in *The American Scene,* that gave me, I felt, unlimited access.

> . . . is to be subject to the superstition that objects and places, coherently
> grouped, disposed for human use and addressed to it, must have a sense of their
> own, a mystic meaning proper to themselves to give out: to give out, that is, to
> the participant at once so interested and so detached as to be moved to a report
> of the matter.

I was hardly detached, but otherwise I was qualified. These objects and
places spoke to me profoundly, and I was moved to a report of the matter. My
Uncle Harry was indifferent to the nuances of exposure. The young man with
his camera had come at a time when the usual reservations were in abeyance.
For Clara, the whole farm was a ruin, an accumulation of losses, a disaster
that her Protestant soul must accept, and here comes this youth, a prodigal re-
lation, who saw in these sorry remains something of value. She could not
imagine what, but she could believe it was what he saw. The reservations of a
lifetime would struggle in her soul with the dim, unlikely hope that the youth
might be right.

At the end of the first day, one of a steady drizzle, I had brought my cam-
era on its tripod in from the porch to make sure it was out of the rain. I stood
it up in a dark corner of the kitchen, the lens reflecting the lampglow. Clara
gazed at it for a moment with her good eye.

''It's not taking pictures now?'' she asked me. I assured her it wasn't. ''Just
so I'm not in them,'' she said, and glanced down her flat, faded frock. Would
anything convince her there was something of value in what she saw?

I was put in the upstairs bedroom I had had as a boy, almost thirty years
before. The window frame was just a few inches off the floor, due to some
miscalculation, the folds of the gathered lace curtain as dry and crisp as paper.
The storm window, put up several years before, had not been taken down. On
the doily of the bureau a satin-lined box that had once contained an ivory-han-
dled comb, mirror, and brush set, now held several corroded rifle cartridges
and the partial handle of the missing mirror. Why had she preserved it? We
were alike in that we perceived these objects in the light of our emotions and
judged this the mystic meaning they had to give out.

At the start my Uncle Harry ignored me. I saw him pass with a hoe, with a
pail of water, with another inner tube that needed repairing, indifferent to my

presence. I drew him in with questions. Would it rain again? He replied that it usually did. Soon he trailed me around, offered dry suggestions, tested me with his dead-pan humor. He still smoked Union Leader, if and when he could find his pipe. When I suggested a picture of himself—the greatest ruin of all—he was compliant. Actually, he had been waiting. In the museum of relics the farm had become he was one of the few that still almost worked. He pointed that out himself.

I had him walk before me, through the door of the barn he had entered and exited for half a century. He had become, like the denims he wore, an imple-ment of labor, one of the discarded farm tools. A personal pride, however, dormant since the Great Depression, reasserted itself in the way he accepted my appreciative comments. Why not? Had he not endured and survived it all, like the farm itself? Over several days I had remarked that he changed his hats according to the time of day and the occasion. A sporty nautical number in the early morning, at high noon and afternoon one of his wide-brimmed straws. In the dusk of evening he preferred an old felt, with a narrow brim, the color and texture of tar paper. All hats suited him fine. The only piece of apparel we both found out of fashion was new overalls, blue stripes on white, that in no way adapted to his figure or movements and gave off the rasp of a file. He was quick to sense my disapproval and stopped wearing them.

It was Clara's suggestion that I might look in on Ed's place. Ed was a bach-elor, related by marriage, who had died several weeks before my arrival. His small farmhouse was directly across the road. The bed had been made, but otherwise I found the house as a bachelor would have left it. The bric-a-brac of a lifetime, pill boxes, pin cushions, shotgun shells, flashlights, a watch and chain, a few snapshots. Although the bed had been made, the imprint of his body remained, his feet were almost visible in the shoes beneath it. What I saw on the ground glass evoked in me a commingling of tenderness, pity, and sorrow, to the exclusion of more searing emotions. Was there another Ameri-can emotion to match it? Were not tragic sentiments alien to a free people who were free to choose, and chose more earthly adornments? "Ed passed on last month," Harry had said, as if he had glanced just a bit too late to catch him. What he seemed to see was a movement of the bushes edging the drive.

One evening Clara had shown me a photograph of the Morris family, taken in Ohio in the late 1880s, showing all members of the family, except my fa-ther and Harry, forming a line in front of a clapboard house in a fresh fall of snow. Their names had been read aloud to me by Harry—Mitchell and Emer-son, Ivy and Mae, Martha and Francena—on and on through a dozen. A crack in time had been made by the click of a shutter, through which I could peer into a world that had vanished. This fact exceeded my grasp, but it excited my emotions. The following day I took the photograph into the open air and pinned it to the clapboards on one side of the house. I saw it clearly on the

ground glass before the shutter clicked. Was it in this way I hoped to postpone what was vanishing? A simpler ritual of survival would be hard to imagine. By stopping time I hoped to suspend mortality.

Since I had taken all of the interior shots without artificial lighting I was anxious to get the negatives developed and see what I had done. In Lincoln, while they were being processed, I drove around through the neighboring towns and found many structures of interest. A weathered church near Milford, a railroad station in Panama, a barber pole and barbershop in Weeping Water, in which the photographer can be seen in the mirror. In Central City I woke up the barber, dozing in his chair after lunch. He remembered my father—a railroad man who had turned to raising chickens—but he had no memory of the boy who had sat on the board placed on the chair arms, heard the chirp of the shears and smelled the tonic water doused on his hair. There had been a lot of boys. Looking at me, front and side, brought none of them to mind.

With the negatives in hand I was eager to get back to work in the darkroom. During the three days of driving east I pondered what I should have as a text. Why not such an experience as I had just had, the return of a long prodigal native? Better yet, let him return with his family, a big-city girl and two city kids who had never corked the holes in a privy. Let them all respond to the objects and places for which they had few, if any, mystic feelings. The smell of pickling beets, the heat from a cob-burning range, and flies to be skimmed off the bucket of water, would have on a city girl an effect more in the line of nausea than nostalgia. More in the line of what this homecoming would need. What would bring them back to such a farm in the first place? The housing shortage in the cities. The need for a place to live. I was so well primed with this story, and it so well suited my emotions, that I postponed the darkroom work and spent the first several weeks writing. Especially fragrant to me was the remembered smell of the beets.

The Home Place, published in 1948, proved to be a radical departure from *The Inhabitants.* The text would be a narration of one day's events, as told by the returning native, and each page of text would face a photograph. The relationship would sometimes be explicit—the object photographed would be mentioned—but in the main the photographs would provide the visible ambience for the story, as if we walked about the farm while listening to the narration. The format would be much smaller than *The Inhabitants,* roughly the size of a novel, and the photographs would be cropped. These mutilations removed them, as a group, from the context of artworks, as "images," and presented them as "things" and artifacts. The decision to do the book in this manner permitted no compromise. I wanted to know what such a book would be like, and I found out. The readers I had in mind—it was part of my euphoria—

were those who would browse through the book like an album. Most of the readers I found objected to the distraction of the photographs, and those who liked the photographs largely ignored the text. The book was very well received, critically, and continues to find reader-lookers, but it was not bought at the time of publication and confused many reviewers about the author. Was he a writer who took photographs, or a photographer who did a little writing? The public is ill at ease with the ambidextrous. The writer who does a little painting on the side is not felt to be a "committed" writer. Or painter. My publisher read these reviews, checked the sales figures, and suggested, sensibly, that I stick to my "proper business" as a novelist. I was angered, injured, hit between wind and high water, grievously disappointed—but I listened. Photo-text books were expensive to produce, and on both books Scribner's had lost money. In the volume on which I was then at work, *The World in the Attic,* the second in the series of photo-text books I had planned, I was persuaded to give up the photographs. This book continued the story of the Muncy family, after they leave the home place, and provides Clyde Muncy, and the author, with deep mind-clearing draughts of small-town nausea. This I very much needed, after *The Home Place,* but more important, in the character of Tom Scanlon I acquired a key to my future as a novelist, a freshet of emotion, memory, and imagination that would prove to be inexhaustible.

At a gathering of photographers—sponsored by Edward Steichen at the Museum of Modern Art, I met Walker Evans, Ben Shahn, Charles Sheeler, and numerous others who were full of plans, talk, and stimulating controversy. Some of us walked the streets and talked until far into the morning. the *Home Place* had just been published, to high praise from Lewis Mumford, but "straight" photographers were not lacking who saw photo-text as a dangerous corruption. It seemed and was, however, a very good and productive time for the making of photographs, books, and talk.

In the early fifties I continued to take photographs and made several trips back to the Midwest, as far as Nebraska. Some photo-text essays appeared in the *New York Times Magazine* during this period, but I became increasingly preoccupied with my writing.

In Los Angeles, in the spring of 1958, I met a young woman, Josephine Kantor, an art collector and dealer who was interested in contemporary painting, and in a few days time, before she left for Paris, I tried to persuade her to be interested in me. Jo Kantor knew many of the painters of the period, Motherwell, Rothko, and Diebenkorn among them, and was influential in promoting their work in California. That fall we met in Paris and later that winter in Mexico City. In the spring of 1959 we sailed from New York to Venice for our first long stay of seven months. On returning to California I obtained a divorce from my first wife, and Jo and I were married. We lived briefly in Pa-

cific Palisades, spent another spring and summer in Venice, then returned to California in the fall of 1962. We settled in Mill Valley, across the Gate from San Francisco, where I joined the faculty of San Francisco State University to teach literature and creative writing, until 1975.

A visit from John Szarkowski, in the mid-sixties, reminded me that I was a photographer. I had no new photographs, but as I browsed through the old ones I noted the change in my response to the same images. They were the same, but I had altered. I was ripe with the memories and emotions that had not previously found expression. The result of this was *God's Country and My People,* a very personal revisitation to both a real and an imaginary landscape, one I had been for many years creating as a writer. This recombining of the visual and the verbal, full of my own kind of unpeopled portraits, sought to salvage what I considered threatened, and to hold fast to what was vanishing. Samuel Beckett had put it memorably:

> Let me try and explain. From things about to disappear I turn away in time. To watch them out of sight, no, I can't do it.

Although we might describe this as the photographic century, the nature and singularity of the photographic image still eludes us. In the face of all evidence to the contrary, we persist in feeling, if not in believing, that facts are what photographs give us, and that however much they lie, they do so with the raw materials of truth.

The simplest snapshot, in its seamless commingling of time's presence and its suspension, testifies to the photograph's ineluctable nature. At once commonplace and unearthly, it arouses us in a way that exceeds our comprehension, yet involves us in time's ineffable mystery. For a bewildering moment we are free of our time-bound selves.

The dawn of consciousness may be the dawn of time as perceived by humankind. From that first moment of awareness people have sought a piece of time's living substance, an arrested moment that would authenticate time's existence. Not the ruin of time, nor the tombs of time, but the eternal present in time's every moment. From this spinning reel of time the camera snips a sampling of the living tissue, along with the distortions, the illusions, and the lies, a specimen of the truth.

Where time is captured in repose, and is seemingly timeless, its fleeting presence is visible in the ghostly blur of a passing figure, the actual track of time's passage. The carriage crossing a square, the pet straining at its leash, are momentarily detained from their destination. On these ghostly shades the photograph confers a brief immortality.

In its unexampled directness the photograph has enjoyed, until recently, an unrivaled artlessness of communication. But now that it has undergone a rise in status, and is an object of value and speculation, the attention it receives is

increasingly verbal. Words now affirm the photographic image, as photographs once confirmed reality. This seems to be the fate of all enterprises that are open to scrutiny and discussion. To the extent the photograph is a ponderable object, it will have to be pondered with words.

Nevertheless, it is appropriate that these new images take their place among the objects we value. They reveal our shared awareness of the world around us, and lift the veil on the mysterious world within us. Photographs now confirm all that is visible, and photographs will affirm what is one day remembered. Many images compete for the twentieth century, and the camera eye has been a steady and impartial witness, but I would guess that planet Earth, seen rising on the moon's horizon, will vibrate the longest in human memory. While we continue to grope, like Niépce, for the precise words to capture what the photograph is, the highest praise should be reserved for what continues to elude us. The photographic dilemma, to the extent that there is one, lies with the photographer, not the photograph.

However varying their points of view, all photographers share the common field of vision that the mind's eye, and the camera's eye, have imposed on this century. Quite beyond the telling of it, as well as the seeing of it, exceeding both our criticism and our appreciation, the camera's eye combines how we see with whatever is there to be seen. What it has in mind for us may not at all be what we have in mind for ourselves.

From *Photography and Words,* by Wright Morris (Carmel, California: The Friends of Photography, 1982).

Structures and Artifacts
INTERVIEW BY JAMES ALINDER

MORRIS: IN THE FALL OF 1944 I asked Max Perkins, my editor at Scribner's, if I might use the curtained windows of his office to hang the mounted texts and photographs of *The Inhabitants*. He agreed. A week later he called me to say they would publish the book. Since no book quite like it had been manufactured, I was able to work closely with the production department and get approximately what it was I wanted, and what we all had in mind. The war paper was a problem, but the book was then, and still is for me, a treasure. I can recall my excitement. I had picked up my bundle of author's copies at the Scribner building, on Fifth Avenue, and walked about the streets with them clutched in my arms, too agitated to relax or take the train for home. My sentiments were those common to writers, painters, photographers, or whatever, who believe—rightly or wrongly—that they are involved in the breaking of old forms and the restructuring of new ones. I experienced this again with *The Home Place,* which was published in the format of a novel, with a photograph facing each page of text.

Alinder: What was the critical reaction to The Inhabitants?

Very good. Much better than I had anticipated. The photographs received an exceptionally wide coverage: even in the pages of the *Architectural Forum*. But no response from the buying public. One problem was the book's scale: the book seller filed it away among the art books, and this was some years before art books were in demand. My editor was so convinced the book would sell he insisted on a price to suit the buyer's pocket: $3.75. It seems hard to believe.

Looking at the prints in The Inhabitants, *and knowing your work from printing the negatives, I find a number of the reproduced photographs reversed. Why is that?*

I once actually believed that by reversing *information* (words, numbers, advertising, etc.) I was rejecting that information, turning the viewers away from it.

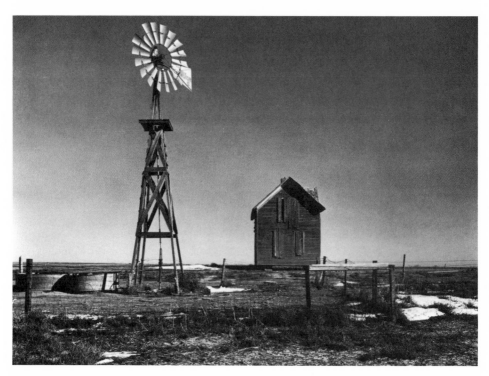

28. *Abandoned Farm*, Western Nebraska, 1941

I soon learned otherwise, but early prints (very few) may testify to this notion. On occasion the print is reversed because I failed to see it clearly in the darkroom. On occasion, in terms of design and structure, I like the reversed print better. What I saw in the darkroom often took precedence over what I saw on the ground glass. For me, the "picture" emerges in the developing solution, and it is the magic of this moment that I find the most exciting. I see my subject through the lens, but I conceive the picture in the darkroom. Photography is *camera obscura*.

After the 1942 Guggenheim, what developed in your photography?

I mentioned the stop with Eddie Cahow, in Chapman, Nebraska. I also took several packs of film on the trip east, in 1943. These negatives were not printed for several years because I had no darkroom in Bryn Mawr, where we were living. I was once more preoccupied with my writing, which had been stimulated by the visit with Eddie Cahow. A second Guggenheim, in 1946, made it possible for me to return to Nebraska and do the fieldwork for *The Home Place*. This volume grew out of my preoccupation with a past I had experienced as a child, but never fully possessed. Fiction was an act of repossession. In *The Home Place* I first staked out my claim on a landscape largely of my imagination. It was what I had *not* experienced that I found it necessary to experience. I wrote *The Home Place* in the summer of 1947, and it was published in the spring of 1948. Once more the critical reception was good, the sales were poor. A more depressing problem was the confusion that existed in the mind of the public. The readers of my fiction considered the photographs intrusive. Those who liked the photographs were not readers of fiction. I had a crucial career decision to make in regard to my next book, *The World in the Attic*, where I had intended to use photographs. The publisher advised me, and correctly in my opinion, that the book should appear as a novel, without photographs. I agreed. To make headway as a novelist is a task that only those who have survived it can appreciate. Until 1967, almost a period of twenty years, I did not again submit a photo-text volume for publication. This was *God's Country and My People*, published in 1968.

What photography did you do after The Home Place?

I received my third and last Guggenheim in 1954. That was for the novel *The Huge Season*, and I went to Mexico to write it. I took along with me some new camera equipment, since I had always found Mexico a special challenge, both as a writer and a photographer. The problem is summed up in the word *exotic*. For the European the Far or Near East, or the south Mediterranean, is exotic. Algiers, Morocco, Cairo, etc. For the American the South Seas, islands of all sorts, the Orient, and recently Mexico. While in college, although

next door to Mexico, it never occurred to me to go there. Nor did it to many of my colleagues. We were oriented to Europe, through literature and the famous exiles of the twenties. When I went to Mexico, in the summer of 1940, it overwhelmed me. A few decades has taken off the bloom, but it is still an amazing experience: a mingling or a failure to mingle of the most bizarre extremes of nature and culture. Antiquity and ultra-chic *kitsch*. Fabulous. In the literal sense of the word I was intoxicated. I took along a camera in 1940 but took only a few pictures. The problem was obvious. Everything I beheld seemed to me photogenic. Everything. Yet photography begins, and journalism ends, when the unusual proves to be commonplace. For this to occur in Mexico takes time. I did not have enough of it that short summer, and did little but gaze like Balboa at the Pacific. Subsequent trips I was holed up writing. So in 1954 I had it firmly in mind to challenge the ''exotic'' illusion in myself and look at Mexico without this enchanting filter. Unfortunately, I became so involved with the novel I was writing I did only occasional photography. I did manage a small album of prints taken on a winter trip to Oaxaca—along with many Sunday afternoons in the *sombra* side of the bullring. Some of these shots are interesting, but not distinguished. They were merely a fresh start on the enormous challenge of Mexico, best captured, in my opinion, in the background scenes of motion pictures. The nature of the dilemma can be seen in Eisenstein's failure to master it in *Que Viva Mexico!*

This same problem of the exotic is also present in literature. Hemingway recognized and bypassed it with his comically cryptic use of dialogue in the novels and stories with a Spanish background. He knew that a minimum use of words might well produce a maximum sense of strangeness. The most successful use of Mexico as a ''place,'' with a full romantic palette, is Malcolm Lowry's *Under the Volcano*. For the young writer, painter, or photographer, it is the first and the last place for the artist to distinguish between what she or he ''sees'' and what is actually there.

As a rule you used a view camera on a tripod, a wide-angle lens, yellow filter, and very slow fine-grain film. How did you arrive at this combination?

I seemed to know from the start, intuitively, what it was I was seeking. It did take me some time to find it, but Rollei pictures taken the first year (1935) have the stamp of the photos taken later. Once I had found the Schneider Angulon lens, I seldom used anything else. Its wide angle gave me both great detail and maximum scope. A notable departure would be the snapshots I took in Venice in 1969, published as *Love Affair: A Venetian Journal* in 1972. Venice is a city my wife and I love, and we have lived in it on several occasions since 1959. On our most recent trip, in 1969, uncertain when we might be able to return, if ever, I took a large number of colored snapshots for our own

fireside, nostalgic viewing. My editor saw these slides a year later and suggested I should do a book. *Love Affair* is the result. All the shots were taken with a Rollei 35, with a 3.5 Tessar, using either Kodachrome or Ektachrome film, without a tripod. I found the projected color slides absolutely dazzling. I did not know, when I took these snapshots, the low esteem in which the color print is held as a "serious" art medium. I continued to find this puzzling and arbitrary, although on reflection I understand the problem.

What is "the problem"?

As I see it, what is unique and fabulous in the color slide is also its limitation. Let me put it this way: the black-and-white negative has already been enormously selective, merely by the act of eliminating color. By including almost everything within our spectrum, the color photograph forces upon it the ultimate banality of "appearances." That is why we tire of them so quickly. The first effect is dazzling; the total effect is wearying.

There is another way to state the problem: Where everything seems to be of interest, the burden of the photographer is greater, not less. The color photograph not merely says, but too often shouts, that everyting is of interest. And it is not.

Now this is an oversimplification, a transitional judgment based on what has been. The possibilities of color for the future are almost boundless, and without question there will be photographers who will meet and fulfill color's obvious challenge and promise.

Do you feel that there have been basic changes in the past three decades in the objects you found of interest? Do you find today's artifacts photographically interesting?

If we look at the record, I seldom found contemporary artifacts of interest. It was their pastness that engaged me. It was their pastness that I wanted to salvage.

Consider the typical house of today, with its accumulation of comforts and appliances. They are marvelous, but only expressive as utilities, as examples of taste: modern, Danish, early American maple, Sears waterfall, etc. As they deteriorate there would be some pathos, but it would seldom achieve home place gothic, or the poignancy of a frayed hole in the Axminster rug. Moving about the contemporary, well-furnished house I am never challenged to take a "picture." Much is foolish, much is vulgar and fatuous, but not in the way that I find of substance. Even less photogenic are the objects that we know to be in "good taste," perhaps even works of art. In moving from sheer utility to "good taste" to "bad taste" we have moved from what is visceral and essential into what is ornamental and superfluous. This dilemma has no resolution.

As it comes full circle, sophistication comes round to the jars, chairs, and toys stored away in the attic. It is a tedious *ronde* that once took a century, but now we recycle it every decade. This in turn leads to pop art and the ceaseless devaluation of appearances. The "artist" who paints with a janitor's broom has already devalued his or her intentions. Enter the art object as a *hoax*.

I have frequently found, and still find, that the aesthetic elements of the emerging, developing print took precedence over the subject matter. There is a vein in my taste, we might call it classic, which seeks for an ordered, harmonious resolution of all pictorial elements. My frontal stance to the subject betrays this intention. I love the way the object stands there, ineluctably, irreducibly visible. The thing-in-itself has my respect and admiration. To let it speak for itself is a maximum form of speech. I believe I felt this before I knew it, but the craft of fiction made me aware of it. So there are occasions when a "new" object will speak to me as forcibly as an old one. But that is not often. The world is full of chairs, many of them works of art, but few chairs speak to me like the veneer-seated straight-backed chairs of *The Home Place,* saturated with the quality of life that I find both poignant and inexhaustible. I don't want to sit on them: I want to look at them. Through human contact they have achieved expressive form.

In a volume I recently stumbled upon, entitled *Quality,* I found one of these chairs, one of my *Home Place* photographs, in a group selected by Walker Evans. I am flattered to have my photographs compared to those of Evans, but this comparison is misleading. He would have been one of the first to say so. Evans was profoundly sensitive to human experience as it is found embedded in artifacts, but his view is usually that of the commentator, the acute social historian. We each selected the same chair, but for palpably divergent reasons. For Evans, and he said so, it is expressive of the cruelty of rural environment, its stark shearing off to what is minimally human. I don't question the accuracy of that impression. But to my eye and my nature the poignancy of that deprivation is moving and appealing. I *love* the chair. Other and more expressive forms lacking, I would accept it as an icon.

What distinctions can be made between reality and photographic experience?

Somewhere Wittgenstein said, "We make to ourselves pictures of facts. The picture is a model of reality." Before all else the photographer is a "picture maker." But he or she seldom provides models of reality. This faculty is provided by the imagination, in its need, in its obsessive hunger, to see through the surface banalities. How one does this is a matter of talent. Until recently it was felt that the photographer was confined to the surface of our illusions. But if we achieve a picture of the facts, we have one of many models of reality. Artists are picture makers, and a few of them will prove to be photographers.

Do you see other pitfalls for photographers?

There is always its amazing facility. Anything so facile has to be questioned. Several hundred million people think of themselves as photographers. They take pictures with lenses, with mirrors, with filters. This has always been so, but never have so many people looked at so many meaningless pictures. Writers begin with writing, composers begin with music, and photographers begin with photographs. They do not begin, as they think, with nature or experience. That is where the artist ends, not where he or she begins. Overexposure to a ceaseless flow of "pictures," overreliance on a ceaseless flow of gadgets and electronics, will dull even the sensitive mind to what is ineluctable in the visible. Joyce's cryptic phrase, which I quoted earlier, is an open-ended way of thinking about photography. The modalities of reality are inexhaustible. But they have their origin in the eye of the photographer, not the lens of the camera.

There has been in the last decade a meteoric rise in interest in photography as an art form. What reasons do you see for this?

A sociologist would tell us that millions have been freed from whatever they once were, to become something else—anything else, including being a photographer. The fabulous wizardry of the modern camera makes it so mindlessly attractive.

A contributory factor to the photographic craze might be the growing fatigue with the *abstract,* in all its forms. We *do* live in a world of representative objects, and they are the source of our needs and affections. I have mentioned a chair. It arouses in me more complex responses than a sign, or a symbol, even when it is good. The cave people knew about signs, but they preferred the bison to resemble a bison. In the long run, so do we. I use "we" in the peculiarly American sense of a people who are at ease with *things.* Most of them had to be made, firsthand, and those that were made by hand have for us a mystic meaning to give out. Thoreau was the first to speak of an architecture "that grows from within outward, out of the necessities and character of the indweller, who is the only outbuilder. . . . " This very American blending of facts and artifacts is at the core of my mingling of words and pictures. Contemporary artifacts—to go back to an earlier question—have been appraised and devalued by pop art—they are objects of utility and ridicule, created in a large part by advertising, rather than tokens of our experience and affection.

You haven't photographed seriously for the past two decades. Why?

In the past two decades I have written and published fifteen books, about ten of them novels. For one decade I have been a teacher. My mind has often bent toward photography, but I have brought it back to my concerns as a writer. If

I had been less productive, if I had been less involved with the expanding world of my novels, I might have continued what began almost hand in hand with my writing. But I have found that being a novelist is work for four hands, rather than two.

Just what are the demands of being a novelist?

In my conception of the craft it is the most comprehensive, and ultimately demanding, of all art forms. Many novels are crowded with photographically vivid scenes and portraits. My own, for example. So I do not give up the camera eye when I am writing—merely the camera. I would say that the people who can write, and want to write novels, are offered few choices and have no options. They must become writers. They will bring the camera eye into their books. I remember my pleasure and excitement when I came on a novel by John Dos Passos, I think *Manhattan Transfer,* or *1919,* wherein he introduced each chapter section with a verbal portrait he called the Camera Eye. I thought them brilliant. I am not sure when I saw the book, but I believe it was toward the end of the thirties. I never saw nor read current novels until I had begun to write them.

My own position was that of a writer who very early saw the visible as a complement to the verbal. Of course I asked, Why not combine them?—and I did. Experience led to complications. Young people—anyone under forty—have learned to live in a visual-dominated world, and they readily accept combined art forms. My books appeared too early for this audience, but my impression is they sense no problem in the many options they are now offered. There will be a continuing harvest of photo-text books, but only a few will combine forms that arise from a single vision. I judge that my good fortune. I use the same eyes to type the pages of a novel and to focus the image on the ground glass. *The Field of Vision* is the title of one of my novels, and that sums it up.

From Wright Morris: Structures and Artifacts, Photographs 1933–1954, (Lincoln, Neb.: Sheldon Memorial Art Gallery, 1975).

PICTURE CREDITS

INDEX